AD REINHARDT

<u>OUTLINE FOR BOOK</u> BY AD REINHARDT

TIMELESS TITLE, "ART-AS-ART"

ART-AS-ART, "AESTHETICS," ABSTRACT ART, FINE ART

ART-FROM-ART, "ART HISTORY," PAST, PRESENT, EAST, WEST
 THE MUSEUM OF FINE ART

ART-ON-ART, "ART CRITICISM," ART ABOUT ART
 ABSTRACTION OF ABSTRACTION
 THE ACADEMY OF ABSTRACT ART

ARTISTS-ON-ART, RULES, THEORIES, DISCOURSES,
 POLEMICS, JOURNALS, LETTERS,
 MANIFESTOES, STATEMENTS, INTERVIEWS

ARTIST-AS-ARTIST TO ARTISTS ON ART-AS-ART
 VS ARTIST-AS-MAN

ARTIST-WITH-ARTISTS, ARTISTS-NOT-WITH-ARTISTS
 COMMUNITIES OF ARTISTS, THREE DECADES
 THREE AVANT-GARDES, THIRTIES, FORTIES, FIFTIES
 UNIONS, CONGRESSES, CLUBS, BARS, SCHOOLS,
 GALLERIES, COMMITTEES, CONSPIRACIES

ARTISTS-AGAINST-ARTISTS, ARTISTS AGAINST ART
 ROMANTICS, REALISTS, SURREALISTS, DADAISTS,
 EXPRESSIONISTS, FUTURISTS, IMAGISTS, POPPISTS

ANTI-ART, ANTI-ART-AS-ART, NON-ART
ANTI-ANTI-ARTISTS

ARTISTS-ALIENATION FROM ARTISTS AND ART-WORLD

ARTISTS-FROM-ARTISTS
 SIXTY YEARS OF ABSTRACT ART
 THREE DECADES IN AMERICA

ARTISTS-AS-ARTISTS BEYOND ARTIST-AS-ARTIST
 ARTIST-AS-MINERAL, ARTIST-AS-VEGETABLE,
 ARTIST-AS-ANIMAL, ART-AS-MAN
 ARTIST-AS-ARTIST, ARTIST-AS--?

ART-AS-ART DOGMA

AD REINHARDT

LUCY R. LIPPARD

HARRY N. ABRAMS, INC., PUBLISHERS, NEW YORK

For Margaret and Vernon Lippard, with love, respect, and gratitude

Frontispiece: Ad Reinhardt. *Outline for Book*.
c. 1965. From a manuscript in the artist's papers.
Archives of American Art

Editor: Donald Goddard

Designer: Leslie Stevenson Fry

Library of Congress Cataloging in Publication Data

Lippard, Lucy R.
 Ad Reinhardt.

 Bibliography: p. 204
 1. Reinhardt, Adolph Frederick.
ND237.R316L48 759.13 79-101623
ISBN 0-8109-1554-5

Library of Congress Catalog Card Number: 79-101623

Printed and bound in Japan

CONTENTS

ACKNOWLEDGMENTS

My greatest debt is to Rita Reinhardt, who put at my disposal all of Reinhardt's papers and provided unlimited cooperation and advice; also to the John Simon Guggenheim Memorial Foundation for the 1968 fellowship that enabled me to write this book. Dale McConathy edited the manuscript twice and without his encouragement and his detailed knowledge of Reinhardt's ideas and personality, the book might never have been completed.

Among the other people who helped me, I want particularly to thank Irving Sandler, Harry Holtzman, Arnold Glimcher, Kaspar König, and Germano Celant. Josef Albers, Tony Smith, Harold Rosenberg, Carl Holty, Carl Andre, Douglas Huebler, and Donald Judd discussed Reinhardt's art with me; Betty Parsons, Jock Truman, Charles Carpenter, Jeff Hoffeld, the Marlborough Gallery, and the Skowhegan School of Painting and Sculpture provided valuable documentary material. I would also like to thank Gretchen Lambert for her photographs, Barbara Lyons for work on the illustrations, Adrian Piper and Terry Berkowitz for typing, the staff of the Museum of Modern Art Library for research help, and Sam Hunter as director of the Jewish Museum for commissioning me to write the 1966 retrospective catalogue that provided the basis not only for this monograph but for a much valued and still influential friendship with Ad Reinhardt.

The "unpublished notes" so frequently cited in the footnotes are Reinhardt's handwritten manuscripts, since donated by Mrs. Reinhardt to the Archives of American Art for microfilming. Since this book was completed in 1970, some of them have been published, though not always in the same version, in Barbara Rose's excellent collection of Reinhardt's writings (*Art-As-Art*, The Viking Press, New York, 1975).

L. R. L., Summer, 1980

PART ONE

Colorplate 1. *Abstract Painting*. 1938. Oil on canvas, 16 x 20". Present location unknown

Afar off in the realm of idealism, let me die drunken with the dreamer's wine.
—quotation next to Ad Reinhardt's picture in his high school yearbook, 1931.[1]

Ad Reinhardt was brought up in Brooklyn and Queens as a Lutheran and a socialist. His mother, Olga, was German, and his father, Frank, was a Lithuanian of German extraction who, before emigrating to the United States in 1907, had been a soldier in the army of the tzar. In America Frank Reinhardt worked as a tailor in the garment industry, in Buffalo, where Adolph Friedrich was born in 1913, in Chicago, and finally in New York, to which he was attracted in about 1915 by the large workers' movement. When Frank and Olga Reinhardt died within four months of each other in 1957, a memorial oration at the Lithuanian Club in which both had been active noted that "Frank stood firm in the ranks of the union. . . . He was working and fighting now to save unions from becoming a tool for the oppressors of the working class. . . . [and in his memory] we must put forth more effort, that liberal organizations and the liberal press might live."

Ad and his younger brother Edward were, therefore, raised poor and politically conscious. By the time he entered Columbia University in 1931, Ad already possessed a tough, open, and acutely inquiring mind. As a precocious high school student he was already doing commercial art for Columbia Pictures and professional book illustration. He also drew stylized heraldic devices (fig. 3), which led to the Synthetic Cubist vignettes he published later in college magazines, notably as covers for *Jester* and the *Columbia Review* (fig. 4). Although he had never doubted that he was an artist (his high school yearbook prediction was "landscape artist"), Reinhardt turned down scholarships to several art schools in favor of a liberal arts education. "A college education for an artist is absolutely necessary," he said years later. "I've never known an artist who hadn't been to school who hadn't felt he'd missed something."[2]

The four years at Columbia were in fact extremely important to Reinhardt's development. From exposure to such teachers as Franz Boas, John Dewey, and Mark Van Doren, he emerged an intellectual as well as an artist, and the former informed, criticized, and questioned the latter throughout his life. Particularly influential was Meyer Schapiro, a brilliant art historian and at that time also a dynamic purveyor of Marxist theory as applied to contemporary visual art, which he knew at first hand. Two of Reinhardt's best friends among the undergraduates, both of whom were still in close correspondence with him until

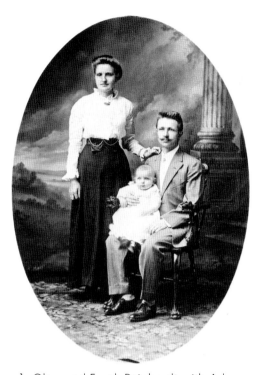

1. Olga and Frank Reinhardt with Ad Reinhardt, c. 1914

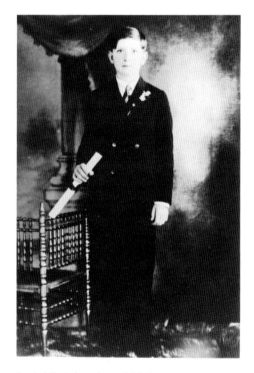

2. Ad Reinhardt, c. 1924

3. Linoleum cut from high school
magazine, c. 1930

his death, were the concrete poet Robert Lax, and the poet, Zen scholar, and Trappist monk Thomas Merton.[3]

At Columbia, in this company, Reinhardt seems already to have made the first of his many distinctions between art and life, distinctions which can be seen as the theses and antitheses which were to be the basis of the synthesis established early as his aesthetic goal. Art history constituted the universal, institutional body of information against which the individual art must be measured or opposed. He saw both a truly fine art and art history as "meaningless" (which in his writings on art can be translated as "most meaningful"): "When objects are moved into the museum of fine arts they *lose* all other meanings. There is no religious art in museums. Try going to the Metropolitan and kneeling down to pray—you'd be thrown out. Meanings vanish." All that is left is the art. "World history is not world history of culture.... The problem of art history is absolutely there all the time. You couldn't possibly be a serious artist from now on without knowing all of art—Chinese and Japanese too."[4]

At Columbia, Reinhardt was already drawn to an art for art's sake, to the emphasis on internal formal relationships as expounded later in Henri Focillon's *The Life of Forms in Art*;[5] to Clive Bell's *Art* ("Every sacrifice made to representation is something stolen from art"[6]); and, inevitably, to abstract art, which, as Schapiro pointed out in a famous 1937 essay, "accustomed painters to the vision of colors and shapes as disengaged from objects and created an immense confraternity of works of art, cutting across the barriers of time and place."[7] Such ideas are related to those of André Malraux, who later published in *The Voices of Silence* his universalist theory of a "museum without walls" engendered by modern communication techniques,[8] and can be seen as one key to Reinhardt's "timeless art." His own anti-expressionist sensibility was already crystallized in these undergraduate years, as is evident in a paper written for Professor E.H. Swift on the International Style in architecture, which Reinhardt praised because "everything about the style is intelligent and cold, calm and impersonally happy."[9]

It seems also to have been at Columbia that Reinhardt acquired his tremendous respect for tradition and simultaneously developed his natural tendency to question everything and argue with everybody. In high school, he had received awards for "art and citizenship." At Columbia, encouraged by Schapiro to join radical campus groups, his most notorious non-academic contribution was presented, typically, in the guise of humor. In 1935, having been elected to the university's student board on a campaign promise to abolish fraternities, he drew a "rectilinear" Nicholas Murray Butler, Columbia's classically dictatorial president, beating "curvilinear" babies (students) with a big club. It was rejected by the college humor magazine, *Jester* (edited then by Herman Wouk and the next year by Reinhardt himself), but accepted by *Spectator*, edited by James Wechsler. This cartoon became the focus of a citywide academic freedom issue. It was the first but hardly the last time Reinhardt was to use humor as a weapon.

To understand Abstract Art is in reality the problem of understanding any and all art from a qualitative viewpoint. "Abstract" signifies a direct untrammeled relationship of the elements of plastic expression. The abstract artist is concerned with the universal values, the real expression of art. Because it is the clearest effort to represent these values, Abstract Art is in the forefront of esthetic development.—Anonymous abstract artist, 1940[10]

In 1935, when Reinhardt graduated from Columbia, New York artists, like other American intellectuals, were becoming deeply engaged in leftist politics. In retrospect it might seem that a similar internationalism would pervade the art itself. But, on the contrary, this political radicalism led, in what has become a historically predictable manner, to the opposite—an increasing aesthetic conservatism. The Depression had drawn American artists into analyses of their own environments; in the mid-thirties a regional social realism, rather than an international abstract art, dominated schools, galleries, and museums.

Modern art in full flourish had first been presented to America at the Armory Show in 1913, the year of Reinhardt's birth. Since then, the prestige and superiority of European art had prompted most American artists to form a closed front, resulting in an art that incorporated ignorance and distrust of the "foreign." Despite the efforts of such isolated modernists as John Marin, Marsden Hartley, Arthur Dove, Max Weber, and Arthur Carles; such dealers as Alfred Stieglitz, Joseph Brummer, Leroy Dudensing, Marian Willard, and Julien Levy; and such institutions as Katherine Dreier's Société Anonyme, A.E. Gallatin's Museum of Living Art, the Museum of Modern Art, the Whitney Studios, and the Guggenheim Collection of Non-Objective Paintings, American artists in general remained insular. Those who pored over copies of *Cahiers d'Art* and studied the few major French paintings available to public view were a distinct minority, and in the late twenties and early thirties the radical impulse was

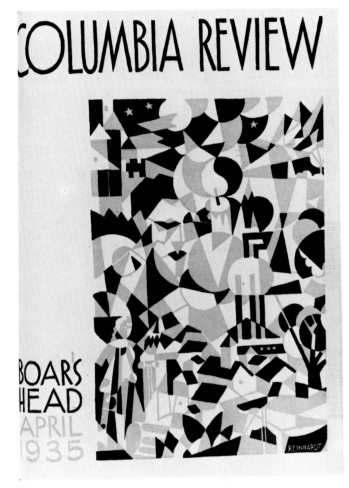

4. Cover of *Columbia Review*, April, 1935

diluted even within the avant-garde. "Ten years ago," wrote G.L.K. Morris in 1946, "a positive emphasis upon the internal properties of art was usually branded as foreign, and hostile to the dominant provincialism....Abstract art— at best tolerated as a legitimate expression for Europeans only—was for the most part regarded as highly unbecoming to any painter working in America; much less was it fortified as a logical contemporary approach by official recognition."[11]

Given this situation, Alfred Barr's "Cubism and Abstract Art" exhibition at the Museum of Modern Art (March 2–April 19, 1936) was particularly instructive for Reinhardt's generation. Including works by all the major Europeans (but no Americans), it supplemented the imported magazines and gallery shows with a sustained demonstration of the powers and possibilities of modernism. Yet this was an isolated instance. The "Modern" museum did little else to emphasize the importance of abstraction in Europe, and certainly nothing to acknowledge its existence in America. One excuse for the latter was the fact that the Whitney Museum of American Art had organized a show in 1935 called "Abstract Painting in America" which, though it included Byron Browne, Stuart Davis, John Graham, Balcomb Greene, Jan Matulka, Irene Rice Pereira, and Theodore Roszak, has been described by George McNeil as "kind of an old-ladies' affair," a historical survey emphasizing the "post-Armory show abstractions of Baylinson, Weber, Zorach" and others "who had experimented with abstraction and then returned to realism."[12] In contrast, the Whitney Biennial that year showed 128 artists, only ten of whom even verged on the abstract (including Marin, Sheeler, Dove, and Stella). The Museum of Modern Art's record from 1935 through 1945 is equally poor, the only major exhibitions (aside from summer loan shows from private collections) focusing on any kind of abstract art being the following: Léger, 1935; "Cubism and Abstract Art," Marin, and "Fantastic Art, Dada and Surrealism," 1936; "Machine Art," 1938; "The Bauhaus," 1939; Picasso, 1940; Miró, 1941–42; Calder, 1943–44; "Hayter and the Atelier 17" and "Feininger and Hartley," 1944; Mondrian, 1945; and Stuart Davis, 1945–46—12 out of some 250 shows over the decade. As Irving Sandler has noted, the concentration of abstract works in A.E. Gallatin's collection, especially the Neo-plasticist and Constructivist sections, "was more important in the development of many local artists than the Museum of Modern Art."[13] Gallatin himself was an articulate member of the American Abstract Artists (AAA), who picketed the museum in April, 1940, handing out a broadside headed "How Modern is the Museum of Modern Art?" Designed by Reinhardt in the style later widely known through his PM newspaper cartoons, it demanded:

> Why and when does a modern museum depart from presenting "the Art of Today" to promoting the art of yesterday? Why not day-before-yesterday? Why not Resurrections, Adorations and Madonnas? Why not build pyramids?[14]

5. *Abstract Painting.* 1935. Oil on canvas, 16 x 20". Private Collection

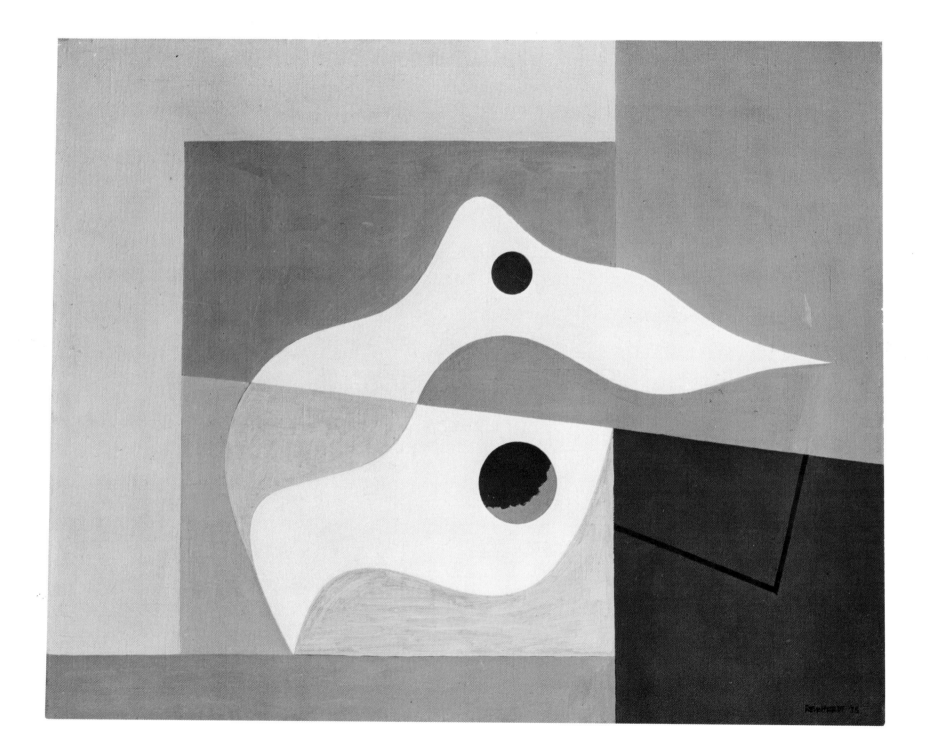

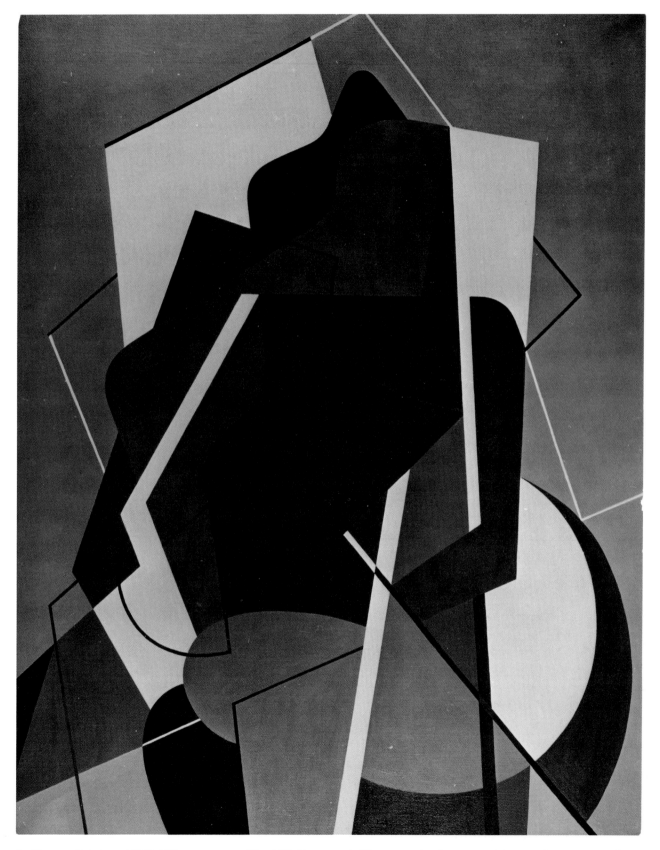

6. *Abstract Painting.* 1937. Oil on canvas, 40 x 32". Destroyed. (Shown at the American Abstract Artists annual exhibition, 1938.)

In 1936, Reinhardt, who during his undergraduate years had been paint-ing in a generally Cubist style influenced by Picasso and Gris[15] and drawing in a highly stylized Synthetic Cubist manner, began to study art history at Colum-bia's graduate school for fine arts. Simultaneously he was studying painting with John Martin at Columbia Teachers College, Karl Anderson at the National Academy of Design, and Francis Criss and Carl Holty at the American Artists School on 14th Street. And at the same time he was working in industrial design with Russell Wright, assisting Crockett Johnson, artist and creator of the comic strip "Barnaby," and taking on a broad range of other commercial work. For instance, he designed books with Robert Josephy for several years; in the late thirties and early forties he did free-lance commercial art for such varied employers as the Brooklyn Dodgers, *Glamour* magazine, the CIO, Macy's, *The New York Times*, the National Council of American-Soviet Friendship, The Book and Magazine Guild, The American Jewish Labor Council, *New Masses*, and the U.S. Treasury (a war-bond poster). He illustrated books and pamphlets (*Birds of North America*, Ruth Krauss's *A Good Man and His Wife*, and Ruth Benedict's *The Races of Mankind*, which was the subject of a classic fig-leaf controversy). He also designed book covers, tie ads and Christmas cards, political cartoons and café murals. In February, 1943, he joined the staff of the newspaper *PM*, for which he worked as a writer and artist, with time out for the Navy, until he was fired in April, 1947.[16]

This hectic schedule enabled Reinhardt to view, with characteristic thor-oughness, the possibilities open to a young artist from one end of New York to the other, quite literally, and quite figuratively. With Anderson he made academic still lifes and drew from life; Criss did neoclassic portraits and later became a precisionist, indicating a certain affinity with Reinhardt's mature style. But Carl Holty was the most sympathetic and respected mentor. He had studied with Hans Hofmann in Munich in 1926 and had recently returned from France, where he and Calder were the only American members of Michel Seuphor's Abstraction-Création, a group oriented to Neo-plasticism in which Mondrian was the central attraction. Holty's work at the time was typical of the late Cubism originating in Léger's machine style; in the late thirties, Jean Hélion was New York's best known proponent of this style and it dominated American nonobjective art at the time. For many, this domination was unfortunate, but for Reinhardt it provided a direct continuation of his own preoccupation with the flat planes and curving shapes of Synthetic Cubism. His work from 1936–38 reflects Picasso's studio interiors of the late twenties, Gris's coolly interlocking still lifes, and Holty's rich pastel palette, often close-valued in a manner that could not have failed to attract the future creator of the black paintings. Holty also served the younger man as an intelligent guide to the abstract art under-ground. Most importantly, he was a charter member and spokesman for the American Abstract Artists, which was founded in 1936 to provide a showcase for the minority committed to nonobjective (or at least abstract) art. Through

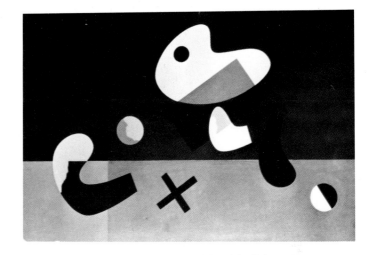

7. Carl Holty. *Abstract Painting*. 1937–38. Oil on masonite, 24 x 36". Present location unknown

Holty, Reinhardt was introduced to the group, and after submitting work to a jury, was elected to membership in 1937. He was twenty-three, and later called this "one of the greatest things that happened to me."[17]

Whatever their accomplishments, the members of the AAA had high standards, and it was no mean feat for an artist so young, who had yet to show a painting publicly, to be elected to the group. It was the ideal milieu for a man of Reinhardt's character, combining as it did an interest in theory, a convincing rejection of Surrealism and Expressionism, and a crusading spirit in support of the underdog abstract art, which was doubly embattled by the powerful forces of regionalism and social realism, and treated with condescension by museum curators as a provincial emulation of worldly French abstraction. The AAA had trouble finding locations for its annual exhibitions. When it *was* successful, journalistic coverage was negligible and patronizing. (For example, in 1938 Jerome Klein wrote: "The young abstractions [*sic*] condemn themselves out of hand by their tameness, want of depth and understanding.... These young artists seem clear only about what they seek to avoid, not what they want."[18]) For this reason, the presence and intermittent but prestigious support of such well-known European exiles as Léger, Mondrian, Moholy-Nagy, Ozenfant, and Albers was crucial.[19]

In addition the AAA, like the WPA, which Reinhardt joined the same year, presented an unparalleled chance to work and discuss one's work with a variety of more experienced American artists. Those who meant most to Reinhardt's development were Stuart Davis, Harry Holtzman, Rollin Crampton, Balcomb Greene, Giorgio Cavallon, George McNeil, and Burgoyne Diller, who sponsored him for the WPA.[20]

The WPA/FAP (Federal Art Project of the Works Progress Administration) was of great pragmatic importance to all American artists at this point. The $87.60 a month Reinhardt received as an "Artist, Class I, Grade 4 in the Easel Division" from 1937 through 1941 was not sufficient to support a family, or even one person in much style, but for the first time American artists were being paid for their labors like any other professional worker. They worked in their own studios and in their own styles, although the non-artist officials were not overly sympathetic to abstract art, nor to innovations within the types of abstraction they expected from individual artists.[21] In 1939 Reinhardt began to evolve a "private" and more experimental style, while continuing to turn out his quota of work for the Project, often ahead of time. He inscribed "New York City Art Project 1940" on a number of 1938–39 canvases, in order to satisfy WPA quotas and restrictions ahead of time; this does not alter one's view of his evolution, since he continued to make both tight, geometric work and looser, more experimental work at the same time, but it does somewhat *uncrowd* the production of 1941–42.

Many of the AAA artists had studios downtown, around Union Square and on 14th Street, west and east. Reinhardt shared one with McNeil and Harry

8. *Abstract Painting*. 1939–40. Oil on board. Dimensions and present location unknown

9. Reinhardt in his studio, 30 Gansevoort Street, New York, c. 1940

Bowden on Seventh Avenue, next door to Stuart Davis. Although fifteen of the twenty-eight original AAA members had been students of Hans Hofmann at one time or another, their devotion to the principles of Cubism, Neo-plasticism, and the Bauhaus eventually opposed them to the directions Hofmann himself took when he began to paint again at the end of the thirties. It was with these artists that Reinhardt was identified at the time, rather than those associated with Hofmann's Eighth Street school, probably because Hofmann did not commit himself to abstraction until the late forties. His importance to New York artists during the late thirties lay in his European contacts and his emphasis on the work of Matisse, Klee, Miró, and Picasso, whereas the AAA was primarily concerned with Picasso, Gris, and Léger. While Reinhardt did hear Hofmann lecture, and recalled "I didn't have any relationship directly, but there was a kind of excitement around that I sensed,"[22] Hofmann's metaphysical approach, his invocations of "soul" and "inspiration" and the loose post-Fauvist style with which he was attempting to "sweat out Cubism" held little appeal for anyone whose sympathies lay so firmly with Cubist abstraction. "I never felt threatened by Cubism," Reinhardt said, "it can be very free, even Impressionist."[23]

The Bauhaus was also influential at the time, through Albers' ideas wafting up from Black Mountain College in North Carolina and through the articulate activity of Werner Drewes, a Bauhaus student who had joined the AAA. Bauhaus internationalism, purism, functionalism, rather Germanic pedagogy, and pragmatic utopianism with an occasional tinge of mysticism were a heady combination of isms for the natives of a country which had never spawned a movement with any solid theoretical foundation. Nevertheless, it was Mondrian who provided the major theoretical impetus both to the AAA and to Reinhardt himself. His work was first available to New York artists at the Museum of Living Art. It was there, and through reproductions in European art magazines, that Holtzman and Diller, the first wholly rectilinear nonobjectivists in America,[24] became aware of Mondrian in the early thirties. His writings had been published only in Dutch and French and were probably available to Reinhardt and other AAA members largely by word of mouth until 1945, when George Wittenborn published six of Mondrian's essays as *Plastic Art and Pure Plastic Art*, with an introduction by Holtzman, who had been instrumental in getting Mondrian to America in 1941 and was, later, his sole heir.

Reinhardt, having come to abstraction not from figuration but from a decorative (as opposed to symbolic) Cubism becoming increasingly nonobjective, was in a position to appreciate the Neo-plastic program of "denaturalization" and annihilation of all "forms." It was later to be a key point in his own mature work. Whether or not someone had translated or repeated for Reinhardt the gist of Mondrian's ideas, it is not too farfetched to attribute agreement on the principles of Neo-plasticism, about which Mondrian wrote in 1926:

10. *Red and Blue Composition*. 1939—41. Oil on celotex, 23½ x 29¼". Estate of Abbott Kimball

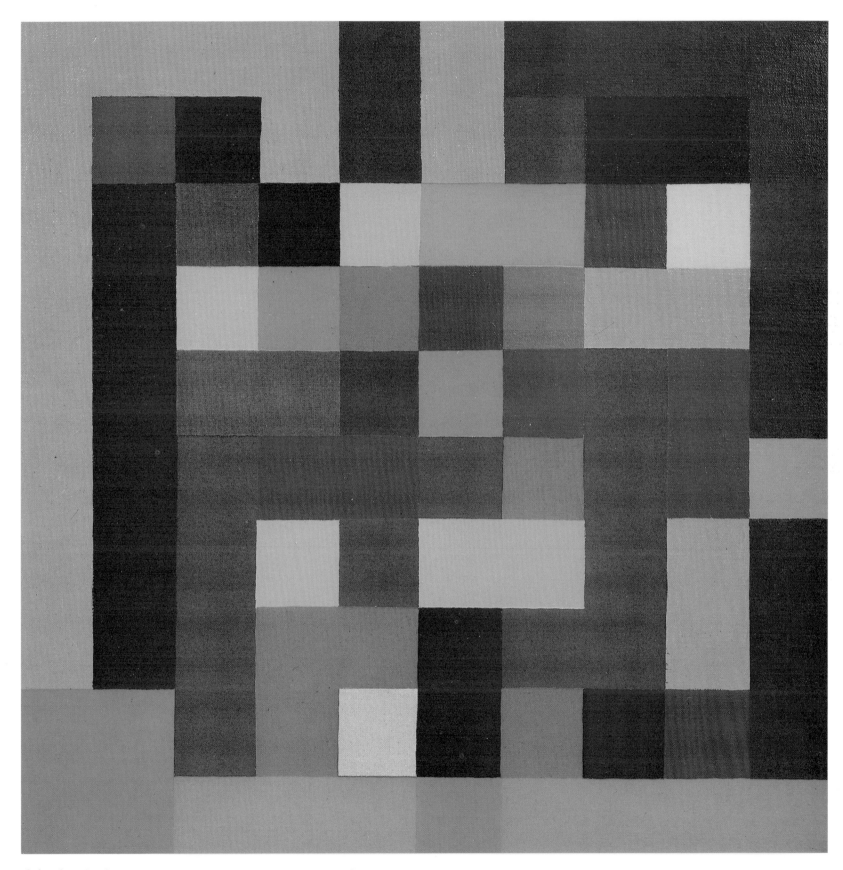

Colorplate 2. *Abstract Painting*. 1940. Oil on canvas, 15 x 15". Pace Gallery, New York

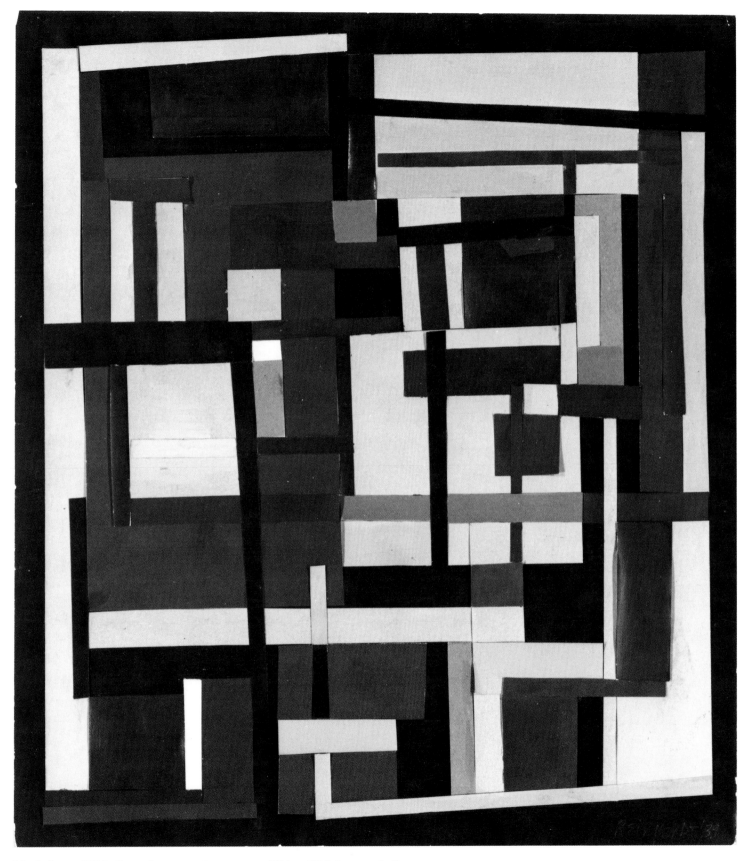

11. *Collage.* 1939. Pasted construction papers, 11¼ x 9⅞". Private Collection

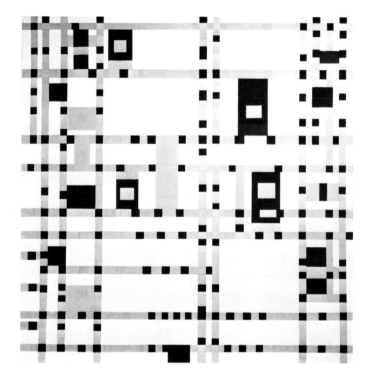

12. Piet Mondrian. *Broadway Boogie-Woogie.* 1942–43. Oil on canvas, 50 x 50". The Museum of Modern Art, New York

Neo-plasticism demonstrates exact order. It stands for equity, because the equivalence of the plastic means in the composition demonstrates that it is possible for each, despite differences, to have the same value as the others.

Equilibrium, through a contrasting and neutralizing opposition, annihilates individuals as particular personalities and thus creates the future society as a real unity.[25]

There is no discernibly direct influence from Mondrian to Reinhardt until around 1940, when the latter made a series of very colorful grid paintings after construction-paper collages (fig.11, pl.2). Formally, these probably owe as much to Diller and Davis as to Mondrian. But there is no question that Mondrian's constant balancing of asymmetrical forms was aimed at a neutrality closely related to that gained by different means in Reinhardt's mature work—the color-brick paintings around 1950, the symmetrical geometric work of the early fifties, and the black paintings—which can be traced back to a homogeneity first seen in his early "Neo-plastic" collages, with their loose grid structures of equalized blocks and stripes in strong, often close-valued color. While Mondrian was opposed to the symmetry to which Reinhardt eventually became totally committed, Reinhardt's exclusion of the image-shape and his concept of synthesis share fundamentals with the work of the man who wrote: "It must be noted that empty space can evoke universal conceptions, create mental and moral activity. But this activity is in the abstract domain and always requires the remembrance of the world of oppositions."[26]

Like Mondrian, though less overtly (for if the black paintings can be called symbolic at all, they depend on a kind of subliminal symbolism that defies both picture-making and phrase-making), Reinhardt was drawn to ritual, to contemplation, to oriental thought, to a pure art as talisman of an ideal society. This last aspect is most clearly felt in Reinhardt's own writings from the thirties and early forties, and relates, in turn, to what Harold Rosenberg (who sees action painting as an unexpected result of the previous decade's desire to *say something*—a way of being inversely political, by getting out of politics) remembers as "endless discussions about how to get a Marxist aesthetic."[27] Marxism was a term used as loosely in the art world then as it is now. Yet Marx's emphasis on the individual's historical role could well have been a factor in the development of an autonomous American art, given the intense search for individual intellectual identity that marked the emergence of the New York School. Someday it will have to be told what Clement Greenberg meant when he wrote: "Someday it will have to be told how 'anti-Stalinism,' which started out more or less as 'Trotskyism,' turned into art for art's sake and thereby cleared the way heroically for what was to come."[28]

Most avant-garde artists in the late thirties were active in the Artists' Union (founded in 1934) and the American Artists' Congress (1936–39). Both organi-

zations temporarily transcended aesthetic rivalry, if not ideological controversy, before the rise of Stalinism and its purge of the intelligentsia led most American artists to feel revulsion for the use of art as a political instrument.[29] Reinhardt had been involved in activist groups at Columbia and it was only natural that he be attracted to them in the art world. Later he recalled that for him "it was a very free situation, very stimulating. There were some terrific debates, primarily aesthetic. From a political point of view, I don't really know what went on, but I'm sure that the political thing wasn't very serious except for some artists who felt they needed it in relation to their art."[30] His own "Marxism" leaned heavily on purely aesthetic utopianism, in which can be heard the voices of Mondrian and perhaps Balcomb Greene and Davis too. Actually, it was primarily the level of naiveté that had changed since he wrote, in a college paper in 1935: "The earth needs an entirely new civilization. The old dwelling must be destroyed so that the hands of men may not be encumbered when they erect the new home."[31] In a talk before an unspecified artists' group around 1941, he asserted:

> A sensitive organization of lines and colors on a canvas must have ultimate social value.... Not until the appearance of abstract painting, at the turn of the century, was direct first-hand experience demanded for its understanding and a direction indicated for the "democratization" of art.... The rhythmic organization of a painting has always been its real value, and, in recent times, certain abstract painters have been able to explore the meanings in line and color relationships by themselves. These relationships remain to be explored and exploited further, in social terms and in relation to people's needs, and this extension from the individual to the social is possible only under democracy and genuine collective activity, probably in the creation of good housing instead of merely good pictures.[32]

In another early talk, Reinhardt himself made the connection between art and politics, noting that "Mondrian, like Marx, saw the disappearance of works of art when the environment itself became an esthetic reality."[33] Later, when his own aesthetic crystallized, Reinhardt saw his work as materialist and historical, and related his interest in the synthesis of opposites to the Marxist concept that contradictions are inherent in every phenomenon. Marxists considered the material primary and the idea of it secondary, or derivative; Reinhardt evolved his paintings-as-paintings with the idea, or anything else, distinctly secondary. Thus his intense and continuing dislike of pictorial art and particularly of Dada and Surrealism, which confused art and life to a degree totally antithetical to his own art-as-art position. "The thing about this great respect for Cubism," he said, "is that you can't have that unless you know all that Surrealism and Dadaism is baloney. The tension between the abstract painters and the Surrealists in the

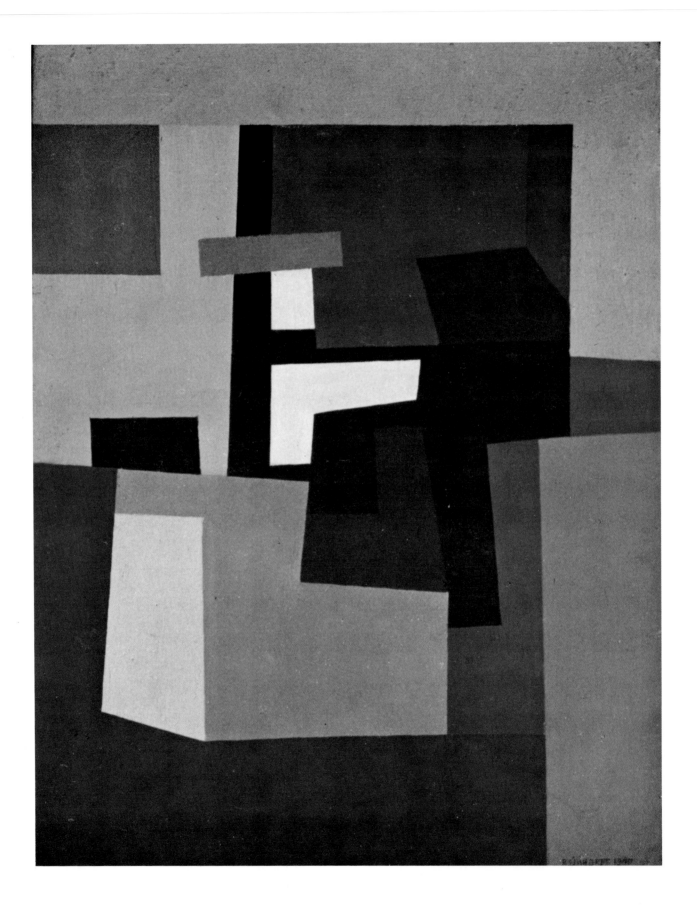

thirties was clear, and you made your choice."[34] Perhaps it was in this regard that he told Irving Sandler, "The Communist issue was very important in the thirties."[35] The fact remains that his own interest in Marxism was intellectual rather than actively political.

In the late forties, when the Abstract Expressionist generation had become entirely apolitical in reaction to the disillusion that ended the thirties, Harold Rosenberg and Robert Motherwell severed art from politics and social responsibility in a joint editorial for *Possibilities*:

> Whoever genuinely believes he knows how to save humanity from catastrophe has a job before him which is certainly not a part-time one. Political commitment in our times means logically—no art, no literature. A great many people, however, find it possible to hang around in the space between art and political action.[36]

Reinhardt, by rigorously separating the two, was one of those people. "Do you think that when a painter expresses an opinion on political beliefs he makes even more of a fool of himself than when a politician expresses an opinion on art?" he asked rhetorically in a *PM* cartoon in 1946, and answered himself with a resounding "NO!"[37] "I believe painting cannot be the only activity of a mature artist.... Esthetic quality is always socially meaningful and the rest is a good gag or a bright idea," he wrote the next year.[38]

In these last two statements, as in many others that succeeded them, Reinhardt harked back to the thirties, and to the writings of Stuart Davis: "The Painting itself is the responsible Social Act of the Artist, and is one of the surest, most direct forms of Communication ever known to Man"[39]; and of Léger, whose writings were published in *Art Front* in the thirties and whose ideas were paralleled by Meyer Schapiro in his essay on Barr's *Cubism and Abstract Art* in *The Marxist Quarterly* in 1937: "A work of art must be significant in its own period, like any other intellectual manifestation whatever. Painting, because it is visual, is necessarily the reflection of outside conditions, and not psychological."[40] The most important and influential writings in Reinhardt's milieu were those by G.L.K. Morris, Jean Hélion, Balcomb Greene, Harry Holtzman, and John Graham. The latter's magnum opus—*System and Dialectics of Art*, published in 1937—seems to have been affected obliquely by Mondrian's essays on art and society, although perhaps they simply share a typically vague Marxism. Graham, who made a strong personal and ideological impact on the loose network of café and studio dialogues which was then the avant-garde's only channel of communication, in turn anticipated Clement Greenberg, and Reinhardt as well. For instance, Graham wrote that "the aim of painting, as of any pure art, is to exploit its legitimate assets which are limitless without encroaching upon the domain of other arts." Citing "the reducing of painting to the minimum ingredients for the sake of discovering the ultimate, logical

13. *Abstract Painting*. 1940. Oil on canvas, 13 x 10". Private Collection

14,15. *Untitled.* 1939.
Two gouaches, 9 x 11½".
Private Collection

destination of painting in the process of abstracting," he continued: "Painting starts with a virgin, uniform canvas and if one works ad infinitum it reverts again to a plain uniform surface (dark in color) but enriched by process and experiences lived through."[41]

Thus it could have been Mondrian, Graham, or any of a number of other contemporary non-art sources who triggered Reinhardt's search for an ultimate resolution of the Cubist principle and, given his view of Cubism as the plastic absolute in itself, the ultimate resolution of painting altogether. It is likely, however, that this search was equally the result of his primary involvement with both separation and synthesis and it is unlikely that Reinhardt had conceived of so specific a goal so early. The black paintings themselves led him to his theoretical demands for the end of painting, which first appeared in the late fifties. In the late thirties, it might have seemed to Reinhardt, as it had to El Lissitsky, that "Mondrian's solution is the last accomplishment in the development of Western painting."[42]

The Easel is a cool spot at an arena of hot events. —Stuart Davis[43]

Modern Art differs from art of the past not in its abstractness, but in its new and contemporary concept of color-space, or form. —Stuart Davis[44]

By 1939, Reinhardt had arrived, perhaps via Holty, at a relatively free, but "colonial" Cubism influenced primarily by Stuart Davis, whose studio was next door and whom, through the kind of social/working proximity that has profoundly affected New York art since its beginnings, Reinhardt would meet at

neighborhood bars, cafés, restaurants, and other studios. It is not difficult to understand why Reinhardt was particularly attracted to Davis's art and ideas. The older man was sharp, tough, unpretentious, iconoclastic, and knowledgeable about art and art history. At that time he was the best known "abstract" painter in America and the only established artist who participated in the avant-garde socially, aesthetically, *and* politically. Active in the Artists' Union, editor of its organ—*Art Front*—a friend of Gorky and Graham, he provided a link between the European and American traditions by virtue of his sophistication on the one hand, and his determined Americanism on the other. Though he did not belong to the AAA and never espoused the cause of a pure abstract art, Davis's sensibility often paralleled that of its members. "The act of painting is not a duplicate of experience," he wrote, "but the extension of experience on the plane of formal invention."[45]

The major contributions made by Davis's art to that of Reinhardt and other younger artists in the late thirties were his mature understanding (and regionalization) of Picasso and Miró, and the freshness, brashness, and unexpected oppositions of his saturated color. In his autobiographical chronology, Reinhardt listed under 1938: "listens to neighbor Stuart Davis' loud ragtime jazz records, looks at his loud colored shirts on clothes-line.... Begins series of bright colored paintings."[46] The paintings were not only brilliantly colored but were constructed in the overlapping and transparent planes, and accented by the dark lines, asymmetrical X shapes leading back into shallow spaces, isolated disks, and stripes that were typically Davis devices. On the other hand, Reinhardt probably felt then the same mixture of admiration and reservation, centering on the vestigial representation in his former mentor's painting, that he later expressed in a review of Davis's Museum of Modern Art retrospective in 1945:

> His work is not "naturalistic," though, and his paintings are not "pictures" nor "window frames," but rather organizations of lines, colors, spaces (American organizations, if you want). I'm sorry that it seemed necessary for him to bring in the lamp-post, radio-tube and light-bulb business in his later and more abstract paintings, as if to give them "extra" meaning and "ease" their communication.[47]

A similar ambivalence toward subject matter was reflected in a nearly identical pair of Reinhardt's gouaches from around 1939–40 (figs. 14, 15). In one, the flat planes are left untouched; in the other, an angular graphic network was superimposed to transform the shapes into an abstract "picture" of an industrial landscape. At the same time, Reinhardt executed several oils that could almost have been painted by Davis himself; these seem to have been made in the nature of an homage, perhaps in the same spirit that led Gorky to "copy" the styles of Picasso and Miró.

Colorplate 3. *Collage*. 1939. Pasted papers, 7 x 9¼". Private Collection

16. Stuart Davis. *Swing Landscape*. 1938. Oil on canvas, 84 x 196". Indiana University, Bloomington, Ind.

Miró, in the late thirties, was an obvious influence in the work of several members of the AAA. His flat biomorphic forms were seen by some as curvilinear Cubism, as a way to paint Cubist pictures without Mondrian's rectangles. He also seemed to point the way "out of the Cubist box," to use Carl Holty's phrase.[48] Miró showed at Pierre Matisse's gallery in 1935, 1936, 1938, 1939, and in 1940 when he also had a retrospective at the Museum of Modern Art. His influence appears in an atypical Reinhardt like the impastoed 1939 canvas dated "40 N.Y.C.A.P."[49] (fig. 8), and in Arshile Gorky's more evolved *Painting*, 1936–37, *Xhorkom*, 1936, and *Garden in Sochi*, 1940. Around 1940, Davis's patterned color planes grew into individual shapes — small, similar, each having several functions in the painting. More than anyone else in New York at that time he seems to have recognized the possibilities of Miró's flowing, overall forms. Certain works imply a transition between Miró as the Cubist he was in the thirties and Miró the modernist, the formally oriented automatist of the forties.

Davis's earlier predilection for a central, vignetted form that wraps line, shape, and color into a single element clearly separate from the ground and canvas edges, and for the use of an interior or subordinated pattern, can be traced back to Picasso's still lifes around 1916. The surface, however, was becoming increasingly homogeneous in paintings such as *Swing Landscape*, 1938 (fig. 16), and culminating in *Ultramarine*, 1943. The great variety of small forms move from edge to edge in a turbulent, if hard-edged, prediction of Pollock, trampling the geometric framework and usually overwhelming the fragments of figuration. In these paintings, the surface is more uniform in emphasis and all-over in movement than in any previous American painting, though the shallow space is still intentionally limited and defined in the Cubist manner. These effects, and the ribbony lettering and line, represent a personal adaptation of Miróesque biomorphism, while the rapid jazz tempo within an

17. *Collage.* 1939.
Pasted papers, 8½ x 10½".
Private Collection

essentially ordered framework less directly anticipates Mondrian's last works. Something similar was happening in Reinhardt's work at the same time, not necessarily in the wake of Davis's development, for Reinhardt too was simultaneously attracted to Miró's freedom and Mondrian's clarity. He was making curving, unfolding, still vaguely figurative works as well as rectilinear abstractions. Autonomous forms had begun to disappear, a process accelerated by his increased use of collage.

18. *Collage.* 1940.
Pasted newsprint, 9 x 11".
Private Collection

"The collage, with its spontaneous and accidental aspects, along with the perfectly controlled, is an important medium for me,"[50] Reinhardt wrote in 1947. He had started around 1938 by making brightly colored construction-paper studies for the Neo-plastic paintings, but by 1939, taking Davis's cue to further fragmentation, he was moving toward a new, all-over surface. The magazine reproduction collages, in halftone or pale colors (figs. 17, 18, 22, pl. 3), replaced what he called his "Late-classical-mannerist-post-cubist geometric

19. *Drawing* ("after" *Collage*, 1940, fig. 18). 1938. Pen and ink on paper, 20 x 26". Private Collection

20. *Abstract Painting.* 1940. Oil on canvas, 40 x 32". Private Collection

21. *Collage.* c.1941. Pasted papers (engravings), 4¾ x 4".
Private Collection

abstraction," which had been anchored to one edge or vignetted in the center of the canvas within a very shallow, overlapping "playing card space" (G.L.K. Morris's term). The collages were studies, and decidedly small-scale, but their transcendence of both Cubist and Surrealist uses of the medium was unique at the time and the collage process was ideally suited to Reinhardt's developing aesthetic.[51] Its flexibility aided compositional discipline in the Neo-plastic studies; it also allowed a greater degree of objectivity, bypassing the personalized brushstroke. It provoked a non-geometric but still mechanical surface and provided an ideal transition between the hard edges of the thirties and the soft edges of the forties.

At the same time, expanded use of the collage medium brought Reinhardt dangerously close to fusing two aspects of art which he considered permanently opposed—the pictorial, or picturesque, and the abstract; or, life and art. He was convinced that the advent of abstraction had freed picture-making, or impure painting, "applied art, and illustration, from traditional *fine art* elaborations and enabled them to fulfill their functions more clearly and honestly.... At the same time, abstract art relieved painting from its picture purpose and permitted a freer and more complete individual expression and a more direct and positive thinking in form and color."[52] Yet Reinhardt was an obsessive clipper of reproductions, art and otherwise, from magazines, books, and newspapers, a collector of the most picturesque of the picturesque—humorous, evocative, grotesque images for which he later found an outlet in the *PM* cartoons and, still later, in his teaching methods. One of the major challenges of the abstract collages, therefore, lay in the rearrangement of highly charged representational images in order to divest them of just those effects for which they might have been chosen. His intense distaste for Surrealism, which at that time had a monopoly on the collage aesthetic and on "found" materials, led him to lean over backward to avoid any evocative effect.[53]

Image juxtaposition was a taboo; Cubist superimposition replaced it. Then, as the planes and forms in the collages broke up, the stability of the central form and of the space also dissolved. Some of Reinhardt's 1939–41 collages show vestiges of rectilinear structures, Hélion-Légeresque machine shapes, or discernible disks, lines, or arabesques; others are entirely homogeneous. While the patient viewer may be able to pick out images and fragments of people, objects, or landscapes from the kaleidoscopic surface, this does not detract from the high degree of abstraction. On the other hand, the unconnected "modeling" of the cut-up photographic images did effect an escape from the absolutely flat plane of Neo-plasticism. In plate 3, large shapes are still forms; the way they bulge from a flat ground evokes Hélion's, or more generally, Gris's and Léger's combination of depicted volume and flatness around 1915. In figure 22, what shapes can be discerned are only parts of a patterned whole. The pasted papers had to be small in order to be cleansed of associative imagery; this gave them an anonymity rare in geometric art at the time, and the disintegration of both form and image paved the way for the black paintings.

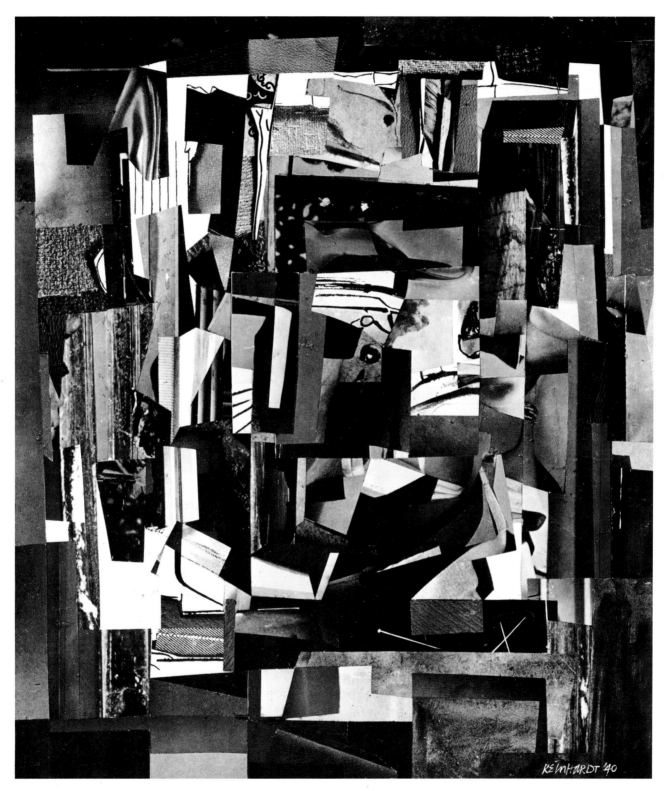

22. *Collage.* 1940. Pasted papers, 15¼ x 13″. Private Collection

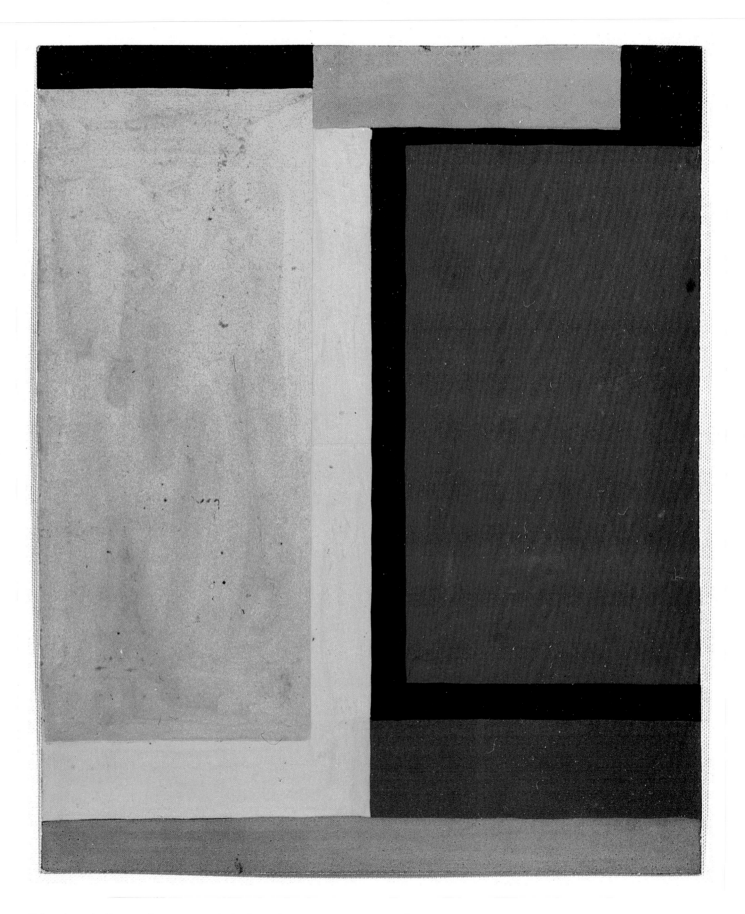

Colorplate 4. *Abstract Painting.* c. 1940. Gouache on paper, 5½ x 4¼″. Private Collection

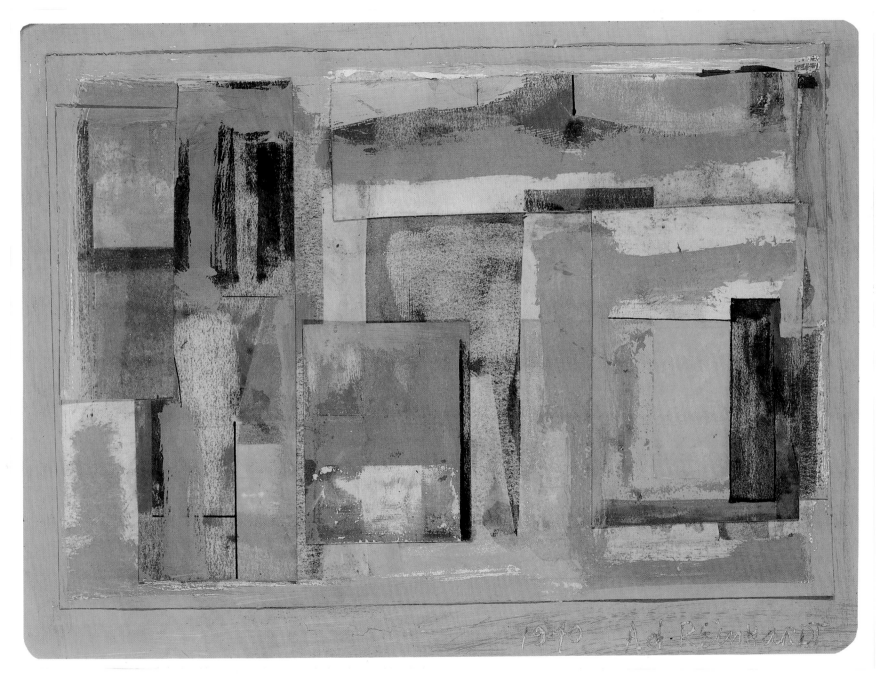

Colorplate 5. *Abstract Collage.* 1940. Gouache and pasted papers, 5¾ x 7¾". Private Collection

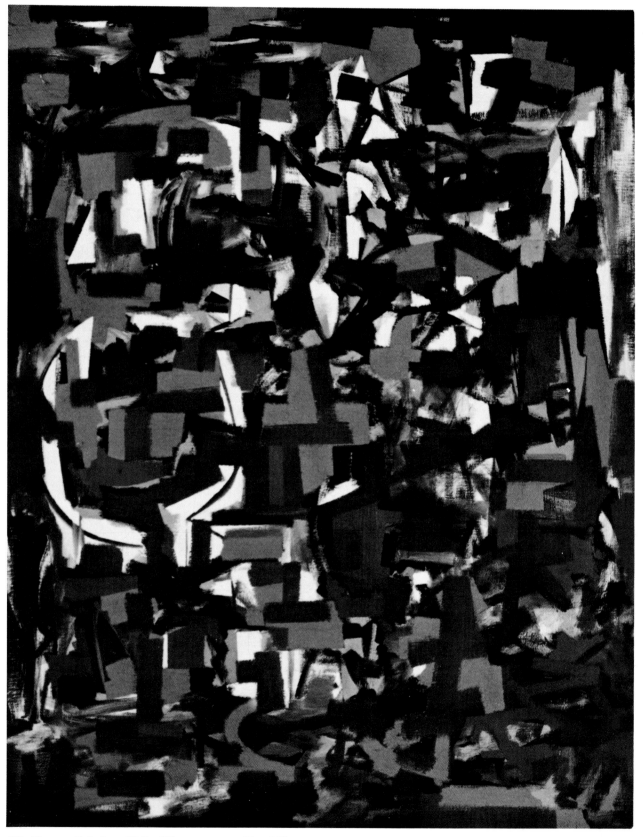

23. *Abstract Painting.* 1941. Oil on canvas, 40 x 32". Private Collection

The paintings in my show are not pictures.... The intellectual and emotional content are in what the lines, colors, and spaces do. —Ad Reinhardt, 1944[54]

The chronology of Reinhardt's work from 1940 to 1946 is unclear and not likely ever to be fully clarified. In 1941, he left the WPA and began at least five years of varied experimentation. In December, 1943, he had a small show at the Teachers College Gallery at Columbia University, and as a result was given his first real New York one-man show at Frederika Beers' Artists Gallery in February, 1944.[55] These shows seem to have included old and new, geometric and painterly work. The latter was unquestionably the most important development of this period. Between 1941 and 1943, Reinhardt began to alter the hard edges and compositional clarity of the paintings as well as the collages. He did so in two ways: first, by a hard, chopped stroke or calligraphy still within the central focus and still more or less influenced by Davis; second, by blurring all the edges, by painting over the rectilinear design until it became very brushy and curvilinear.

In 1940, for instance, Reinhardt made a tiny (5½ by 4¼ inch) vertical gouache (pl. 4) with two strikingly simple panels of open, clear color bounded by bands of other colors, which might have been made by an "advanced" young artist in the sixties or by Reinhardt himself twelve years later. However, he did not pursue this direction at the time, and instead confronted the difficult task of developing a new, very painterly technique which would parallel the looseness and dispersion achieved in the collages. A surviving transitional work (pl. 5) is a small, delicately colored painting in which the underlying collage (painted paper) elements are veiled by an overlay of gouache. There are oils from this time showing how the brush served the same function the scissors did in the collages, even to the point of simulating the angular sickle or blade shapes of a cut edge (fig. 23). The broad ribbony strokes can be seen as vestiges of Davis's influence, but they also anticipate by several years a similar use of flat calligraphy by Adolph Gottlieb and Bradley Walker Tomlin.[56] There are also watercolors (fig. 24) with more rounded and irregular elements that relate distantly to De Kooning's contemporary abstractions (the group from the late thirties in Edwin Denby's collection,[57] or *The Wave*, c. 1942). In a 1946 cartoon, Reinhardt explained a De Kooning canvas in the following terms, also applicable to his own work at the time:

> Like in much modern painting, we see in the work of de Kooning and [Harry] Bowden what may seem to be a "sketchiness" and un-finishedness which only shows the actual process of creation but asks the onlooker to "complete" and "finish" the painting in the looking-act. These are not (bad) neat, finished buck-eye pictures to "appreciate" passively (and exhaust and dismiss with one glance), or

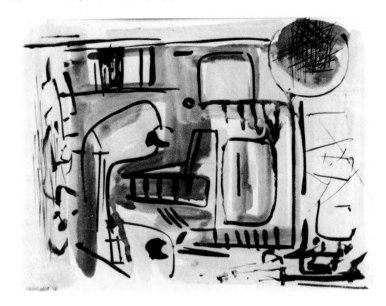

24. *Abstract Painting.* 1941. Watercolor on paper, 16 x 20". Present location unknown

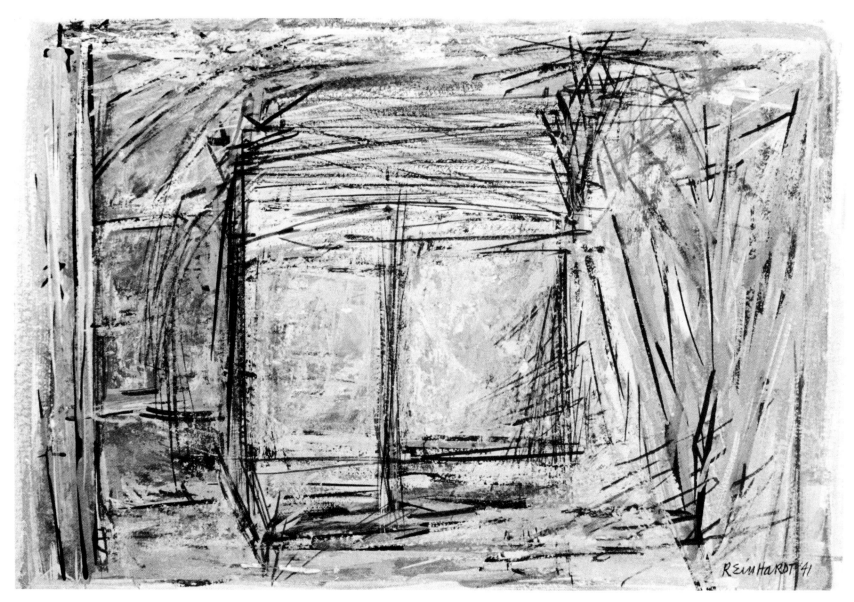

25. *Abstract Painting*. 1941. Gouache on paper.
Dimensions and present location unknown

picture-puzzles to ''figure-out'' (in two glances) but (good) paintings—experiences which can stand a lot of looking.[58]

The classic prototypes for a shattered monochromatic surface veiling an angular structure are of course Picasso's and Braque's Analytical Cubist oils from 1912–13; the impetus toward a formally looser (rather than simply more brushy) construction was characteristic of the forties in New York. As in Analytical Cubism again, the color in Reinhardt's early all-over work was for the most

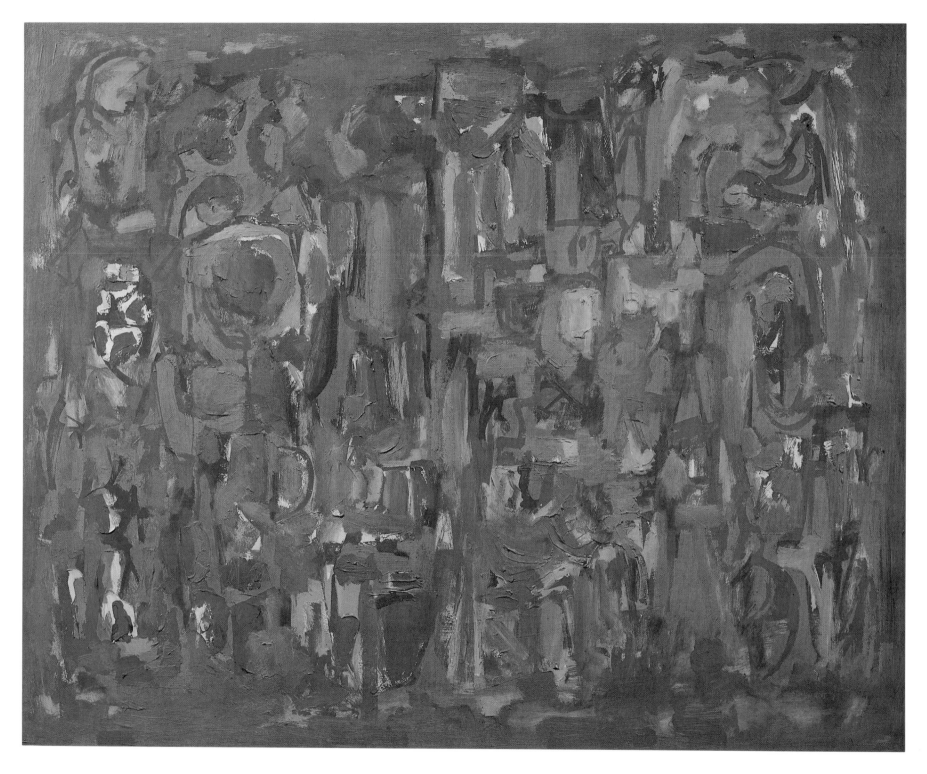

Colorplate 6. *Abstract Painting*. 1943. Oil on canvas, 32 x 40". Private Collection

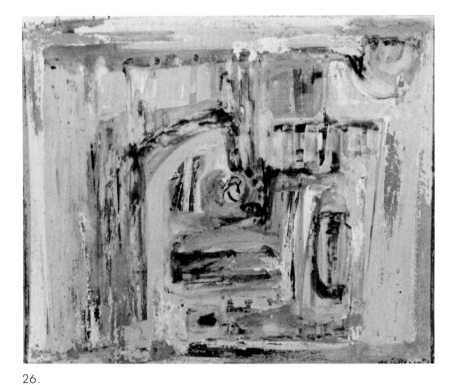

26.

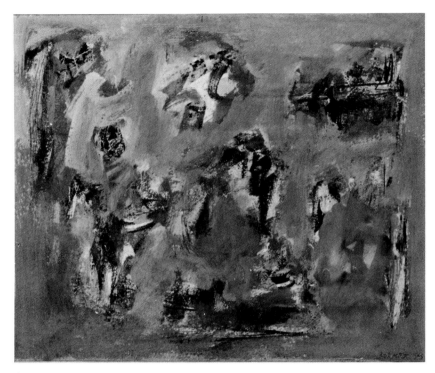

27.

part subdued. The best collages are black and white, or pale and near grisaille (as were many of the postwar paintings from what the artist actually called his "Analytical Cubist" period). Throughout all his developing years, Reinhardt moved between such pale or shimmering colors and the hardest, flattest, most brilliant hues, represented in the early forties by the Neo-plastic paintings (pl. 2). Close values later presented a solution by which these apparently conflicting interests could be fused. The blue and red monochromes from the early fifties, with their rigorous structures and warm glows, and the black paintings, with their gray, shape-effacing light, represent the resolution of conflicts initiated around 1940.

In April, 1944, Reinhardt went into the Navy, and for over a year his production was limited to watercolors, drawings, and gouaches. He first attended photography school in Pensacola, Florida, then went to Anacostia, D.C., in January, 1945, and was finally, briefly, photographer's mate on the S.S. *Salerno*; he was discharged from San Diego after a brief stay in the army hospital there as an "anxiety case." (In the hospital he painted quite a bit and was "lionized," as he put it, to the extent of being asked to lecture on art to the other patients.) In photography school he specialized in motion picture photography, sent occasional cartoons back to the newspaper *PM*, and read a great

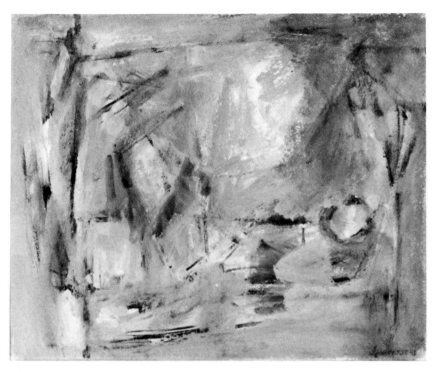

28.

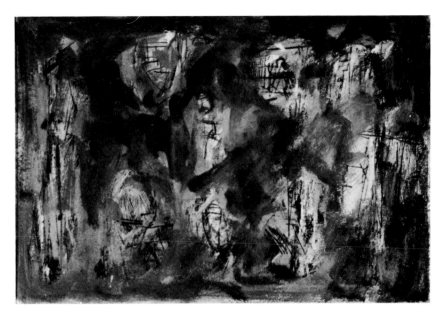

26 to 29. Four gouaches. 1942-43. 26: 9 x 11"; 27: 9½ x 12"; 28: 8 x 10"; 29: 7⅜ x 11". Private Collection

deal. He had hoped to learn and to be able to apply his inventiveness to a new technique, but was soon disillusioned, becoming a regular contributor to the school "gripe sheets":

> I feel there should have been at least one lecture or one instance where photography could have been treated more seriously, intellectually, emotionally, culturally, conceptually or what—some indication of what makes great photographers, what makes great photographs, what makes great movies. I think it was quite curious to have studied and talked movies for a month and not have mentioned, even once, for example, Griffith.[59]

For the most part he was bored and enervated in a military situation where his considerable talents and commercial experience could have been useful but were left untapped.

Most of the work done during the war departed from the tentatively all-over direction in a rather unsatisfying manner. The brushwork was loose and color minimized, anticipating the "all-over-baroque-geometric-expressionist patterns" of the postwar period, but the paintings lacked control

and assurance. This was the only time Reinhardt used white extensively, though it was used to paint *out* the forms beneath it, leaving a grayish, linear palimpsest or a near relief (fig. 30). Once he was isolated from New York, Reinhardt's evolution anticipated more closely that of a postwar European moving toward *tachisme*. Perhaps this was because his Cubist orientation brought him closer to the international point of view than were, say, Rothko, Pollock, or Gottlieb, all of whose figure paintings from the thirties had verged on an introverted regionalism.[60] In any case, this was a bad time to interrupt a rapidly maturing oeuvre and to be away from New York.

For an advanced American artist the advantages of being in New York in the mid–1940s were, admittedly, intangible. The broad sense of community engendered by the politically motivated artists' groups had broken up with those groups. The café-studio dialogues were continued by individuals who shared not only aesthetic goals but a kind of general angst reflecting total public indifference and shared financial crises. In 1948 Clement Greenberg wrote, "Isolation is, so to speak, the natural condition of high art in America," and described New York Bohemia (west of Seventh Avenue and below 34th Street, at the time) as "the shabby studio on the fifth floor of a cold-water walk-up tenement on Hudson Street; the frantic scrabbling for money; the two or three fellow-painters who admire your work; the neurosis of alienation that makes you such a difficult person to get along with."[61]

On the other hand, with isolation from Europe during the war arose the feeling that America was on her own, and that this was the moment to make a strong aesthetic bid for world attention. Not, of course, that such a bid was preconceived, but events contributed to bolster New York's growing confidence and activate its reservoir of talent. When the Surrealist exiles arrived, around 1940, there were already members of the struggling avant-garde who wanted nothing to do with them, on the grounds that "we'll work things out for ourselves." Eventually such an attitude would spawn the jubilant chauvinism that marked Abstract Expressionism's triumph in the mid-to-late fifties. At the time, however, it was fortunate for the Americans that their move for autonomy came when Paris's leadership was destroyed by the war and New York had attracted so many of its leading artists and intellectuals. Even indirect and infrequent contact (occasionally familiarity and friendship) with such heroes as Léger, Mondrian, Ernst, Breton, Hélion, Masson, Lipchitz, and the younger but vital Matta reduced the awesome aura that surrounded the School of Paris and made its art, if not the artists themselves, easier to deal with. In addition, again according to Clement Greenberg:

New York artists were able to assimilate and digest Klee, Miró and the earlier Kandinsky to an extent unmatched elsewhere either then or previously (we know that none of these three masters became a serious influence in Paris until after the war). At the same time

30. *Abstract Painting*. 1945. Oil on canvas, 60 x 40". Private Collection

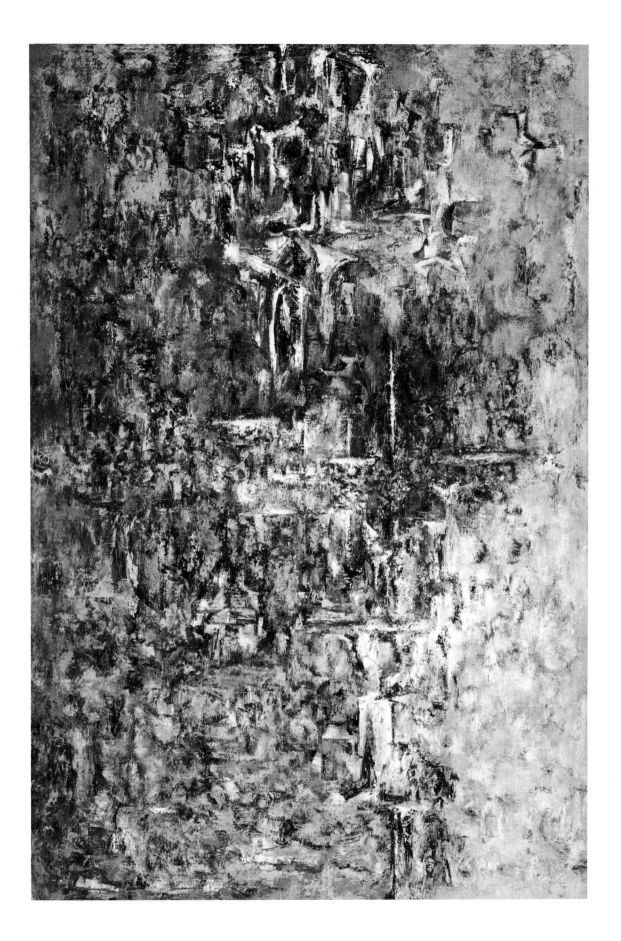

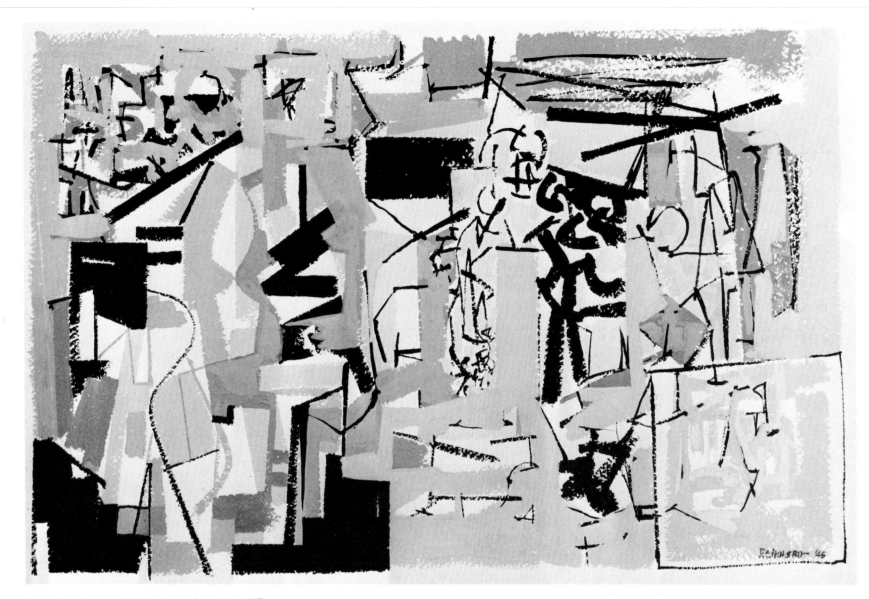

31. *Yellow Square*. 1945. Gouache, 14 x 20".
Formerly the Dickey Collection, San Diego, Calif.

Matisse's influence and example were kept alive by Hans Hofmann and Milton Avery in a period when young painters elsewhere were discounting him. In those same years Picasso, Mondrian and even Léger were very much in the foreground in New York—Picasso to such an extent as to threaten to block the way and even the view. Of the utmost importance to those who were to overcome Picasso after learning from him was the accessibility of a larger number of early Kandinskys in what is now the Solomon Guggenheim Museum. All in all, this marked the first time that a generation of American artists could start out fully abreast—and perhaps even a little bit ahead—of their contemporaries elsewhere.[62]

Through the forties, when some of the great ideas of recent painting were being nurtured, the new art was underground to an extent difficult to comprehend in this day of rapid maturation, success, and instant art history. The magazines gave it no more attention than infrequent mentions of group shows.[63] Aside from Peggy Guggenheim's Art of This Century, which closed in 1947, there were only three New York galleries committed to the avant-garde (Betty Parsons, Charles Egan, Sam Kootz), and virtually no interested collectors. Certain ideas were simply not yet possible. "It was not a theological world then; it was a real one. The thinking was not about the art world; it was personal. One of the real dilemmas was scale," Tony Smith has recalled.[64] Mark Tobey, and for that matter, Paul Klee, had made all-over paintings which, like Reinhardt's in the forties, bore references to Eastern and Near Eastern calligraphies, but the graphic quality remained predominant; only when it was opened up and liberated into a painterly context did the scale of such work expand beyond the miniature. Theodoros Stamos, working from the authority of Arthur Dove's abstraction with the advantages of a sophisticated, analytical mind, was one of the first painters to sense the possibilities of graphicism beyond Surrealism; Richard Pousette-Dart was another. Adolph Gottlieb's "pictographs," begun in 1942, invested the calligraphic symbol with the robust quality of a gesture.[65] Still and Pollock were already abstractionists in a harsh and wholly un-European manner in the early forties, and Motherwell, Rothko, and Newman developed their mature styles and consequent scale a little later. However, just after the war the only consistently mural-scale paintings to be seen in New York were by Picasso, Wifredo Lam, and the Mexicans.[66]

I don't understand, in a painting, the love of anything except the love of painting itself. If there is agony, other than the agony of painting, I don't know exactly what kind of agony that would be. I am sure external agony does not enter very importantly into the agony of our painting.
—Ad Reinhardt, 1950[67]

Klee and Miró were fairly acceptable, they could be looked at as abstract artists. I guess Max Ernst would ultimately be the best Surrealist for me because he's the one that has explored the most and had the widest kind of work. —Ad Reinhardt, 1966[68]

Preoccupation with the human content of the work is in principle incompatible with aesthetic enjoyment proper. . . . Even though pure art may be impossible, there doubtless can prevail a tendency toward a purification of art. Such a tendency would effect a progressive elimination of the human, all too human elements predominant in romantic and naturalistic production. . . . The new art is an artistic art. —José Ortega y Gasset[69]

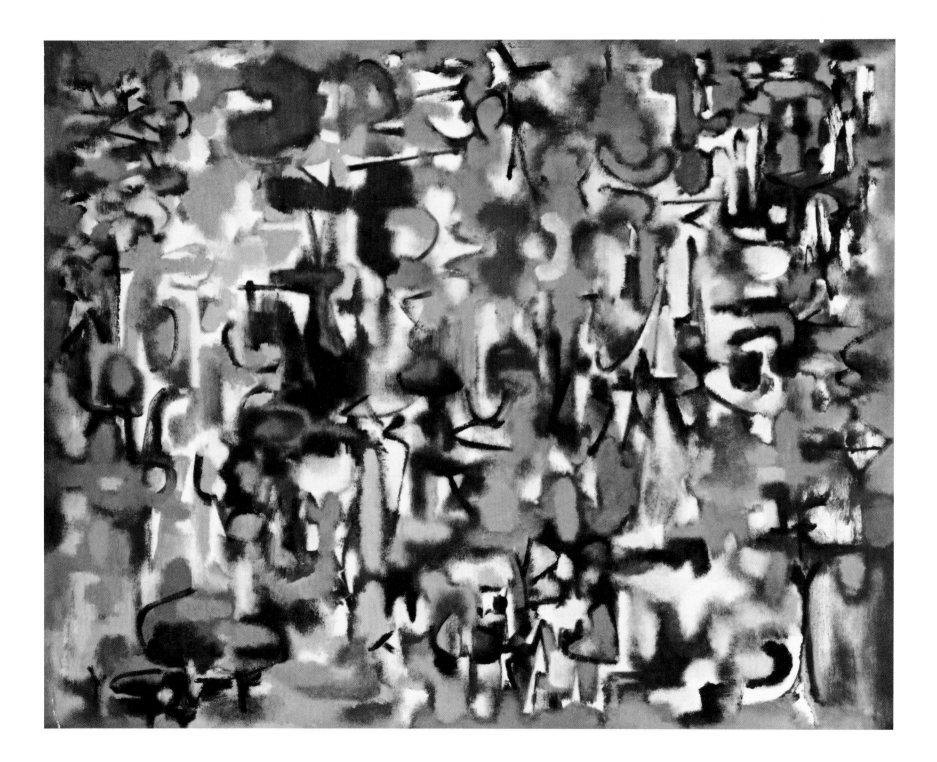

But only God can make a tree. —Joyce Kilmer[70]

At this point, it becomes necessary to interrupt the account of Reinhardt's stylistic development in order to discuss the effect of Surrealism on his work. Despite his distaste for the idea of an art for life's sake and his deep commitment to rectilinear forms, the time came, in the early forties, when he realized that an escape from geometric art, even geometric art as postulated by Mondrian, was necessary for his own individual development and for American painting's more general advance. He had made several false starts, some of which predicted later mainstream tendencies. Having accepted the pseudo-modeled effects of photographic materials in his collages, while still manipulating them in a relatively shallow and at times flat space, he had opened up his work to an ambiguity denied by geometric abstraction. He could no longer ignore the formal possibilities offered by the best of Surrealism.

The degree to which the arrival in New York of several major Surrealist exiles (especially Matta, less known, but younger and more abstract than his colleagues) affected the history of Abstract Expressionism and its offshoots continues to be disputed. Robert Motherwell has advised historians not to "underestimate the influence of the Surrealist state of mind on the young American painters in those days, or that, through them, we had a first-hand contact with the School of Paris, and especially its preoccupation with poetry, and its understanding of 'automatism' as a technique; though none of us were much affected by its painting."[71] "Poetry," for Reinhardt, had nothing to do with art. The concept of automatism, in which lack of control was implicit, did not appeal to him for the same reason. Nevertheless, automatism was crucial to the general development of painterly abstraction, and, at least for intellectual reasons, Reinhardt was interested in the possibilities offered by such an alternative. In 1945 he did some very spontaneous brush drawings in a meandering line that appeared in a more disciplined and calligraphic form in later all-over oils. The blurred and luminous shapes, often jewel-like colors and "underwater" effect of those oils had something in common with Matta's work, as well as with Gorky's, Rothko's, and Baziotes'. Even the columnar configuration underlying most of the canvases of the forties is the nonobjective counterpart of the totemic verticals of then surrealizing artists such as Pousette-Dart, David Smith, and Wifredo Lam, as are the abstract biomorphic *personnages* found in Rothko's and Still's work around 1943[72] (see figs. 32, 37). Above all, Surrealism offered the edge-to-edge patterns of Miró, whose fantastic but precise and quite homogeneous imagery had a broad appeal transcending stylistic boundaries, an appeal prematurely recognized by Reinhardt, via Davis, around 1941. For instance, in 1945 that arch-classicist Josef Albers said approvingly of Miró's paintings: "They scan like mine."[73]

However, the "Surrealist state of mind" was reflected primarily in the work and the writings of those artists who adopted the Jungian return to myth as a

32. *Abstract Painting.* 1949.
Oil on canvas, dimensions unknown.
Formerly Collection Alex Turney

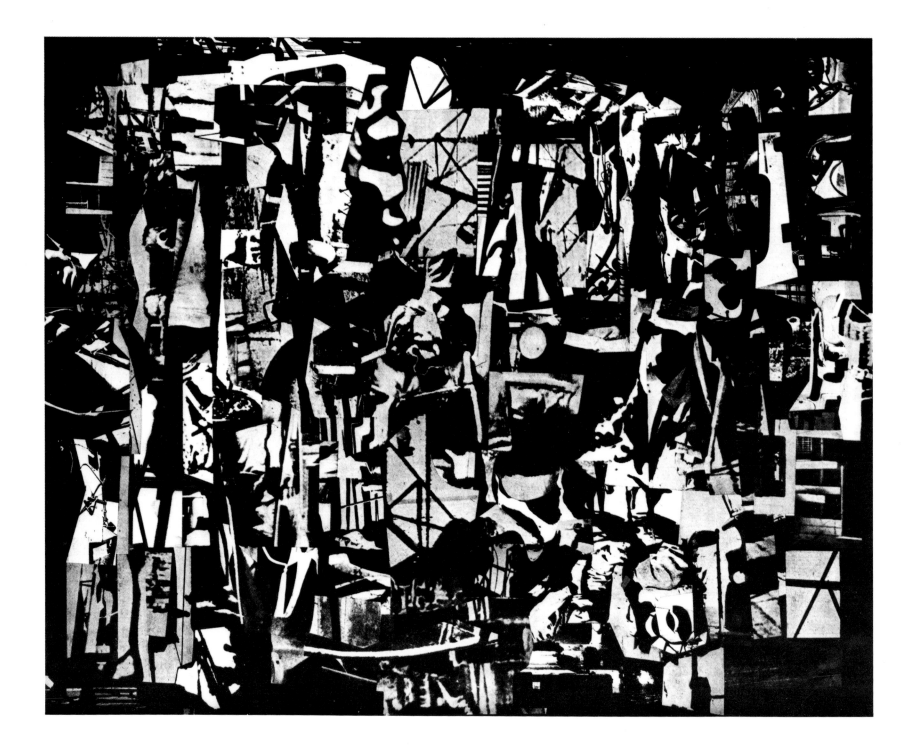

way out of Picassoid abstraction, and whose stronghold from 1942 to 1947 was Peggy Guggenheim's gallery, Art of This Century.[74] Their literary bastion from 1947 to 1949 was Ruth and John Stephan's little magazine, *Tiger's Eye*, in which inquiries were held on such subjects as "What is Sublime in Art?" and reproductions of the Parsons Gallery group's work often appeared.[75] By then the orientation toward content was long-standing. On June 13, 1943, *The New York Times* published a letter from Newman, Rothko, and Gottlieb (signed only by the last two) replying to critic Edward Alden Jewell's "befuddlement" about their work, which read in part:

> To us art is an unknown world which can be explored only by those willing to take risks.... There is no such thing as good painting about nothing. We assert that subject is crucial and only that subject matter is valid which is tragic and timeless.[76]

Reinhardt, on the other hand, made clear his opposition to *any* subject matter. His position was that there is no such thing as good painting about something. The satirical titles of his paintings shown at Betty Parsons in 1947–48 were aimed at the suggestive titular excesses of other artists, especially those linked with Surrealism, and they constituted a list of contemporary conceits, all of which he rejected: "Sign paintings," "industrial design," "painting for a modern cave," "fancy figures," "rough characters," "space markings," "bits of information," "pure myth," "color scheme for a social painting," "object lesson," "Rock that Expressionist Dreamboat," "dialectical spectacle," "transcendental tangent," and "Esthetic Device 33."[77]

While Reinhardt was willing to benefit from the fringe effects of Surrealist automatism in hopes of resolving his own conflicts between a temperamental inclination to geometry and order and an equally strong desire to go beyond the rigid structures of the thirties into a new art, the prospect of "voyaging into the night, one knows not where, on an unknown vessel..."[78] filled him with righteous disgust:

> It is not right for an artist to make believe that he doesn't know what he's doing, when everyone else knows what he's doing.... Artists who leave decisions of what is not right to someone else, especially to those who don't know, should be put to the rack and given the brush.... It is not right for artists to mix their art up with other arts, with the idea that the arts augment each other.... It is not right for an artist to make his bag of tricks a matter of life and death.... It is not right for artists to encourage critics to think that sloppy impasto is Dionysian and that neat scumbling is Apollonian. Artists who peddle wiggly lines and colors as representing emotion should be run off the streets.[79]

33. *Collage*. 1946. Pasted papers, 16 x 20". Private Collection

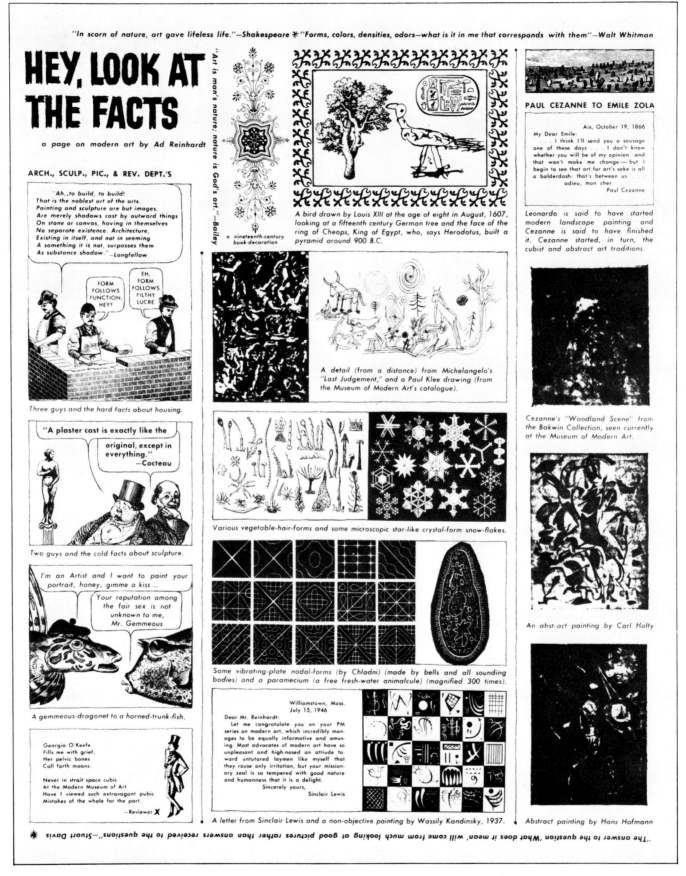

"In scorn of nature, art gave lifeless life."—Shakespeare ✳ "Forms, colors, densities, odors—what is it in me that corresponds with them"—Walt Whitman

HEY, LOOK AT THE FACTS

a page on modern art by Ad Reinhardt

"Art is man's nature; nature is God's art."—Bailey

ARCH., SCULP., PIC., & REV. DEPT.'S

"Ah.,to build, to build!
That is the noblest art of the arts.
Painting and sculpture are but images,
Are merely shadows cast by outward things
On stone or canvas, having in themselves
No separate existence. Architecture,
Existing in itself, and not in seeming
A something it is not, surpasses them
As substance shadow."—Longfellow

FORM FOLLOWS FUNCTION, HEY?

EH, FORM FOLLOWS FILTHY LUCRE

Three guys and the hard facts about housing.

"A plaster cast is exactly like the original, except in everything."
—Cocteau

Two guys and the cold facts about sculpture.

I'm an Artist and I want to paint your portrait, honey, gimme a kiss...

Your reputation among the fair sex is not unknown to me, Mr. Gemmeous

A gemmeous-dragonet to a horned-trunk-fish.

Georgia O'Keefe
Fills me with grief,
Her pelvic bones
Call forth moans.

Never in strait space cubic
At the Modern Museum of Art
Have I viewed such extravagant pubic
Mistakes of the whole for the part.
—Reviewer X

a nineteenth-century book-decoration

A bird drawn by Louis XIII at the age of eight in August, 1607, looking at a fifteenth century German tree and the face of the ring of Cheops, King of Egypt, who, says Herodotus, built a pyramid around 900 B.C.

A detail (from a distance) from Michelangelo's "Last Judgement," and a Paul Klee drawing (from the Museum of Modern Art's catalogue).

Various vegetable-hair-forms and some microscopic star-like crystal-form snow-flakes.

Some vibrating-plate nodal-forms (by Chladni) (made by bells and all sounding bodies) and a paramecium (a free fresh-water animalcule) (magnified 300 times).

Williamstown, Mass.
July 15, 1946

Dear Mr. Reinhardt:
Let me congratulate you on your PM series on modern art, which incredibly manages to be equally informative and amusing. Most advocates of modern art have so unpleasant and high-nosed an attitude toward untutored laymen like myself that they rouse only irritation, but your missionary zeal is so tempered with good nature and humanness that it is a delight.
Sincerely yours,
Sinclair Lewis

A letter from Sinclair Lewis and a non-objective painting by Wassily Kandinsky, 1937.

PAUL CEZANNE TO EMILE ZOLA

Aix, October 19, 1866

My Dear Emile:
. . . . I think I'll send you a sausage one of these days . . . I don't know whether you will be of my opinion—and that won't make me change—but I begin to see that art for art's sake is all a balderdash: that's between us. . . . adieu, mon cher.
Paul Cezanne

Leonardo is said to have started modern landscape painting and Cezanne is said to have finished it. Cezanne started, in turn, the cubist and abstract art traditions.

Cezanne's "Woodland Scene" from the Bakwin Collection, seen currently at the Museum of Modern Art.

An abstract painting by Carl Holty

Abstract painting by Hans Hofmann

"The answer to the question 'What does it mean' will come from much looking at good pictures rather than answers received to the questions."—Stuart Davis ✳

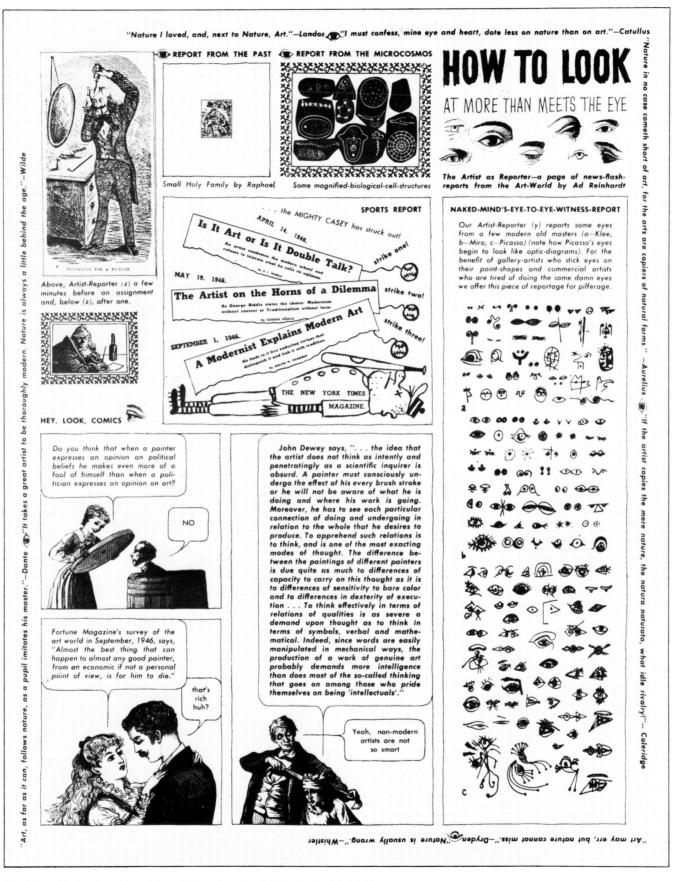

35. "How To Look at More Than Meets the Eye," *PM*, Sept. 22, 1946

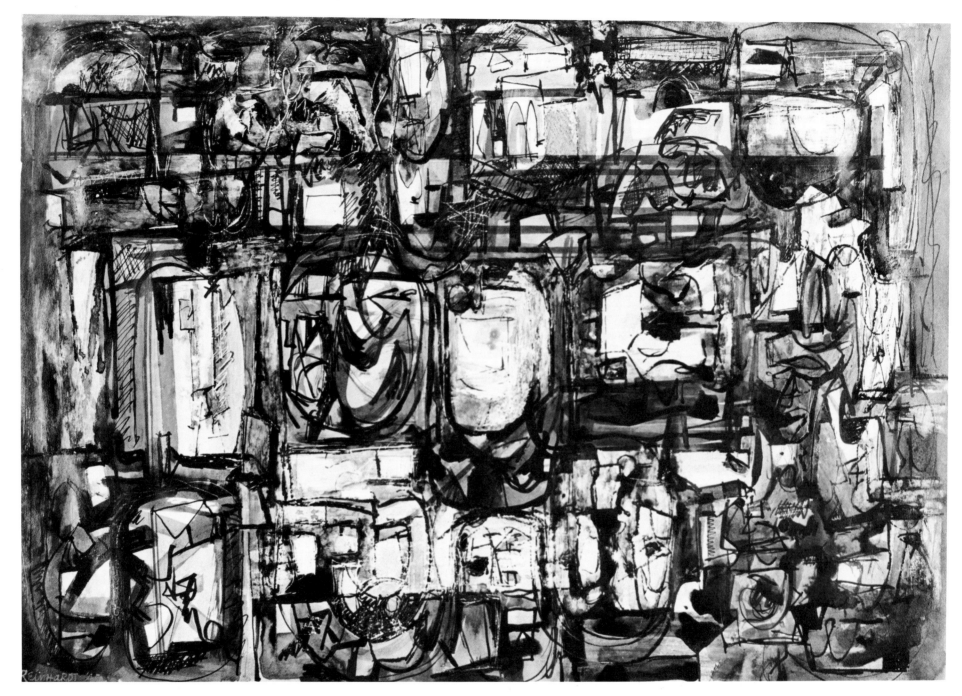

36. *Abstract Painting.* 1945. Ink, crayon, gouache. Dimensions and present location unknown

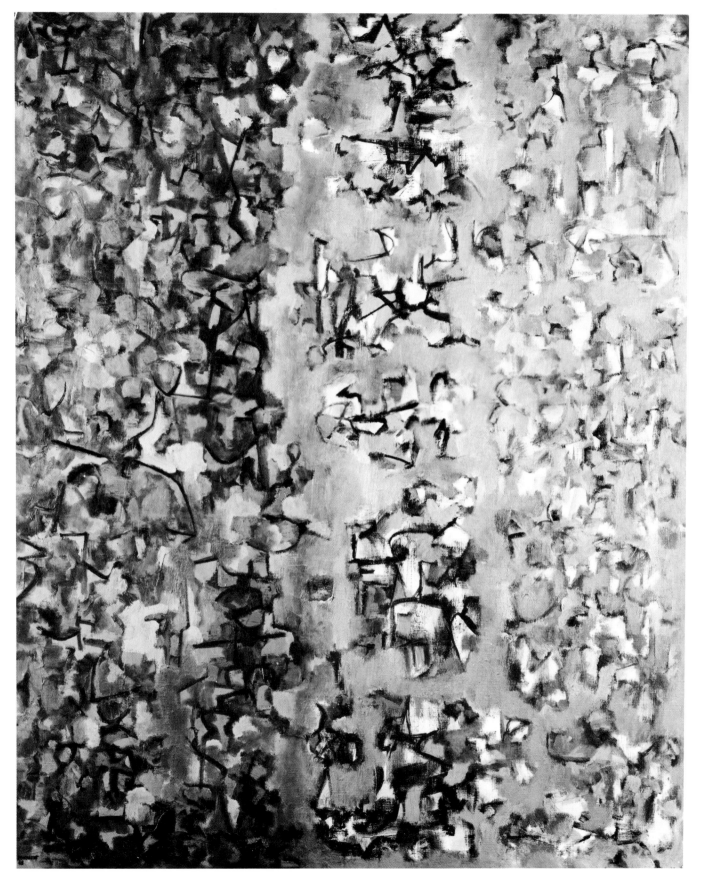

37. *Abstract Painting*. 1948. Oil on canvas, dimensions unknown. Private Collection

These lines were written in 1960, but the ideas first appeared in the mid-forties. While other artists made euphonious literary cases for a new content, Reinhardt was producing a unique series of cartoon critiques in which didactic messages were made palatable by a mordant and literate wit. Collectively titled "How to Look," the series ran from January 27, 1946, to January 5, 1947, in the newspaper *PM*.[80] It is the source of the later art-as-art dogma, and if the wording was different, the idea was what he called "the same old idea," the repetitive style hammering in the "distinction between a painting and a picture," between high and low art, between abstraction or "art as art," and Surrealism, or any "art as life." He quoted Louis Aragon: "The camera has opened the eyes of all except the eyes of the painter." Pictures in frames could not compete with the pictures in magazines and movies. The young artist could learn "more about his environment from film in a few years than he had from centuries of representational painting."[81]

In Reinhardt's out-of-hand rejection of all movements that exploited art for other than purely aesthetic ends, or incorporated in art other than aesthetic elements, lies the source of his differences with the New York School, long before that "school" actually existed. He never agreed, for example, with Motherwell, who wrote in 1942 that Mondrian's art had value as a demonstration, but was a failure because "he has spent his life in the creation of a clinical art, in a time when men were ravenous for the *human*."[82] Where other painters, with typically American backgrounds in a social or romantic, Ryderesque figuration, were moved to innovation and a new freedom by contact with the Surrealist program, with the Mexican muralists, with primitive or naive art, with early Kandinsky or the theories of Jung, Reinhardt derived his impetus from the dispersion of focus in Davis's and Mondrian's later canvases, which also heralded the breakup of the picture plane and of hierarchically organized space by which the New American Painting moved away from the characteristic self-containment of European modern art.

Shortly after his return to New York, in March, 1946, Reinhardt was given a show at the Brooklyn Museum School Gallery which apparently covered early work again, since the ubiquitous Hélionesque collage (pl.3) reappeared on the notice, accompanied by two more recent paintings with baglike shapes and irregular, round-edged rectangles overlaid by a painterly crosshatching that threatens to obscure them (fig. 36). By November of that year, when Reinhardt had his first show at Betty Parsons' new gallery,[83] the shapes and strokes had lost their solidity. The canvases from 1946 through 1949 are vertically oriented, often in exaggeratedly thin formats. Many are entirely single-surfaced with no border separating the repetitive patterns from the edges of the supports, while others retain a slightly columnar design. In some, which may be the earlier works (fig. 37), a field of irregular fragmented shapes floats in three intermingled layers, combining cloudy blotches, soft-edged but perceptible forms, and an overlay of flatter line and hooked shapes derived from his geometric calligraphies.

Colorplate 7. *Abstract Painting, Red.* 1948. Oil on canvas, 60 x 40". Private Collection

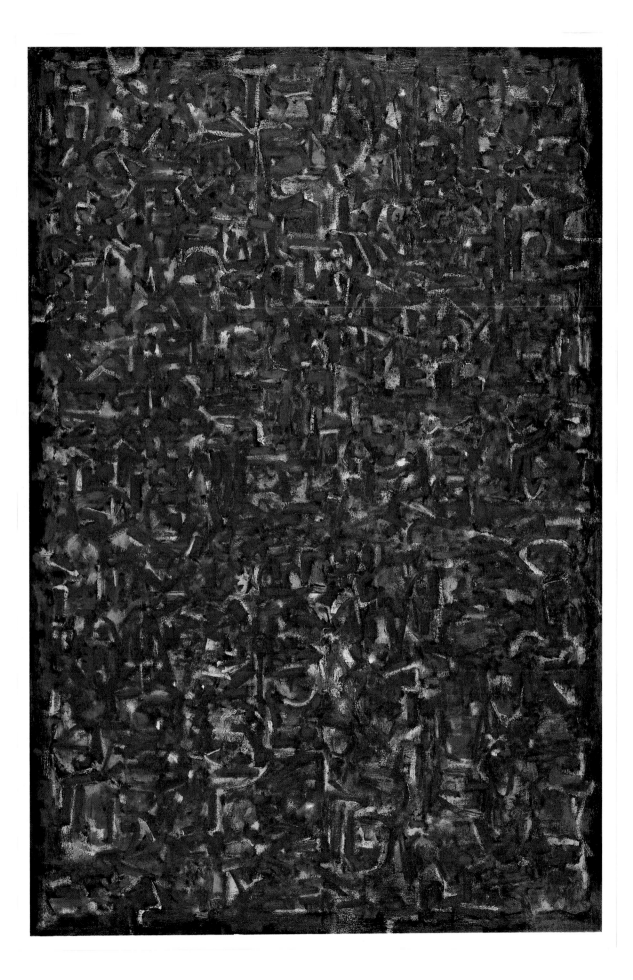

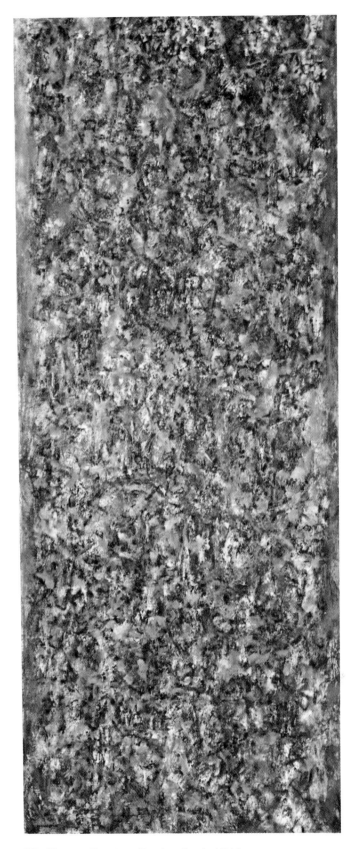

38. *Abstract Painting (Persian Rug)*. 1946.
Oil on canvas, 50 x 20". Present location unknown

A review of this exhibition noted that Reinhardt's paintings held nothing identifiable as particular objects and could be called "Abstract Impressionism."[84] Most of the paintings included seem to have been quite dryly painted, heavily scumbled; in some, crystalline linear shapes emerge like the striated details of a cliff-face. Others of the period are more intricate, tightly woven, and all-over; Reinhardt called them, half-seriously, "Persian Rugs," because of their textures and refined, luxurious colors. In 1947–49, these alternated with more loosely handled, fluid atmospheric canvases which he called "Chinese Verticals," acknowledging their resemblance to oriental monochrome landscapes. Both types had a long, thin vertical format and a clearly vertical-horizontal structure beneath the painterly surface. Some (fig. 40) recall Mondrian's plus-and-minus period; others (fig. 41) the hooks and lines of Kufic script. Reinhardt had long been interested in calligraphy, having copied Old English and German Black-Letter printing as early as 1924; his own starkly beautiful neo-italic handwriting in black ink with broad nibbed pen was a significant element in his dogmas as well as in his unceasing flow of letters and postcards to friends and adversaries. His graduate school lecture notes are visual masterpieces in themselves, the regular handwriting (often reduced to almost microscopic size) illustrated by rapid but incredibly assured sketches of the slides shown: innumerable Chinese bronze patterns, stylized cloud, hill, and water motifs from early Chinese paintings, Buddha after Buddha, and sculptural details, all demonstrating the differences between things that look alike, as did his journal sketches on his first trips to Europe, where he concentrated on common but decorative objects, such as telephone poles in Italy (fig. 42).

The general impression provided by the all-over canvases of 1946–48 is one of a light- and color-filled lyricism. The better examples reveal a gridlike underlayer; in the less successful examples this is clouded by an excess of dragged brush and light-over-dark modeling, or else the bold hooked lines that anchor the shapes to the picture plane are replaced by blurred fragments that seem to blow across rather than define the surface. It is in those canvases which bear the most obvious, if superficial, resemblance to an Abstract Expressionist aesthetic[85] that the difference between Reinhardt and the majority of his New York School colleagues is most striking. American "awkwardness"—irregular shapes, spontaneous composition, uninhibited gestures—never came easily to him. He was not only unwilling, but unable to court chaos. It is perhaps because of this personal and historical antipathy to the flamboyance of romantic declarations for the "sublime," for "crisis" and "risk," that his all-over paintings from the forties are finally less interesting than those of Pollock and others. The all-over method may have occurred to Reinhardt so early precisely because he was not interested in images—even abstract or symbolic ones—and did not have to work them out of his paintings. At the same time, his preference for harmony over dynamism and modesty over grandeur precluded extensions of

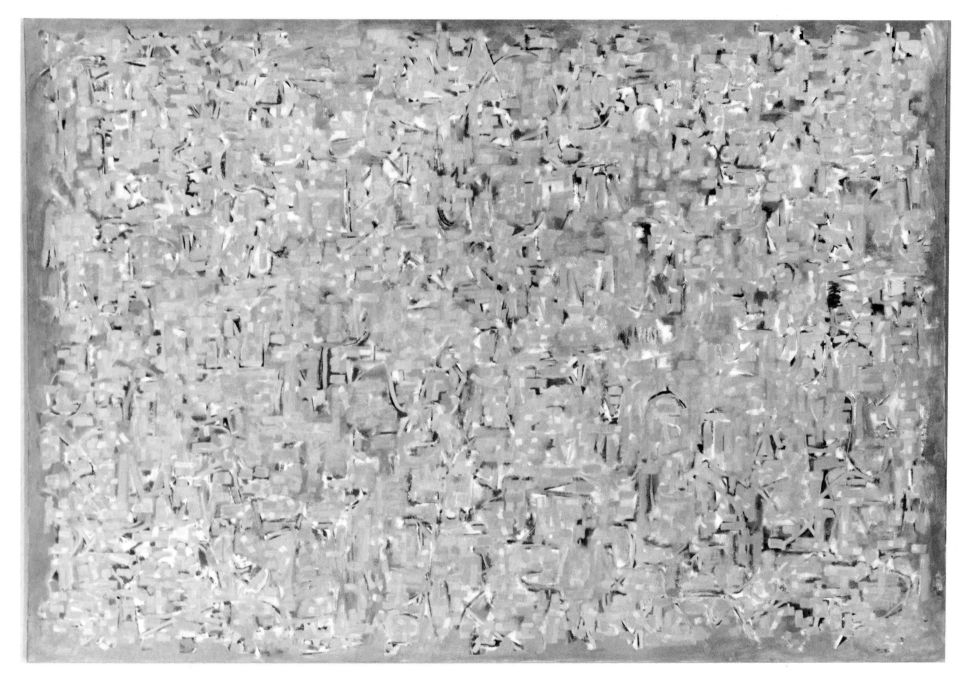

39. *Abstract Painting*. 1948. Oil on canvas, 40 x 60". Private Collection

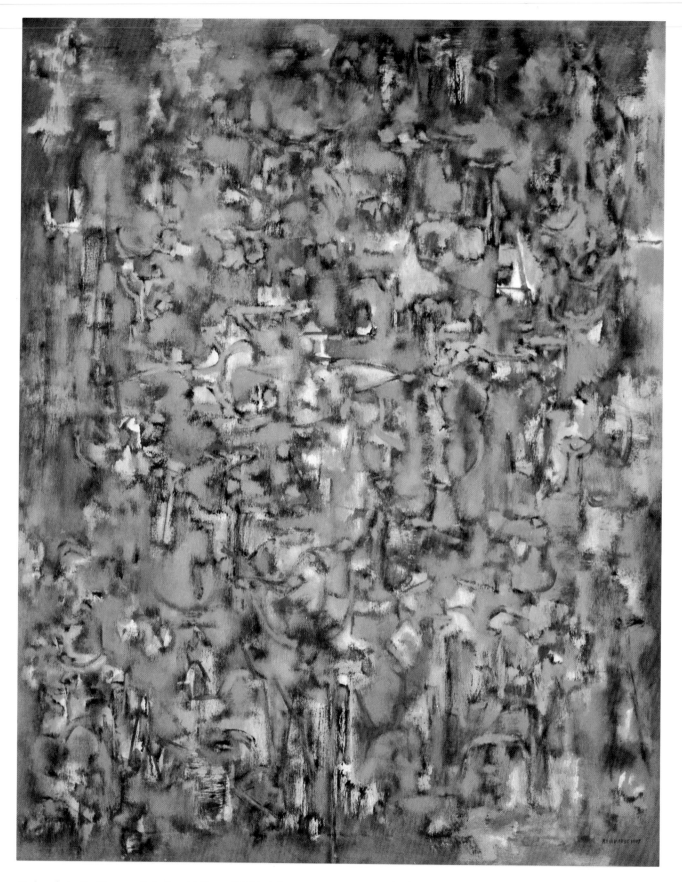

Colorplate 8. *Abstract Painting, Yellow.* 1947. Oil on canvas, 40 x 32″. The Museum of Modern Art, New York

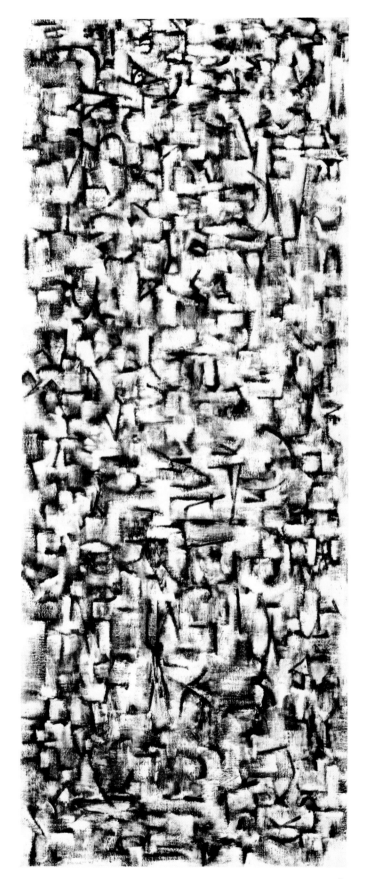

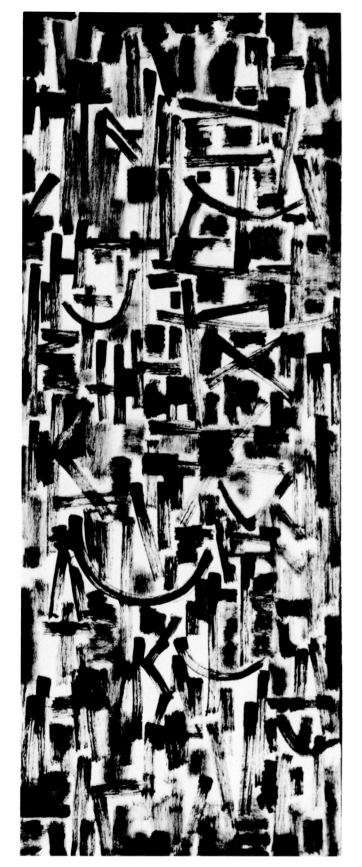

40. *Abstract Painting No. 22.* 1949. Oil on canvas, 50 x 20".
The Museum of Modern Art, New York.
Gift of Mrs. Ad Reinhardt

41. *Abstract Painting.* 1948. Oil on canvas, 50 x 20"
Collection Bernar Venet, New York

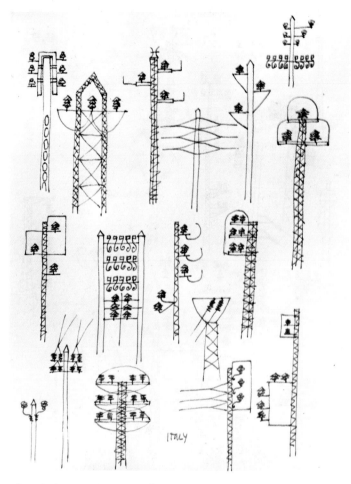

42. *Telephone Poles, Italy* (from journal kept in Europe). 1953. Pen and ink, 12¾ x 9½".
Private Collection

the all-over method into the immensely scaled, continuously lateral spaces achieved by Pollock, or the unrestricted color fields chosen by Barnett Newman. Reinhardt understood the needs and necessities of a new and liberated American art and to a point was able to follow them up with formal innovations. Yet his own real breakthrough was to come later as the result of a very different aesthetic and different circumstances.

Included in important early exhibitions of the new styles, such as "The Ideographic Picture" at Parsons in 1947 and "The Intrasubjectives" at Kootz in 1949 (with fig. 37), Reinhardt was *in* but stylistically not entirely *of* the New York avant-garde. His developing position as devil's advocate and scapegoat ("I was always the foil at the Club")[86] and finally as self-appointed community "conscience" further emphasized his simultaneous commitment to and detachment from the New York School. Reinhardt was a regular participant in the original, informal Artists' Club, which first met just after the war under a big tree in the northwest corner of Washington Square. He once said he was there (in the Club, until its demise in the early sixties) because there was nowhere else to go; he also knew, and said, that it was where he *belonged,* whether or not anyone agreed with him. His identification with and intellectual attachment to these artists as a group was unassailable. In 1950 Reinhardt was one of "The Irascible 18" artists who protested the Metropolitan Museum's "American Painting Today, 1950: A National Competitive Exhibition" because the choice of jurors "does not warrant any hope that a just proportion of advanced art will be included."[87] He was still protesting the next year, though by then the eighteen had shrunk to seven—Newman, Still, Rothko, Gottlieb, Ferber, Motherwell, and Reinhardt. Ten years later, disgusted with the alleged sell-out of his former comrades, he dedicated a paper read at the annual College Art Association meeting to "the seventeen irascible artists of 1950 who have since successfully adjusted themselves to their non-environment;" he noted in the course of that talk:

> It is not right for artists to feel it's all right to be "irascible" when young and without means, and "docile" when doddering and well paid-off. Artists stricken with "fall-out" or "sell-out" should be institutionalized, pensioned, and enabled to lead a comfortable hand-out-to-mealy-mouth existence for the rest of their natural lives.[88]

Thus the generalizations usually made about this generation of the New York avant-garde apply only peripherally to Reinhardt. While he called his work from the forties "rococo-semi-Surrealist fragmentation," and while the technique of automatism inherent in his earlier collages was pervasive enough for him to be able to benefit from it despite his antipathy to Surrealist rhetoric, he was also subjected to other, self-imposed formative factors not shared by most of his colleagues. In 1944, and then after the war on the GI Bill, Reinhardt

studied oriental art history with Alfred Salmony at New York University's Institute of Fine Arts. He did not work toward a degree, but remained there until 1952. Balcomb Greene had encouraged the decision to go back to school "to get out of a daytime job," and the choice of Eastern studies Reinhardt attributed simply to the fact that he already knew about the West. One is tempted to read more into it. Widely read as he was, Reinhardt was undoubtedly aware of aspects of oriental art to which he would be particularly sympathetic. Later he admitted that Islamic art had satisfied a self-conscious search for an antidote to the romantic expressionism that dominated the avant-garde through 1960. His old friend Thomas Merton was immersed in Zen Buddhism; Klee's, Kandinsky's, and of course Mondrian's interest in the Orient was not unknown to him. He was attracted to the Zen paradox because it "goes over and over something until it disappears"[89]; he lectured on it at the Artists' Club before it became popular and attended D.T. Suzuki's seminars at Columbia in the early fifties. The principle of the Sung Academy was particularly attractive because of its emphasis on "timelessness," its recognition of the possibilities open within the apparently unchanging framework of the set tradition. And the minimized composition and emotion, the emphasis on pattern in Islamic ornament, reinforced his own pictorophobia. He associated the icon with abstraction:

> The idea of an icon is to do a picture over and over again, to lose oneself in a few simple ideas to just get that rightness...no composition and color and expression, but invisibility. Mondrian did this; he made icons, not murals. In the original icons, the figures were just formulas, not everyday people. That idea came with the Renaissance. Islamic art is not religious and it's too fanatic and obsessive to be decoration. It is a composite art, an art from art. In abstract art you deal with problems of art.[90]

Perhaps Reinhardt also found in Buddhism a replacement for the Marxist aesthetic that artists in the thirties had failed to define. He considered Buddhism "an aesthetic, not a religion."[91] The intellectual challenge of both Buddhism and Marxism may lie in their cyclical implication that "the end is the beginning," a favorite concept of Reinhardt's. Claude Lévi-Strauss makes the connection as follows:

> This great religion [Buddhism] of not-knowingness is not based upon our incapacity to understand. It bears witness, rather, to our natural gifts, raising us to the point at which we discover truth in the guise of the mutual exclusiveness of being and knowing. And, by a further audacity, it has achieved something that, elsewhere, only Marxism has brought off: it has reconciled the problem of metaphysics with the

The Artist as Reporter—a page of news-flash-reports from the Art-World by Ad Reinhardt

NAKED-MIND'S-EYE-TO-EYE-WITNESS-REPORT

Our Artist-Reporter (y) reports some eyes from a few modern old masters (a—Klee, b—Miro, c—Picasso) (note how Picasso's eyes begin to look like optic-diagrams). For the benefit of gallery-artists who stick eyes on their paint-shapes and commercial artists who are tired of doing the same damn eyes we offer this piece of reportage for pilferage.

a—Klee

b—Miro

c—Picasso

43. "Naked-Mind's-Eye-to-Eye-Witness-Report," *PM*, 1946. Collage

problem of human behaviour....Buddhism can remain perfectly coherent and, at the same time, respond to appeals from without. Perhaps even, in a vast section of the world, it has found the missing link in the chain. For if the last moment in the dialectical process which leads to enlightenment is of value, so also are all those moments which precede and are similar to it. The absolute "No" to meaning is the last of a series of stages which leads from a lesser to a greater meaning. The last step needs, and at the same time validates, all those which went before it. In its own way, and on its own level, each of them corresponds to a truth. Between Marxist criticism which sets Man free from his first chains, and Buddhist criticism, which completes that liberation, there is neither opposition nor contradiction. (The Marxist teaches that the apparent significance of Man's condition will vanish the moment he agrees to enlarge the object that he has under consideration.) Marxism and Buddhism are doing the same thing, but at different levels.[92]

[Rothko and Pollock] have found something of their own and will perhaps be the start of a third party, of which modern art stands compellingly in need.
—Maude Riley, 1944[93]

I believe that here in America, some of us, free from the weight of European culture, are finding the answer, by completely denying that art has any concern with the problem of beauty and where to find it. — Barnett Newman, 1948[94]

Isn't the large size of modern abstract paintings a new insistence on the art-experience and a rejection of decorative intention? Isn't this another affirmation of independence and responsibility, of clarity and increasing consciousness of the total "process of creation"? —Ad Reinhardt, 1950[95]

Colorplate 9. *Abstract Painting.* 1948. Oil on canvas, 76 x 144". Allen Memorial Art Museum, Oberlin, Ohio

The late forties and early fifties is one of the most tangled periods in the annals of recent American art, a fact complicated by the personal animosities developed and the historical smokescreens set up during the intervening decades. The vagueness of statements about who was whose best friend, who visited whose studio when, what effect the various personalities had on each other, is compounded by the fact that critical coverage of the most important exhibitions was inadequate, and no attempt was made to establish any but the most superficial relationships between the various artists' work. Only one writer, Clement Greenberg, was concerned with the formal problems and processes confronted by the artists themselves, and no single person is equipped to elucidate the complexities of such a situation. In retrospect, Reinhardt seems to have been closest, as friend *and* artist, to Rothko and Newman at the time,

44. Artists' Session, Studio 35, April, 1950 (left to right: Brooks, Reinhardt, Pousette-Dart, Bourgeois, Ferber, Tomlin, Biala, Goodnough, Sterne, Hare, Newman, Lipton, Lewis, J. Ernst)

although he was also editing a book with the other younger member of the group — Robert Motherwell.[96] The artists represented by Betty Parsons (Reinhardt, Ferber, Hofmann, Newman, Pollock, Pousette-Dart, Stamos, Rothko, Still, and Tomlin) formed a close group, to which Tony Smith must also be added, by virtue of his close friendship with Pollock, Still, Rothko, and Newman.

The Parsons group seems to have felt that their goals differed from those of the Egan artists (De Kooning and Kline) and of the more Europe-oriented group (Motherwell, Baziotes, Gottlieb) at the Kootz Gallery, which someone called a "sweetening factory." Questions of mutual influence, or interaction, among the Parsons artists have yet to be clarified; they are arguable and are, in fact, being argued.[97] It is possible that the stature of the men involved precludes attribution of direct influence in any meaningful way. Solutions and approaches to common problems were pooled in discussion and at times collected in artist-organized exhibitions, such as Newman's "The Ideographic Picture" at Parsons in 1947, where a stylized graphicism was explored as a Jungian symbol via the primitive arts, and as the schematic device for abstraction adopted by Reinhardt.

Around 1950 American vanguard artists sensed as a group that a new kind of simplicity was necessary to achieve an expanded scale and presence. Pollock had found his unique course. Most of the others were grappling with conflicts between order and disorder, accident and intent. Having for the most part

rejected figuration, they were seeking at the same time a meaningful image vague enough to be suggestive beyond its pictorial associations. Their attitudes toward a geometric solution, associated with the Cubist orientation of the thirties and with European abstraction, were particularly ambivalent. Reinhardt was the sole proclaimed classicist in the Parsons group. He did not share Newman's distaste for the "empty world of geometric formalism,"[98] but like Newman, and to some extent Rothko, he realized the necessity to "escape geometry through geometry itself."[99] An exchange in the Studio 35 discussion of April 23, 1950, reflects the ambiguous role of geometry in the new art:

De Kooning: I consider all painting free. As far as I am concerned, geometric shapes are not necessarily clear. When things are circumspect or physically clear, it is purely an optical phenomenon. It is a form of uncertainty; it is like accounting for something. It is like drawing something that then is bookkeeping. Bookkeeping is the most unclear thing.

Reinhardt: An emphasis on geometry is an emphasis on the "known," on order and knowledge.

Ferber: Why is geometry more clear than the use of swirling shapes?

Reinhardt: Let's straighten out our terminology, if we can. Vagueness is a "romantic" value, and clarity and "geometricity" are "classic" values.

De Kooning: I meant geometry in art. Geometry was against art—the beauty of the rectangle, I mean.

Lippold: This means that the rectangle is unclear?

De Kooning: Yes. . . . The end of a painting in this kind of geometric painting would be almost the graph for a possible painting—like a blueprint. . . .

Newman: The question of clarity is one of intention. . . .

De Kooning: About this idea of geometric shape again: I think a straight line does not exist. There is no such thing as a straight line in painting. . . .

Reinhardt: I would like to get back to the question of whether there is another criterion of truth and validity, apart from the internal relationships in a work of art. . . .

De Kooning: If a man is influenced on the basis that Mondrian is clear, I would like to ask Mondrian if he was so clear. Obviously he wasn't clear, because he kept on painting. Mondrian is not geometric, he does not paint straight lines. A picture to me is not geometric—it has a face. . . . It is some form of impressionism.

Newman: De Kooning has moved from his original position that straight lines do not exist in nature. When I draw a straight line, it does exist. It exists, optically. . . . A straight line is an organic thing that can contain feeling.[100]

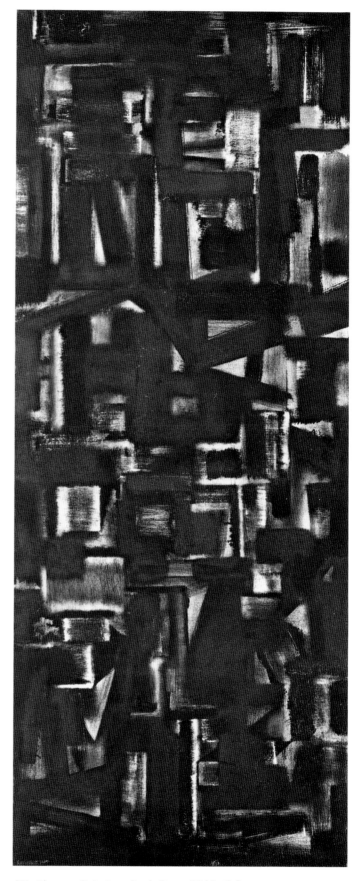

45. *Abstract Painting, Dark Gray.* 1948. Oil on canvas, 50 x 20". Collection Marlborough Gallery, New York

46. *Abstract Drawing*. 1947. Brush and ink collage, 24 x 18¾". Private Collection

At some point in the late forties, the "Persian Rug" brushstrokes became less lines and patches than flat slabs with ragged ends (fig. 45). Several paintings from 1948–49 reverted to the ribbon-like calligraphy of the 1941–44 works, so that Reinhardt seems to have exited from his "Surrealist-Expressionist" period by exactly the same gate that he entered it. Though he was now master of several interchangeable manners by which to accomplish a unified but lively surface, none of them brought him complete satisfaction. In the late forties he began to attempt the synthesis he may have had in mind all along. A large key painting from 1947–48, later overpainted, demonstrated his dilemma (fig. 47). In it the short graphic strokes and shapes that made up the weave of the all-over canvases are isolated and enlarged against a ground irregularly divided into flat, rectilinear forms. On top of this a bright-colored, rather arty arrangement of filled-in free shapes intercedes between the calligraphy and the solidity of the ground.

The years between 1948 and 1950 indicated two conflicting directions in Reinhardt's art. The first produced some of the most "expressionist" works of his career. Some of these are very good paintings, but formally they were a blind alley. The 1949 exhibition at the Betty Parsons Gallery included several canvases in which the heavily painted uniform covering of previous works was torn away from large areas, revealing irregular whiplash lines and the contours of loose parabolic shapes set in among rough-edged blocks (fig. 48). They were painted in the Virgin Islands, but as Reinhardt took pains to note in the catalogue, they bore no intended relation to "seashells or undersea coves," "native land or sea or sky-scape," "camouflaged Caribbean stories," or "local racial or political myths."[101]

The second direction, in which the quasi-rectangular slablike strokes combine with the blurry edges of the more lyrical paintings to become either fields of glowing color bricks or airy monochromatic geometries, was to prove the important one. Yet around 1950 Reinhardt's production was still highly diverse. Apparent stylistic differences usually represent trial solutions to the same problems — scale, painterliness, geometry. The broad open area cut by dry-brushed "windows" into an underlayer was, for example, attempted with wet brush and dry, with strongly contrasting multicolors, monochrome, and close values. The same methods were applied to all-over fields of color bricks or bars. Others, such as a flat calligraphic canvas in white-on-white (fig. 50), and a handsome vertical divided into four rectangular areas of black, white, and gray (fig. 51), were geometrically composed, simply but strongly related to the shape of the support. Only the black-and-white calligraphies continued to employ diagonals and curves of any kind, and they too dealt with shapes of a single size and formal emphasis.

The color-brick paintings of 1949–50 are clearly related to the brilliant, flat, close-valued geometric paintings from the late thirties; at the same time, they profit from a painterly handling achieved in the intervening years: the

47. *Abstract Painting*. c. 1948. Oil on canvas (now destroyed)

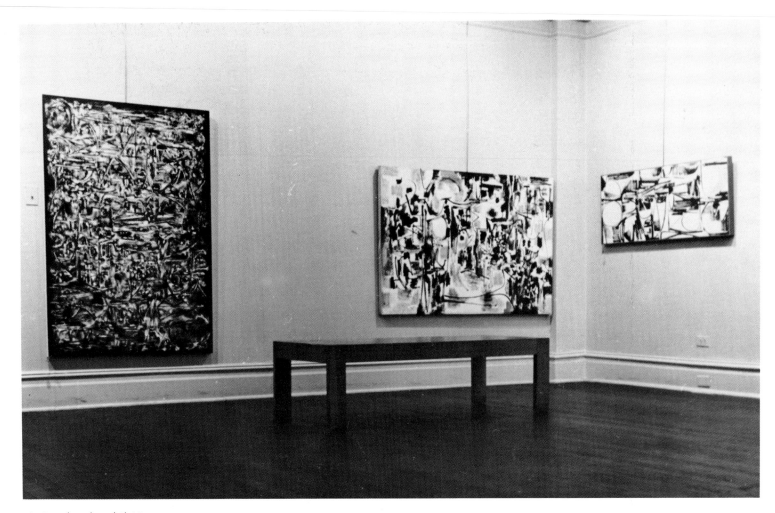

48. Reinhardt exhibition at Betty Parsons Gallery, New York, 1949

loosening compartmentation of the work around 1945, and the infinite variety possible within minute differentiations of pattern and color of the work in the late forties. The all-over paintings had been dependent on a visible variety— a chiaroscuro that sparked patches of light and dark distributed uniformly over the canvas as in Impressionism—and on contrasts of wet and dry brush (presumably to give the "woven" surfaces a certain textural interest in lieu of specific form juggling); they had also contrasted blurred and linear contours. The new thinly painted, watercolor-effect canvases de-emphasized contrast and stressed color and luminosity. In some canvases (fig. 54, pl. 10), the bricks are lined up across a horizontal surface to form alternate bands leading off the side edges, like an orderly version of Pollock's expanding spaces. In others (figs. 55, 56, pl. 11), the same effect is more strongly accomplished by a regular division of the surface into overlapping blocks of the same size. If ever a painting deserved the label "Abstract Impressionism," a shimmering yellow gouache of 1949 (fig. 57) is it, though Reinhardt took pains to point out that his use of the word "Impressionism" was "entirely involved with the sensation and impulse of the marks on the surface—*not* sensations and impulses of anything else—phenomenology, epistemology, Meyer Schapiro's theories, etc."[102]

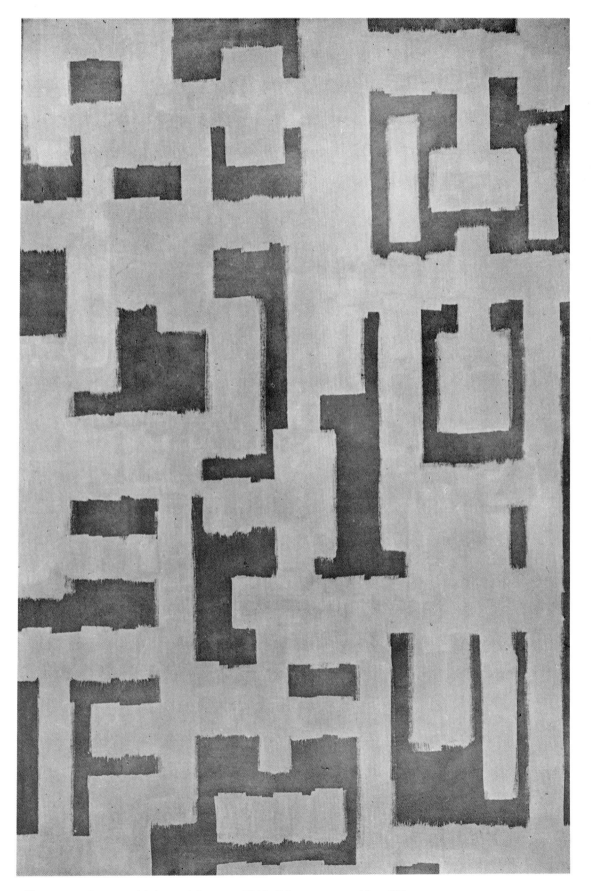

49. *Abstract Painting, Violet and Orange.* 1948. Oil on canvas, 60 x 40".
Collection Mrs. Sheridan Hudson, Paris

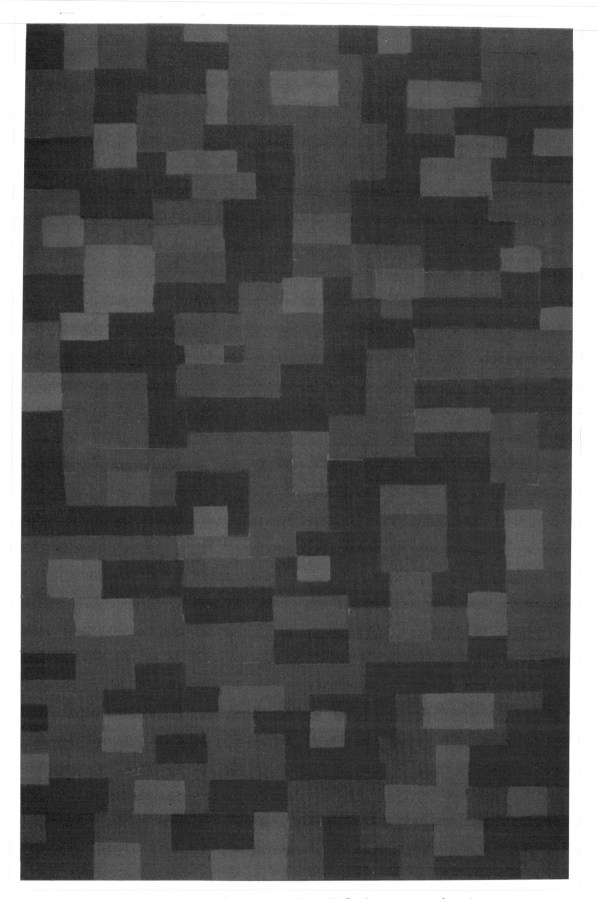

Colorplate 10. *Number 114.* 1950. Oil on canvas, 60 x 40⅛". The Museum of Modern Art, New York. Gift of Mrs. Ad Reinhardt

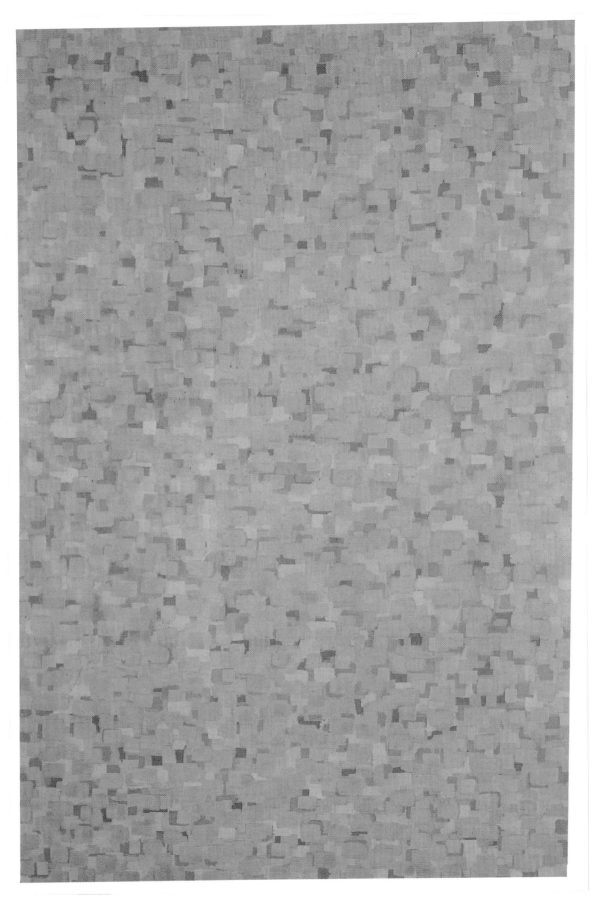

Colorplate 11. *Abstract Painting*. 1949. Oil on canvas, 60 x 40".
The Museum of Modern Art, New York

50. *Abstract Painting, White.* 1950. Oil on canvas, 80 x 36".
The Museum of Modern Art, New York (promised gift)

51. *Abstract Painting, Black, White and Gray.* 1950.
Oil on canvas, 36 x 12". Private Collection

52. *Abstract Painting, No. 8.* 1950.
Oil on canvas, 80½ x 34". Private Collection

53. *Abstract Painting, Blue on Black.* 1950.
Oil on canvas, 50 x 20". Private Collection

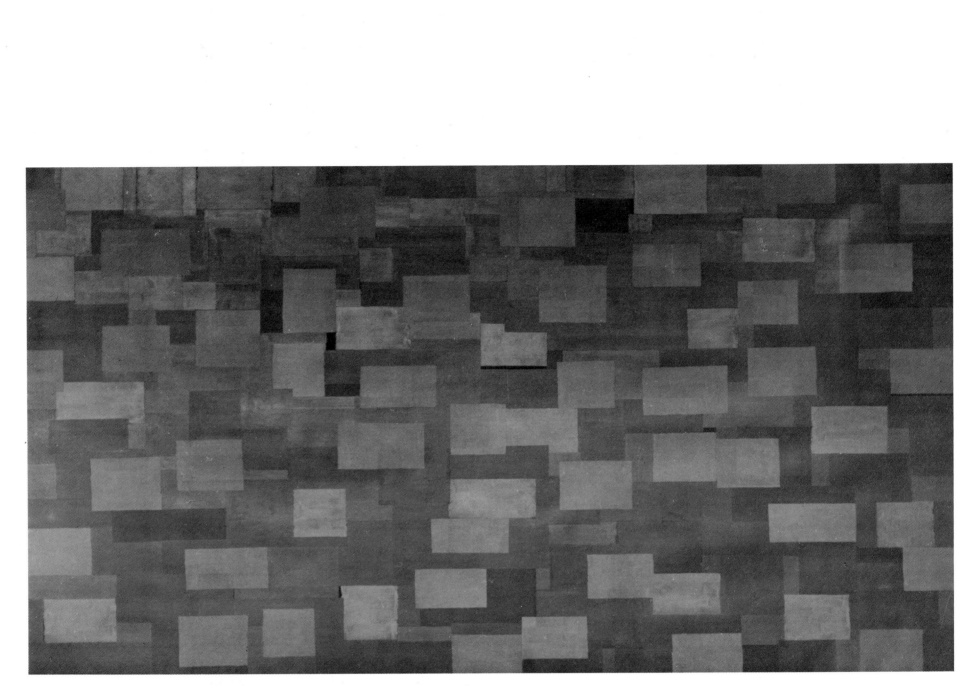

54. *Abstract Painting.* 1950. Oil on canvas, 76 x 144". The Hirshhorn Museum and Sculpture Garden, Washington, D.C.

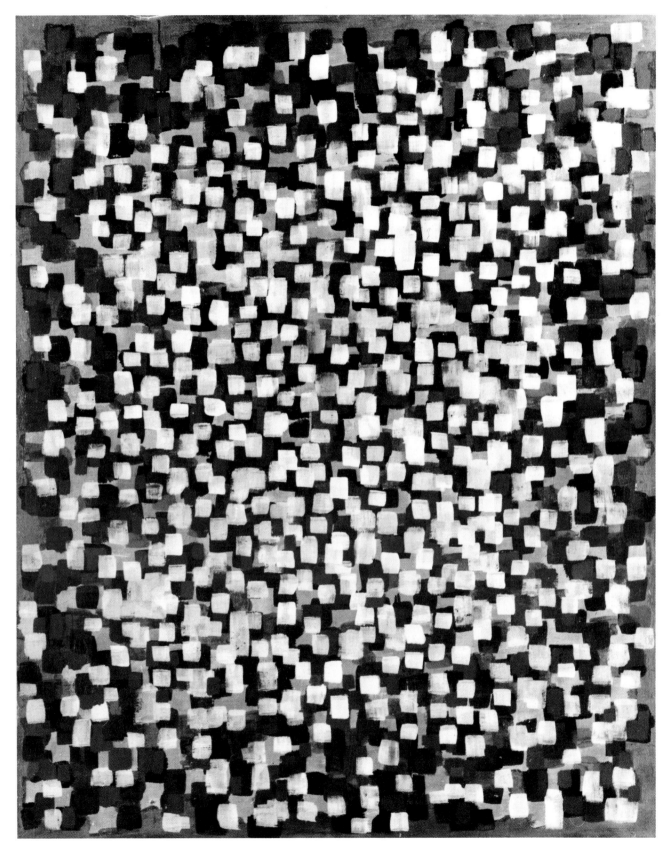

55. *Abstract Painting.* 1949. Oil on canvas, 40 x 32". Private Collection

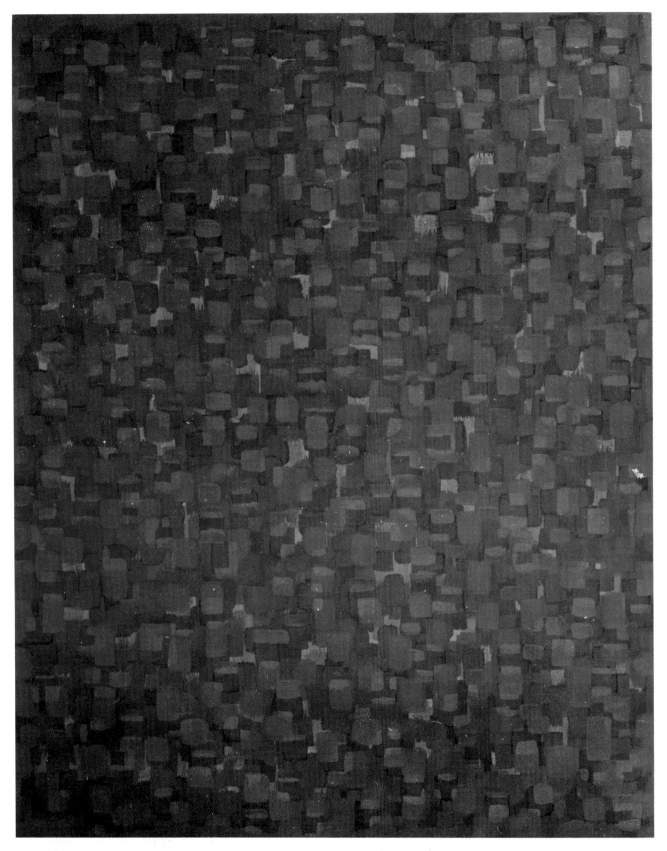

56. *Abstract Painting.* 1949. Oil on canvas, dimensions and whereabouts unknown

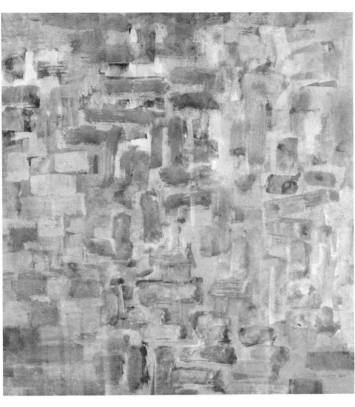

57.

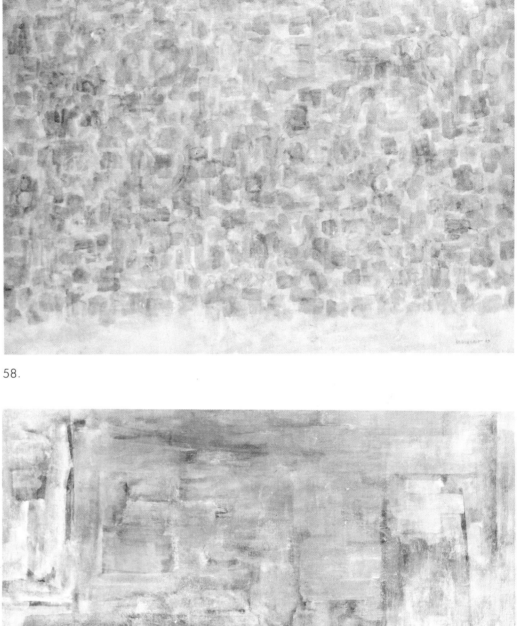

58.

57. *Abstract Painting.* 1949. Gouache
on paper, 27½ x 25½". Private Collection

58. *Abstract Painting.* 1949. Gouache,
22½ x 30½". Private Collection

59. *Abstract Painting, Gray.* 1949. Oil on
canvas, 32 x 40". Private Collection

59.

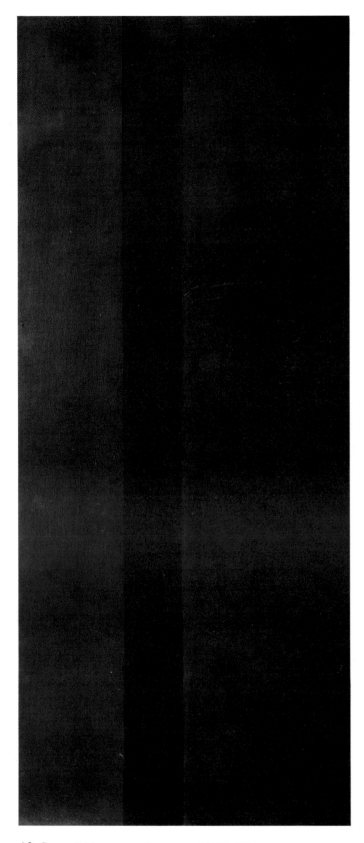

60. Barnett Newman. *Abraham.* 1949. Oil on canvas,
82¾ x 34½". The Museum of Modern Art,
New York. Philip Johnson Fund

Throughout this period, and on until the mid-fifties, Reinhardt continued to alternate between hot, bright hues and equally close-valued, but more somber hues—the grays, browns, greens, and blues that became typical of his mature work. A major painting from 1950 (pl. 12) consists of very thinly painted, rough-edged gray rectangles with traces of yellows and greens surfacing like a mortar of light between the bricks. Now that our eyes are accustomed to far darker and closer values, its chromatic distinctions are clear enough; at the time, however, such lack of color was being explored by only a few painters—Rollin Crampton, Newman, and Still among them.[103]

While Still was probably the first to open up a broad field of almost unbroken color into then unprecedented size and scale, and while it was Pollock who first "broke the ice," as De Kooning has put it, Barnett Newman seems to have been the source of a peculiarly New York concept, further extended in the sixties—that of an art based on one idea, on a single (rather than all-over) image; the concept of the thinking artist, as opposed to the physically active artist constantly in the process of working out ideas in paint. "The basis of an aesthetic act is the pure idea," Newman wrote in 1947:

> But the pure idea is, of necessity, an aesthetic act. Here then is the epistemological paradox that is the artist's problem. Not space-cutting nor space building, not construction nor fauvist destruction; not the pure line, straight and narrow, nor the tortured line, distorted and humiliating; not the accurate eye, all fingers, not the wild eye of dream, winking; but the idea-complex that makes contact with mystery—of life, of men, of nature, of the hard, black chaos that is death, or the grayer, softer chaos that is tragedy. Everything else has everything else.[104]

Aside from Newman's first controversial show of "stripes" in 1950, which was not taken seriously even by certain members of the avant-garde audience, there are of course precedents for exhibitions in which all the paintings closely resemble each other. Mondrian's shows minimized variety and Josef Albers' "Homage to the Square" series, begun in 1949, did so even more radically, though neither Mondrian nor Albers combined single image and very large size in the way that became characteristic of the New American Painting. Reinhardt, who eventually took the single-image concept further than anyone else, did not restrict himself to the trisection until 1952. From 1949 to 1952 he was still seeking his own solution to the issues with which the entire avant-garde was confronted. He worked well in large size, but the effect was always more restrained than that of his Parsons colleagues. While he added to the classical harmonies of pure painting an element that has, dangerously, but not inaccurately, been called "American" breadth and openness, and while he was as concerned as anyone with a continuous surface as a vehicle for "color-space,"

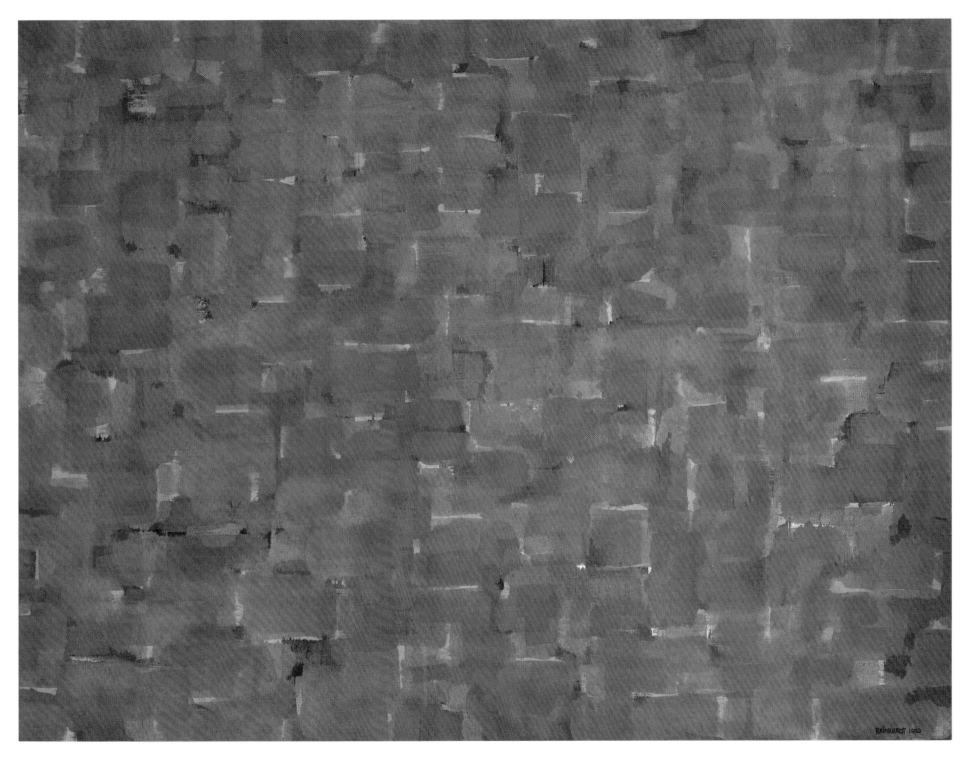

Colorplate 12. *Abstract Painting—Grey*. 1950. Oil on canvas, 30½ x 40½". The Metropolitan Museum of Art, New York. Gift of Henry Geldzahler, 1976

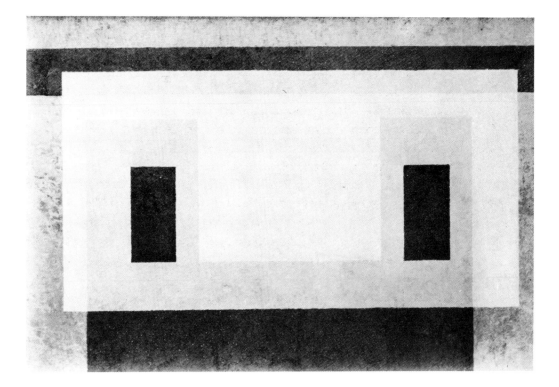

61. Josef Albers. *Dark*. 1947. Oil on canvas, 26½ x 38". Collection Budd Goldberg, Chicago

his sensibility was not attuned to the subjective combination of grandeur and intimacy inherent in their work. He saw painting as an ordered, pure, and preferably immobile construct in a period when "purity" was despised. In this sense, he was a "thirties painter" in the forties and a "sixties painter" in the fifties, for he soon found that huge size was not necessary for the particular self-contained luminescence he sought. Like Mondrian twenty years earlier, and like the Minimal artists ten years later, he eschewed the monumental for a quieter middleground scale that was neither overpowering nor easily over-powered.

This "un-American" modesty he shared with Josef Albers, whom he saw fairly frequently in the early fifties.[105] Albers remembered seeing a yellow-on-white, semi-geometric canvas by Reinhardt (probably plate 13) in the 1951 AAA exhibition; he thought at the time that here was the only New York artist dealing with the kind of color ideas in which he himself was involved.[106] Again, it is difficult to assess the extent or even the existence of direct influence. Albers doubted that there was any. Reinhardt had synthesized geometry and close values in 1949, abandoned the idea, returned to it briefly, and abandoned it again. By 1950 he was headed back toward a hard-edged geometric style and away from the looser all-over idiom that had preoccupied him in the forties. Nevertheless, the example of Albers' "Homage to the Square" series may well have provided an encouraging suggestion that conventional geometry did offer a valid vehicle for color research and a viable alternative to Mondrian's asym-

metricality. The study of bright, clear values and minute color variations by juxtaposition was general knowledge through the Impressionists and through Matisse, whose impact on the New York School is well known. Yet Albers' studies went considerably further both in experimentation and systematization.[107] Certain of Reinhardt's larger canvases from 1952 or 1953 are clearly related to works such as Albers' 1950 *Variant on a Theme: White Wall*[108] or his 1947 *Dark* (fig. 61), exhibited in Andrew Ritchie's "Abstract Painting and Sculpture in America" at the Museum of Modern Art in 1951. Albers and Reinhardt agreed on reduction of form in favor of color, although Albers' methods, his emphasis on theory, and his strict self-limitation to the unmixed color straight from the tube were unsuitable to Reinhardt's more intuitive process.

The 1950 paintings indicate Reinhardt's rejection of Still's physically substantial impasto (though not of his strong verticality), Pollock's emphasis on process and material, and the indeterminate, atmospheric space of Gorky, Rothko, and Pollock. Nevertheless, the blurred edges of the shapes show his reluctance to abandon entirely the painterly handling associated with other new work. Reinhardt was certainly most drawn to Rothko's and Newman's intellectual clarity. He personally objected to the aura of angst that surrounded Pollock. Yet Rothko and Newman continued to "compose" in a minimal sense, to rearrange their rectangular areas in order to solve different color and space problems in each canvas, whereas Reinhardt was far more attuned to the homogeneous surface, non-hierarchical arrangements, and generally anti-formalist approach that Pollock represented. Pollock came to such an approach emotionally; Reinhardt came to it through a fundamental disinterest in form. He was to be increasingly concerned with symmetry and with ordered pattern, which Thomas Hess had perceived in 1949, when he wrote: "Reinhardt seems to be an inventor of patterns, not of forms."[109]

This comment may have been intended pejoratively, yet it was precisely such a rejection of "significant form," "dynamic equilibrium," and associative images that freed Reinhardt from the restrictions of conventional geometry. His perpendicular strokes and color bricks, or bars, were already modular units rather than forms. The blurred, asymmetrical, rectilinear calligraphies and airy "watercolor" oils of 1949–50 were Reinhardt's last attempts to fuse his own classicizing nature with the romantic breakthroughs of the painterly abstractionists.

In his 1951 show at Betty Parsons, the geometric framework, hidden for years under virtuoso surfaces, was allowed to emerge in stark elegance. The soft, luminous color came from what the artist called the "Chinese Verticals," while the crucial openness and breadth seem to have resulted from a decision to concentrate on close-valued, pale monochromatic hues, emphasizing yellow or light gray on white, as well as a bold black-and-white calligraphy. By 1953 he had fully committed himself again to geometry, albeit a geometry that by symmetry and close values extended previous geometric art.

62. Mark Rothko. *Number 10*. 1950. Oil on canvas, 90⅜ x 57⅛". The Museum of Modern Art, New York. Gift of Philip Johnson

Colorplate 13. *Abstract Painting, Yellow and White.* 1950. Oil on canvas, 80 x 60". Marlborough Gallery, New York

Colorplate 14. *Abstract Painting*. 1950. Oil on canvas, 60 x 40". Private Collection

63. *Abstract Painting, Black and White.* 1949–50. Oil on canvas, 42 x 42". Collection Mrs. Barbara McMann, New York

64. *Abstract Painting.* 1950. Oil on canvas, 40 x 36". Private Collection

65. *Abstract Painting, No. 17.* 1951. Oil on canvas. Dimensions and present location unknown

The expressive and structural meaning of color space in painting is my main interest.—Ad Reinhardt, 1947[110]

To those horrified that we may take the mystery out of painting, we promise to keep the question of color quality a deep (bright) secret.
—Ad Reinhardt, 1947[111]

[Gestalt psychology] came about negatively, as a protest against what is now called the atomistic approach: the method of explaining things by adding up local effects, qualities, functions of isolated elements.
—Rudolph Arnheim, 1943[112]

Considering the revolté nature of modernism as a whole, [the aim to create a new convention] is an odd and uncharacteristic ambition, an ambition which separates the geometrical painters from their contemporaries in other styles. In the context of the modern movement they stand alone in their willingness to set up strict rules of procedure. They are unique in their adherence to pictorial goals that are capable of exact definition. Every other notable style in the modernist spectrum aims at a release from the ties of convention in order to be on its own, free from distracting obligations not immediately relevant to its expressive task, whereas the geometrical style strives for the very opposite; the imposition of a new convention which will rescue the work of art from the hazards of free expression and personal fancy. This faith in the absolute was, in a peculiar and subtle way, a faith that others exist, whereas a great deal of the free-form painting of our time issues from the neurotic need of artists to reassure themselves that they exist. The loss of faith in the pictorial absolute has thus been to some extent a loss of faith in the social function of art—which is to say, a loss of faith in society itself.—Hilton Kramer, 1960[113]

Reinhardt had no one-man exhibition in 1950. The work shown in 1951 included the flat, calligraphic paintings, often two-color and close-valued (or monochrome in the Chinese sense—one color plus white). The painter Robert Goodnough's review in *Art News* described them as a:

> ...refreshing experience in color imagery in which simplified areas give free vent to a continuous, flat activity of relationships that rest, unchecked, throughout the canvases.... Reinhardt works with an interplay of positive and negative areas that are so conceived as to reverse themselves and transcend these elements—positive becomes negative and vice-versa, and the whole settles into a restful presentation of feelings in paint.[114]

66. *Abstract Painting.* 1950. Oil on canvas, 80 x 36". Present location unknown

67. *Abstract Painting.* 1951. Oil on canvas,
24¾ x 40". Private Collection

Meanwhile, the color bricks, which had first appeared in 1949, were gradually crystallizing into geometric elements. They became less and less painterly until only the edges of the horizontals reflected the drag of the brush.[115]

Regular fields of color bricks—some more geometric, some more painterly—comprised the 1952 show. Most of the paintings were "in bright drug-store colors of almost the same value that make your eyes rock"; Fairfield Porter described *Number 14* as "a little blue and much shiny and full black that reverse themselves in a changing light."[116] Another artist-reviewer, James Fitzsimmons, noted that these were:

> ...non-objective paintings, some close to the Constructivist tradition, but without the quasi-scientific element....Colors are muted and subtly contrasted....It is in the variations of color and of the intervals between blocks and bars of color that Reinhardt's patient ingenuity is expressed. Sometimes he produces a busier, denser mosaic of small

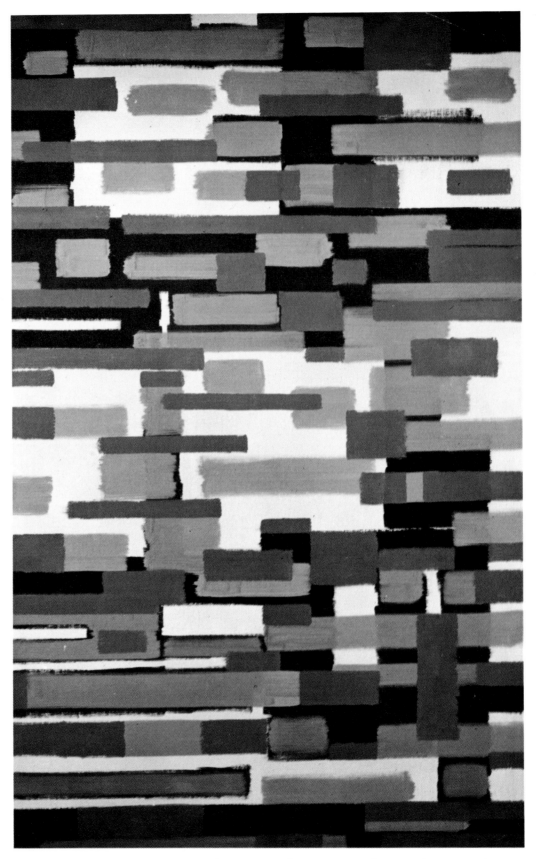

68. *Abstract Painting, No. 2.* 1952. Oil on canvas. Dimensions and present location unknown

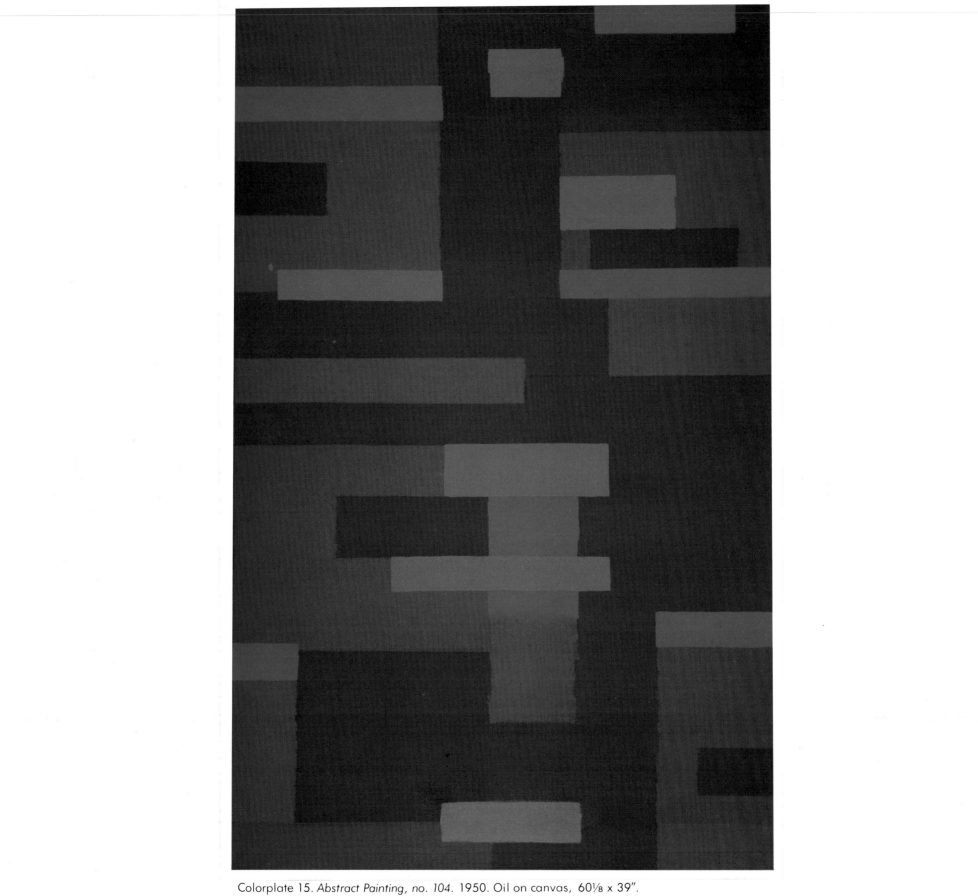

Colorplate 15. *Abstract Painting, no. 104.* 1950. Oil on canvas, 60⅛ x 39".
The Museum of Modern Art, New York. Gift of Mrs. Ad Reinhardt

overlapping dabs of color....But in this reviewer's opinion his most successful paintings—and some are highly successful—are those in which he achieves a sort of poetry of understatement, with acid color providing an occasional quiet shock.[117]

The 1952 show included one "very large horizontal canvas," with "short vertical bands of color applied flatly on longer or wider bands often crossing from one rectangle to another. Colors are muted and subtly contrasted. A desultory rising and falling pattern, rather like the piston movement of a slow engine, is set up across the canvas."[118] The 1953 show continued this direction. (In the interim he had been to Europe for the first time, and in 1953 he returned, but this seems to have made no impact on his work.) Some of the paintings were monochromes, other multicolored; all were based on a simple interlocking device such as an E, H, L, or I shape. One was twelve feet high. Martica Sawin noted a "mysterious quietism" and sensed an "indeterminate metaphysical value."[119] Thomas Hess wrote the first full article on Reinhardt in response to these works, and since it applies to the work of the succeeding fifteen years as well as to that of 1953, it is worth quoting at length:

> Reinhardt's exhibition at the Parsons Gallery is one of its and his best....The major effect is transmitted by large paintings, physically over-size....The precious aspect of the small 1919 Mondrians is avoided, as is the overwhelmingly panoramic suction into surface of the giant-scale works by such men as Jackson Pollock or Clyfford Still. Reinhardt's paintings are human objects.
>
> The pigment is applied in flat, even, anonymous-looking coats....The edges of the shapes are neat but not precise, soft, obviously handmade. Despite the artist's protestations about the triviality of handwriting in painting, and the impersonal distance he observes in the applications of his pigments, the pictures themselves betray an individual (if cool) involvement with and appreciation of the material. This quality counts, willy-nilly, in his art.
>
> The hues, too, are distributed evenly....Contrasting colors are often adjusted to equivalences...which, in Fairfield Porter's phrase, make your eyes rock. Or again, close values will cause differences of hue to vanish. Sometimes the hues themselves barely vary from shape to shape. Rectangles tend toward invisibility in one black painting, only floating into view under certain lighting conditions. But despite their variety, flatness is positively asserted in all the pictures: there is no overlapping, no play with illusion of dimension. Reinhardt's work might be called mural, except that this word suggests a too palpable materiality. Similes for the surface energy released could be the scream of a bat (which our ears cannot hear) or the sound snow makes falling on snow. Yet the energy is here, and is apprehended easily.[120]

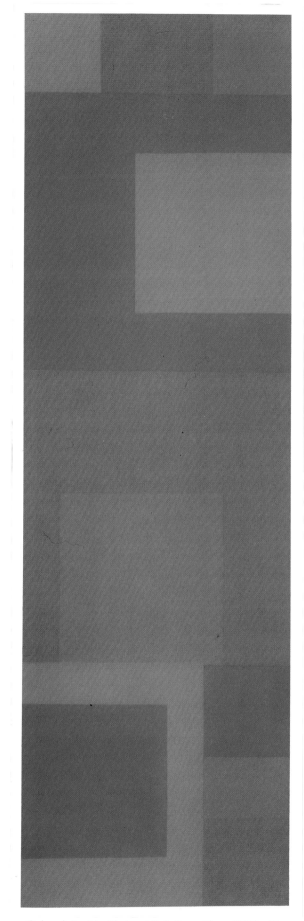

Colorplate 16. *Abstract Painting, Blue.* 1950–51. Acrylic and oil on canvas. 78 x 24". Collection Donald B. Marron

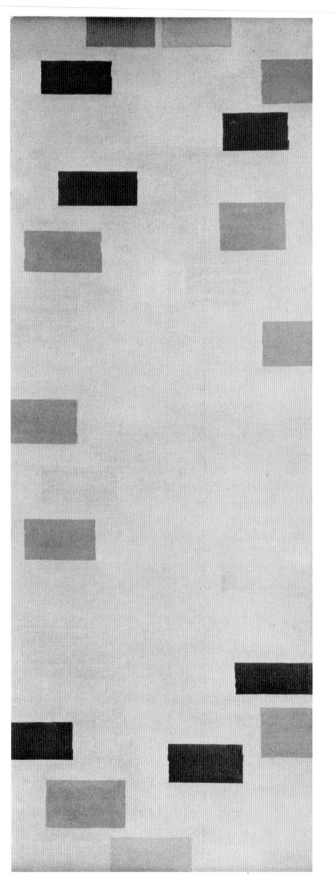

69. *Abstract Painting, Dark Blue.* 1949–50. Oil on canvas, 50 x 20". Collection Rita Reinhardt

70. *Abstract Painting, No. 7A.* 1952. Oil on canvas, 108 x 40". Collection Mr. and Mrs. Ben Heller, New York

71. Ad Reinhardt in his studio, c. 1951

From 1952, the strongest examples of the "early classical, hieratical, red, blue, black monochrome square cross-beam symmetries" fused the open field of edge-to-edge rectangles with a closed or interlocking arrangement that compactly united them with a minimum of balancing; painterly method and geometric clarity fused as well. The all-over pattern, superficially irregular in its gestural surface, is more symmetrical than asymmetrical in its non-hierarchical approach, and it paved the way for the symmetrical red and blue monochromes.

With the standardization of means by which geometric composition became merely a vehicle for pure color-light, and with the total neutralization of composition in his black squares, discussion of Reinhardt's single works inevitably becomes more generalized. On entering a room of the red or blue monochromes from the early fifties, one's initial impression is that the surface divisions are nearly identical, whether in vertical or horizontal formats (most of the work after 1949 is either square or vertical). On closer scrutiny, however, they reveal a mastery of subtle spacing and nuance which is not so much admirable in itself as it is crucial to the overall color relations. After 1954, when

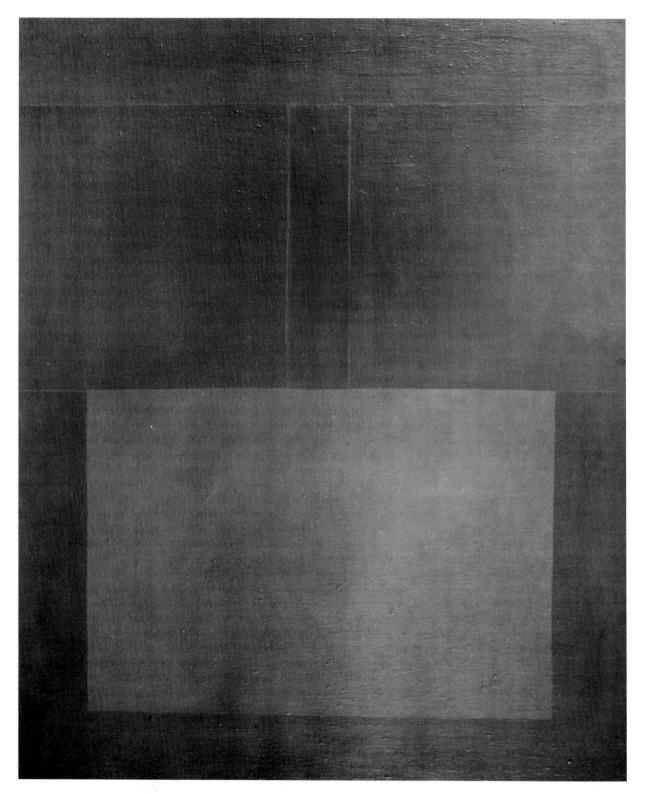

72. *Abstract Painting, Red*. 1951. Oil on canvas, 41 x 33". Private Collection

the symmetrical, trisected, or single-crossbeam device (originated in 1952) was used consistently, the short, broader, usually horizontal element overlaps the longer, thinner vertical element, and the horizontal is closest to the picture plane, partially compensating for the verticality of the support (figs. 73, 77). In some of the earlier works, where the value contrasts are still quite salient, this crossbar stands as a kind of confrontational barrier which must be registered in its total simplicity before the less visible background is related to it. In the red horizontal canvas owned by the Metropolitan Museum (plate 17), the strongest color is reserved for the central vertical; the crossbar, more closely attuned to the ground shapes, squeezes the strong vertical forward, up against the picture plane, between the two paler elements. The overlapping of such elements exists in a Cubist space. The result is, nevertheless, a flat surface, for the overlap is received in a secondary, intellectual, rather than a primary, perceptual manner.

As the increasingly frontal and symmetrical arrangement and close-valued tonal system obscured individual shapes and their design roles, Reinhardt allowed color full range. He seems to have settled on monochrome as a major direction in 1953, though the first centrally divided monochromes (a yellow-gold one and a white one) were painted a year or so earlier, and isolated monochromatic paintings were made in the late forties as well. His choice of red and blue may have been in recognition of a dualism present in all his work from the early forties, his interest in both a very warm and a very cool light. The red paintings began as gold, orange, pink, ochre, maroon compositions with quite strong value contrasts; the earliest were monochromatic but not monotonal. The blue ones exhibited a variety of hues for a longer period, ranging from cobalts and brilliant purples to Prussian, ultramarine blues and emerald greens. It was in this period that any color-theory discussions with Albers would have been particularly meaningful for a younger artist developing his sense of close chromatic manipulation.

The red paintings became closer and closer in value, hotter in tone, until the edges of the perpendicular forms were virtually burned up in the overall radiance. Despite such vibrations, however, the underlying schemes are calm enough and the contrasts invisible enough so that these beautiful glowing rectangles produce none of that irritating discord for discord's sake exploited by the Op art movement in the early sixties. There are equally saturated blue paintings (usually in a turquoise-to-green range for brilliance), but for the most part the blues moved in the other direction toward a muted, nocturnal appearance, effective even when the colors used were relatively pale. Reinhardt had been experimenting with grayed-out color since the late forties, but the first geometric monochromes were flatly painted with enough oil to make them glossy from certain angles; at times he worked with the contrast of matte and shiny surfaces of one color. The nocturnal effect that was soon to invade even the red paintings, resulting in the earliest "black" (red, green, and blue) ones, was due to the oil being drained from the paints. The slightly grayed, matte surface

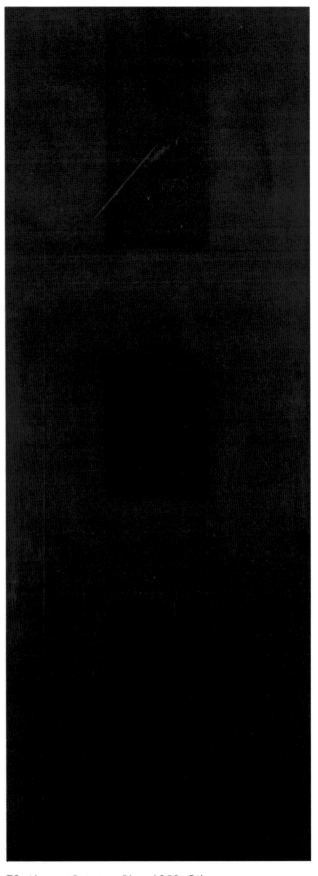

73. *Abstract Painting, Blue.* 1952. Oil on canvas, 108 x 40". Present location unknown

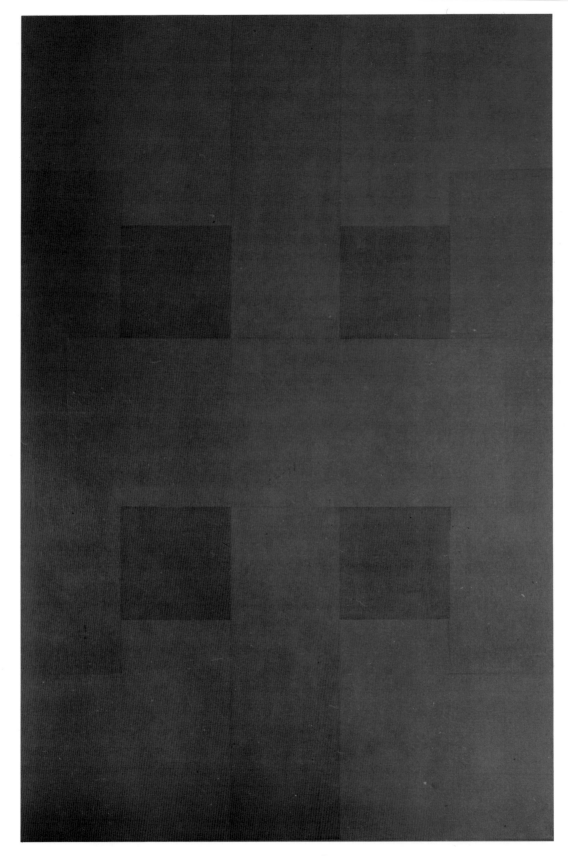

74. *Abstract Painting, Red.* 1952. Oil on canvas, 60 x 40". Collection Yale University Art Gallery, New Haven, Conn.

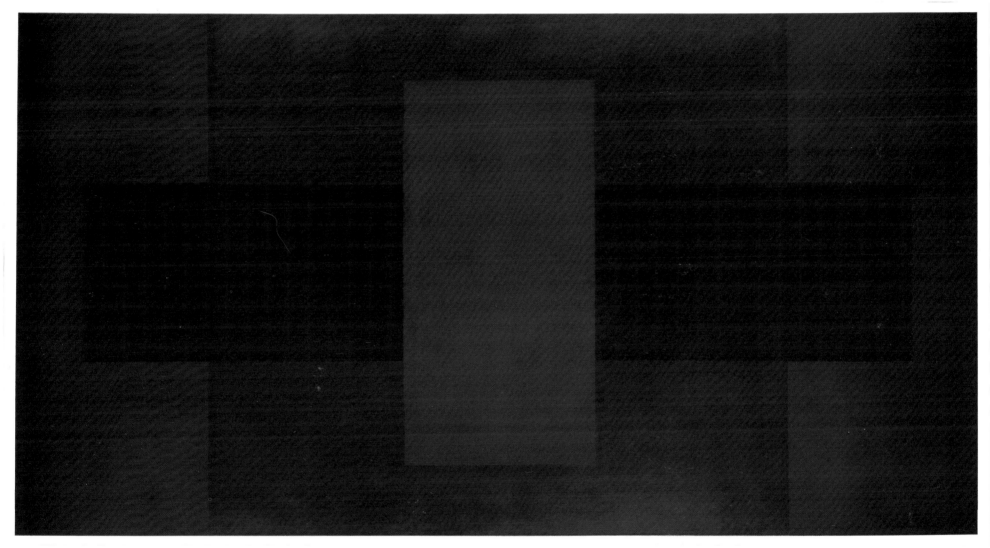

Colorplate 17. *Red Painting*. 1952. Oil on canvas, 78 x 144". The Metropolitan Museum of Art, New York. Arthur H. Hearn Fund

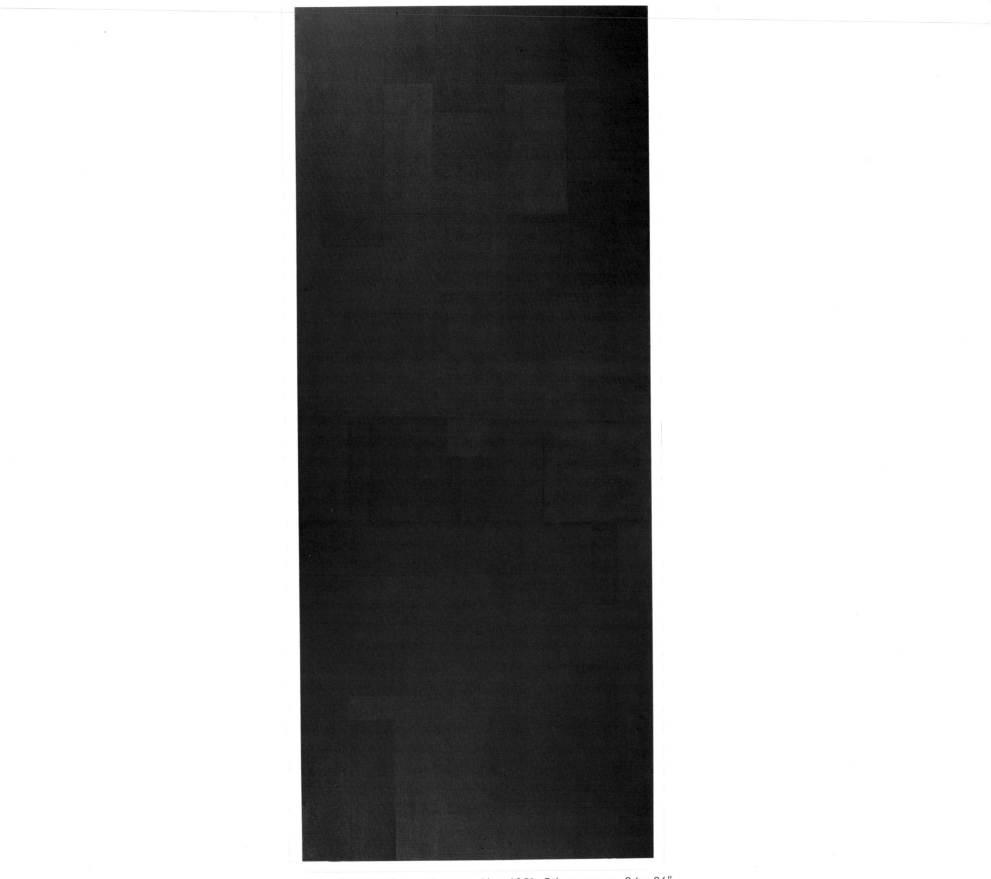

Colorplate 18. *Abstract Painting, Blue.* 1951. Oil on canvas, 84 x 36".
Collection Dr. William Greenspon, New York

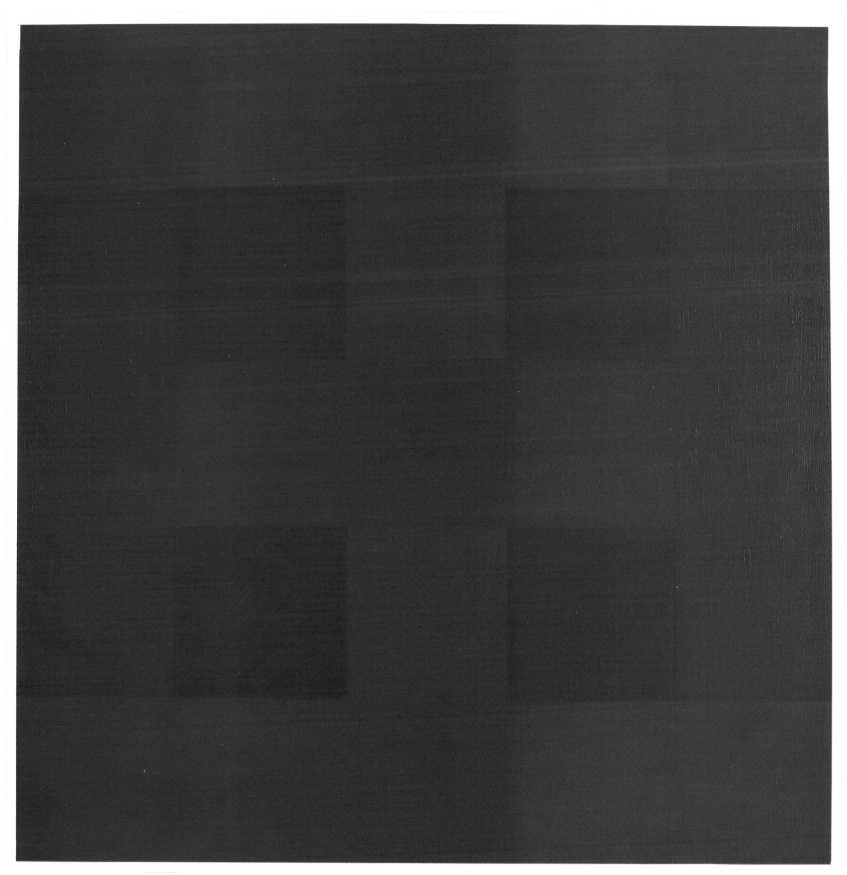

Colorplate 19. *Abstract Painting, Red*. 1953. Oil on canvas, 40 x 40". Collection Gilbert Kinney, Washington, D.C.

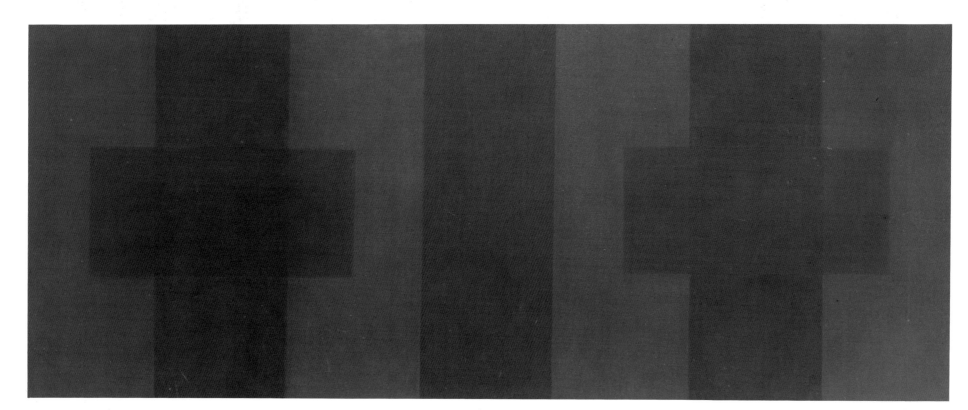

75. *Abstract Painting, Blue.* 1952. Oil on canvas, 20 x 50". Private Collection

also further de-emphasized disparities of hue, enabling Reinhardt to bring ochre, for instance, into a "black" range.

The motive for such destruction of standard paint surfaces (making his work increasingly susceptible to damage from any oily substance, especially fingerprints) was a concern with light that finally overwhelmed concern with color as it is generally understood. Color, like composition, became to him "unnecessary" for painting, more satisfactorily employed in other mediums. Though he made at least four white-on-white paintings (pl. 22), he once wrote that all painting should be black, all sculpture white, and all architecture colored[12]: "White is 'not artistic'; [it is] appropriate and pleasing for kitchen fixtures and hardly the medium for expressing truth and beauty."[122]

Reinhardt's paintings have always had something of the character of significant experiments within the context of artistic modernism; in fact, they were among the first paintings since Monet's canvases in extremely light values to assert the importance of contrasts of color over those of value. —Michael Fried, 1964[123]

Colorplate 20. *Abstract Painting, Blue*. 1953. Oil on canvas, 30 x 30". Collection Mr. and Mrs. Charles H. Carpenter, Jr., New Canaan, Conn.

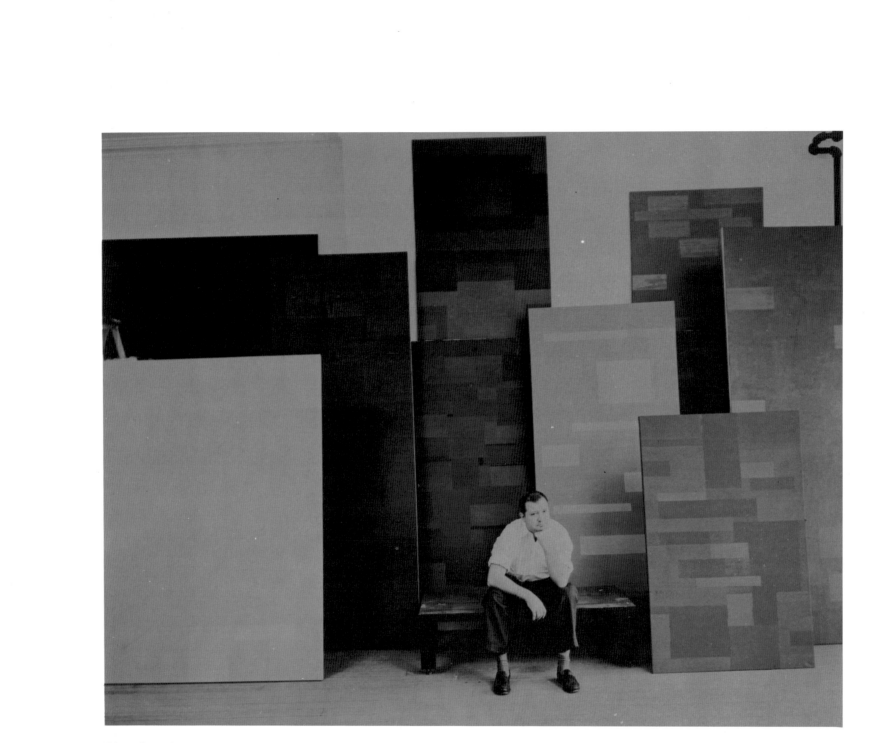

76 . Ad Reinhardt in his studio, c. 1953

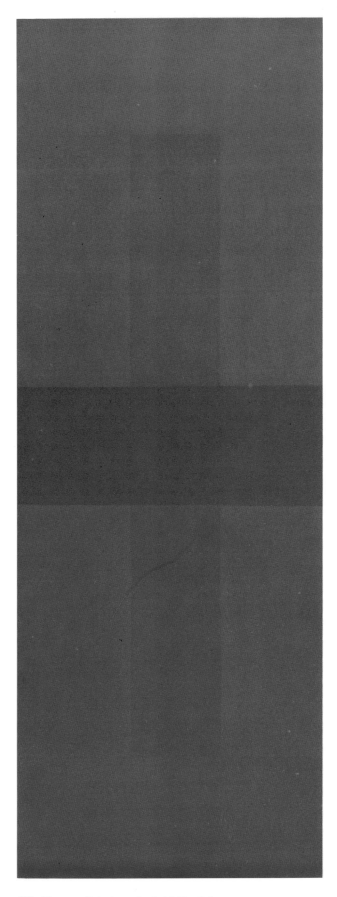

77. *Abstract Painting, Red.* 1951. Oil on canvas,
60 x 22". Collection Jesse Philips, Dayton, Ohio

Colorplate 21. *Abstract Painting, Red.* 1953. Oil on
canvas, 108 x 40". Collection Mr. and Mrs. Gifford
Phillips, Santa Monica, Calif.

78. *Abstract Painting.* 1953. Oil on canvas, 30 x 24″. Private Collection

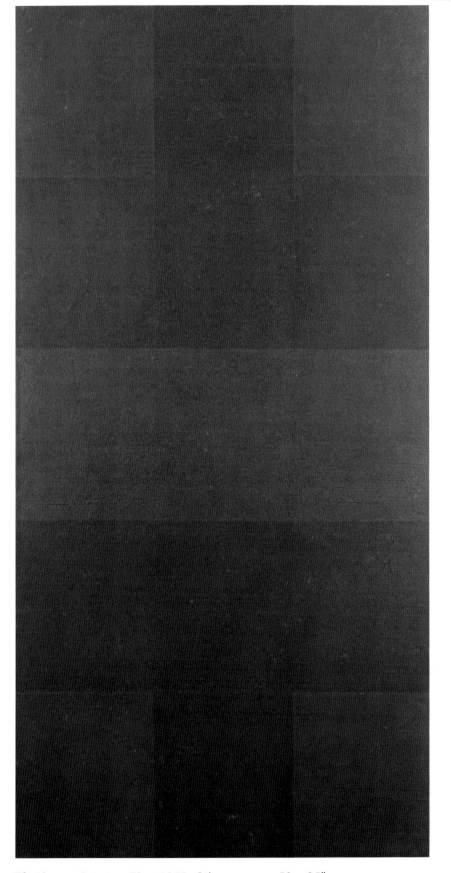

79. *Abstract Painting, Blue.* 1953. Oil on canvas, 50 x 25″.
Private Collection

Colorplate 22. *Abstract Painting, White.* 1955. Oil on canvas, 60 x 60". Private Collection

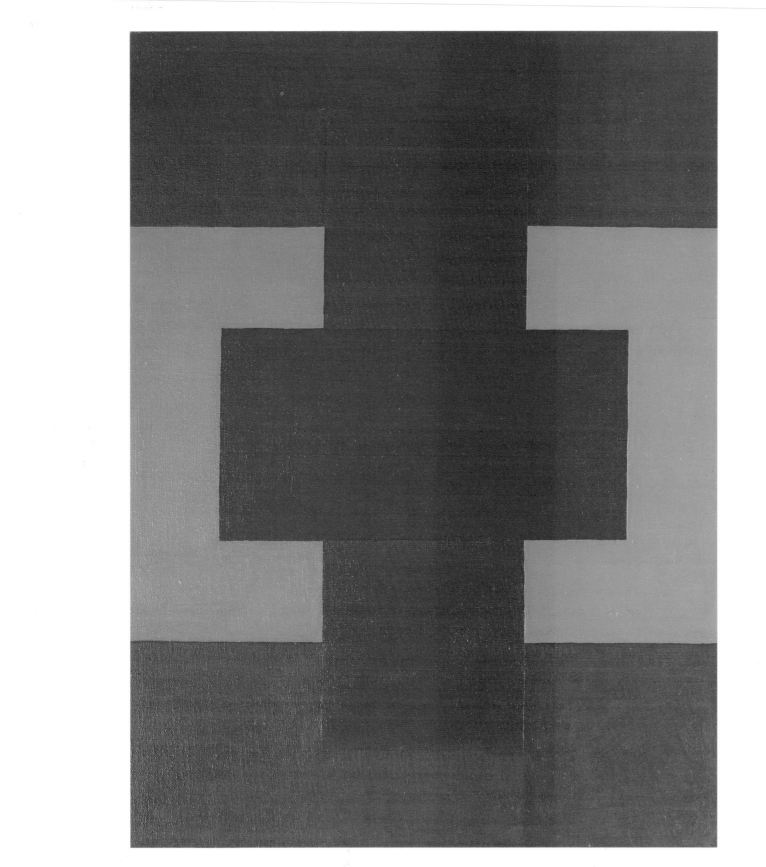

Colorplate 23. *Abstract Painting, Red and Blue.* 1952. Oil on canvas, 16 x 12". Private Collection

Reinhardt is also the only member of "The Intrasubjectives" group which showed in 1949 who has not been a great howling success, nor has he had the kind of recognition he deserves. This is not to say that he is unknown. His paintings enjoy, as it happens, a kind of profound unpopularity. Perhaps Pollock did something which struck an intensely popular note and during this period, dominated by Pollock's breakthrough, Reinhardt has been steadily evolving in an opposite direction. —Lawrence Campbell, 1960[124]

It was around 1956 that Reinhardt made the final decision to concentrate on dark paintings alone. His show of that year provided a small retrospective of this preoccupation, covering muted color-brick works from 1950, those with lines of rectangles straining to be regular, the geometrically interlocking type from 1953, and from 1955, in Thomas Hess's words, the "canvas-filling cross-or-H-shapes equally made up of background and foreground, neither of which thus exists. Such simple symmetry eliminates 'balancing' because the shapes are pre-balanced. The closeness of hues, in a way, eliminates color, for in extreme closeness violet or brown or green act the same."[125]

It seems important, in view of the singular attention given in many critical surveys to historical one-upmanship and chronological illogic, to establish the date of the first monochromes, the first black painting, and when Reinhardt gave up "color" and "composition." For several reasons, which coincide with the artist's contention of timelessness, such precise dating is virtually impossible, and, in context, relatively unimportant. First, there is no question of anyone else having "done the same thing" so there is no point in a race to the prototype prize. No other American painter was interested in a combination of invisibility, purity, and the end of painting, until at least 1960. Rodchenko (whose writings incidentally were also composed of lists of quotations) made a black-on-black painting in 1919, in reply to Malevich's "White on White" series; between then and 1956, several Americans had also made what amounted to black-on-black canvases: among them, Still, Newman, Rollin Crampton, Edward Corbett, and Robert Rauschenberg. Yet the historical interest of these works lies in the possibilities they suggested for extremely close-valued color, also raised by Turner, Manet, Monet, Vuillard, and Bonnard, rather than in the choice of black or darkness as a formal vehicle.

The fundamental problem is the fact that Reinhardt himself never painted a solid black or a black-on-black canvas. What he was doing had little in common with the now innumerable examples of paintings (American and European) that contrast two or more blacks. His one-color decision was not a gesture, but a plastic development, a refinement rather than an abrupt reversal of previous work. The move towards black instead of white was the kind of personal decision that can only be explained after the fact.

There was no sudden element in this decision, no painting that can be established as *the* turning point. Reinhardt continued to work in multicolor after

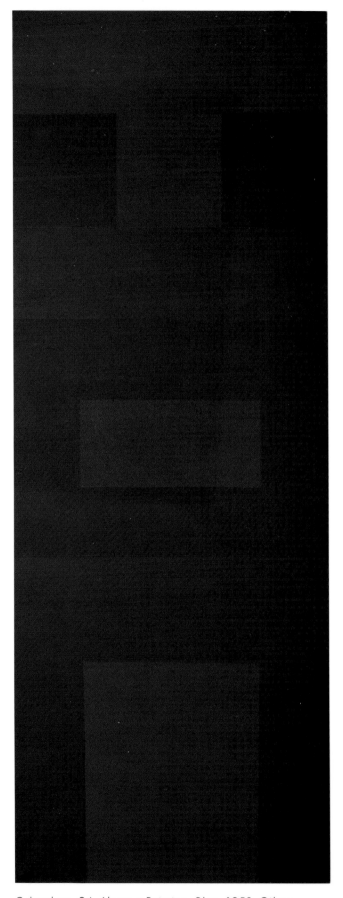

Colorplate 24. *Abstract Painting, Blue.* 1953. Oil on canvas, 75 x 28". Museum of Art, Carnegie Institute, Pittsburgh, Pa.

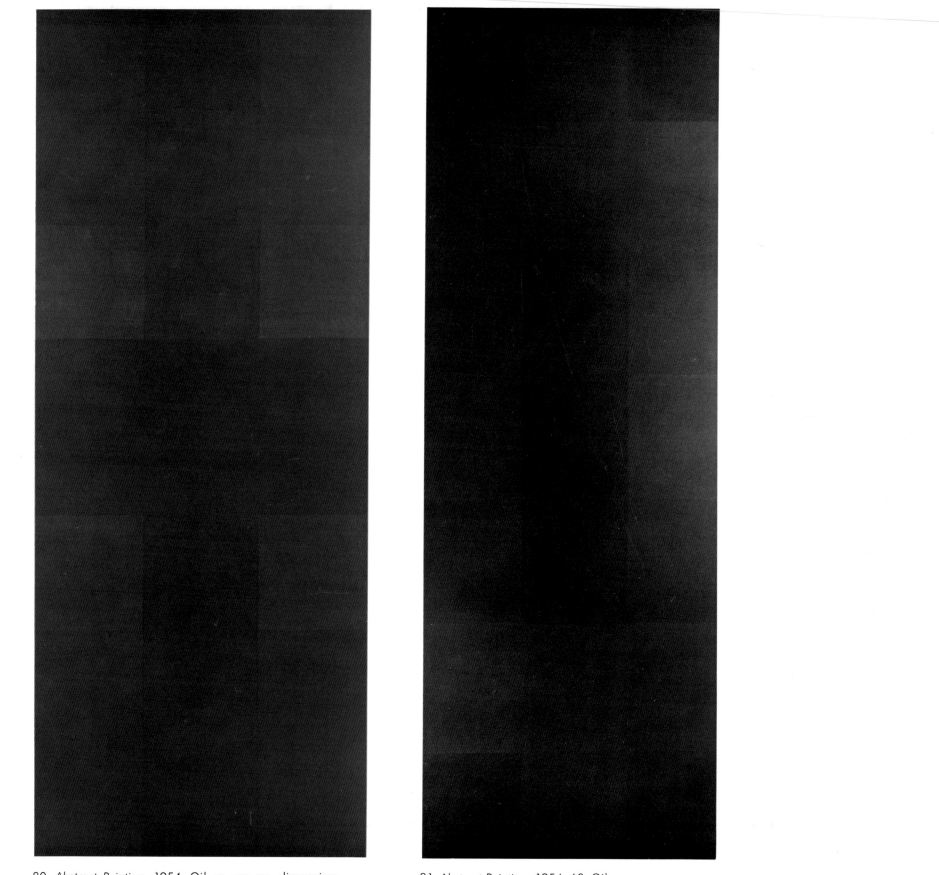

80. *Abstract Painting*. 1954. Oil on canvas, dimensions
unknown. Private Collection

81. *Abstract Painting*. 1954–60. Oil on canvas,
108 x 40". Private Collection

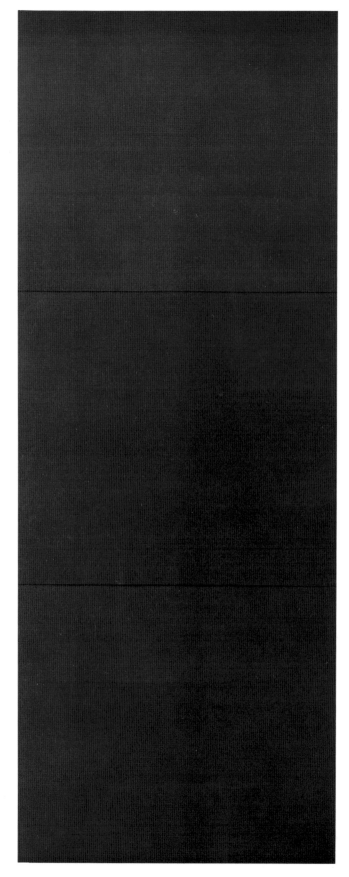

82. *Timeless Triptych, Black.* 1960. Oil on canvas,
45 x 17". Marlborough Gallery, New York

83. *Abstract Painting, Black.* 1955. Oil on canvas. Dimensions and present location unknown

84. *Black Quadruptych*. 1955. Oil on canvas, 60 x 53". Private Collection

Colorplate 25. *Abstract Painting (Number 17)*. 1953. Oil and tempera on canvas, 77¾ x 77¾". Whitney Museum of American Art, New York

85. *Abstract Painting, No. 12.* 1955–56. Oil on canvas, 108 x 40". San Francisco Museum of Modern Art

making his first monochromes, and in asymmetrical monochrome after making his first symmetrical monochrome. Even after most of the paintings were restricted to dark, near-black tones and a cross device, occasional variations occurred. The single most rejective decision was that made in 1960: to paint only black, trisected five-foot squares. But each painting was still different, and they were at times connected to make a diptych, triptych, or larger square. The privileges of consistency extended to inconsistency.

Reinhardt's canvases are usually dated on the back according to the year they were first shown rather than to the year they were painted. As his habit was not to show the most radical new work until it had evolved to his satisfaction and could be shown in the context of other similar work, the exhibitions give only fallible clues to the dating of specific works. Often by the time he did get around to showing something he no longer remembered what the date was; photographs turn up labeled in Reinhardt's own handwriting with three or four different dates on them. In addition, he had a penchant for showing much older paintings that fit in with the recent work. The Parsons Gallery's files are rather haphazard, as were the artist's; the result is that very few works can be precisely dated, and even their whereabouts is often in doubt.[126]

But the greatest barrier to chronological accuracy is the fragility of the later paintings, which resulted in damage virtually every time they were exhibited. Back in the studio they were repainted according to the original scheme with the same colors and tones, which were saved and labeled for such emergencies. However, if a canvas had not been sold, and if Reinhardt was not fully satisfied with it, he often made quite radical changes. Some of the red and blue canvases were repainted in acrylic instead of oil in the sixties; this produced an unavoidable difference in paint quality and at times in color. (The largest red and pink canvas shown in the Jewish Museum's 1966 retrospective, for instance, lacks the richness of many of its contemporaries in oil; its size—it had to be rolled—had dictated a repainting in plastic paint.) And at times he simply used the canvas again for a new painting after the old one had been photographed.

Aside from the technical and documentary problems, a basic question arises: is there such a thing as a black painting, strictly speaking, in Reinhardt's oeuvre? And if so, is there a monotonal or uninflected black painting? Reinhardt began calling his (red, green, blue, purplish, ochre, brown) dark paintings "black" as soon as he realized that the *painting out* of obvious color and contrast (form) was his prime concern. In 1960 he stated that he had been making black paintings for a dozen years; it is only in this very broad sense that such a statement can be supported.

The historical misunderstanding of Reinhardt's art arises from the almost automatic reaction against the values of the thirties, when American art was still dependent on Europe, by critics who came of age with the Abstract Expressionist artists and shared their more justified condemnation of alternatives to their own strongest drives. (In the late sixties, a similar automatic and superfi-

Colorplate 26. *Abstract Painting, Blue*. 1953. Oil on canvas, 60 x 40". Private Collection

cial reaction against things that looked "Expressionist" and "fiftiesish" occurred in writings by critics then in their thirties.) This speaks primarily of the limitations of any single-minded criticism at any given time, the fact that the defection of one artist can blind even the most perceptive observer to the alternatives that artist may offer to the mainstream, or to future developments of the mainstream. Reinhardt is done a disservice by continuous comparison with Rothko and Newman, not because they did not share some common goals in about 1950, but because he was involved with a very different aesthetic; after his work matured there was no longer any reason to compartment him with these colleagues, yet there was no one else to attach him to at the time. And Reinhardt continued to consider himself an active member of the New York School despite his disillusion and disagreements with its other members.

Permit us to go on record: we believe that Reinhardt's "black" paintings are among the memorable works of art produced in this country during the 1960's. —Alfred H. Barr, Jr., James Thrall Soby, 1963[127]

[Ad] can't play the game anymore, but nobody can get around the paintings anymore either. If you don't know what they're about you don't know what painting is about. —Frank Stella, 1967[128]

The subversive aspect of Reinhardt's art was all too successful. In 1960, he wrote in a characteristically forthright manner to the Whitney Museum, observing that it was time for him to have a retrospective. When they demurred, he organized it himself at Betty Parsons' regular gallery and her "Section 11" annex nearby on 57th Street. It was all but ignored, despite an increasingly powerful reaction against the dregs of expressionism.[129] The second such show, in three New York galleries in 1965, was given much more attention, following, as it did, the Museum of Modern Art's "Responsive Eye" exhibition of Op art, or "perceptual abstraction." Its success was also due to the fact that each gallery included only one-color monochromes—blue at Stable, red at Graham, and black at Parsons, and that these beautiful shows were, indeed, eye-openers.

More people now began to realize that if anything had achieved "a new kind of flatness, one that breathes and pulsates," and if anything were the product of "darkened, value-muffling warmth of color,"[130] it was these serenely glowing canvases. They seemed to synopsize the aims of an increasingly important group of younger artists who came to be known as "Minimalists," "Primary Structurists," or "Rejectivists," and attracted surprised attention from those who had always "known" Reinhardt's work but had never looked at it in its own context. Until this time, most of the younger "rejective" artists had been more influenced by Newman than by Reinhardt, though Frank Stella and Robert Morris were attracted to the work of both older artists. Newman's show at French and Co., his first in eight years, and Rothko's retrospective at the Museum of

86. *Abstract Painting, Black.* 1956. Oil on canvas, 43 x 43". Collection Mr. and Mrs. Bernard Levy, Kensington, Conn.

Colorplate 27. *Black Triptych*. 1955. Oil on canvas, 50 x 20".
Collection Mr. and Mrs. John R. Jakobson, New York

Colorplate 28. *Abstract Painting, Black*. 1956. Oil on canvas,
80 x 32". Collection Richard Brown Baker, New York

87. *Abstract Painting.* 1956. Oil on canvas. Dimensions and present location unknown

88. *Abstract Painting.* 1958. Oil on canvas, 60 x 40″. Present location unknown

Modern Art in 1961, had turned younger artists' attention to the non-expressionist branch of the original New York School. Under Clement Greenberg's aegis, Rothko, Still, and Newman succeeded Pollock, De Kooning, and Kline as the heroic triumvirate; had it not been for the intense and mutual antipathy between Reinhardt and Newman on one hand, and especially between Reinhardt and Greenberg (who epitomized the "corrupt" results of dealer-critic-artist relationships) on the other, Reinhardt's art and ideas would probably have had a good deal more currency, and their pertinence to the germinating Minimal trend would have been clearer earlier. However, bucking the power structure provided its own obstacles, and, as it turned out, recognition of Reinhardt's full stature was left to artists of a still younger generation who had carefully considered his ideas, especially Joseph Kosuth, Robert Smithson, and Carl Andre. "'Fortunately or unfortunately,' writes a sixth-century Chinese artist," as quoted by Reinhardt,"'things grow worse and then mend; men pass through periods of rise and fall.'"[131]

The black paintings have even been seen as strictly nihilist proposals. If the red and blue works had turned black overnight, such an abrupt elimination of color and image would have constituted a Duchampian gesture, an abandonment of Reinhardt's previous goals. But the black crept up from twilight to dusk to darkness over a twelve-year period. There was no sudden outcry of rage from reviewers, no immediate reaction from a younger generation, and no acclaim of a "breakthrough" from the critics. Just as the sensory awareness of a person going blind heightens each day, so the black paintings had been acting quietly on the art world's perceptions for years. It is also significant that toward 1959 Reinhardt's writings tightened up into the art-as-art dogmas, complementing the paintings' restriction to black five-foot squares. This doubly unequivocal demand certainly brought home to the Minimal generation the radical implications of his work. By the early sixties it had become apparent that the main reaction against painterly and expressionist modes was to take the form not only of hard edges and flat, thin, or stained color as an autonomous element, but also of more radically framed proposals for a pure and even ultimate art that would in turn lead to broader development of an anti-object art.

The term "Purism" had been somewhat discredited in America by association with earlier European movements which tended to end in sterility. (In 1957 Elaine de Kooning wrote an amusing satire on Reinhardt called "Pure Paints a Picture."[132]) Nevertheless, the advent of so-called Minimal art as a major trend in 1964–65 announced another cycle of the sensibility that had last been paramount in the twenties and thirties, particularly in Suprematism and Constructivism. The works and writings of Malevich, Tatlin, and Rodchenko became better known in America in the late fifties, thanks largely to the publication of Camilla Gray's book, The Great Experiment.[133] Far less influential, because they were better known and their formal solutions had often been exhausted, were the de Stijl and Bauhaus groups to which less-informed critics attempted to

89. Abstract Painting, No. 87. 1957. Oil on canvas, 108 x 40". The Museum of Modern Art, New York

90. *Abstract Painting, No. 5.* 1958. Oil on canvas, 79 x 60". Collection Betty Parsons, New York

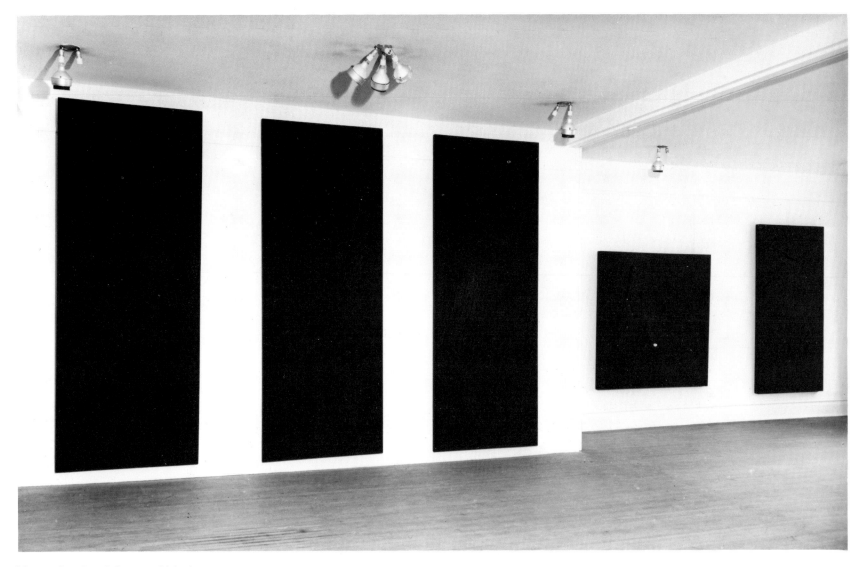

91. Reinhardt exhibition of black paintings at
Betty Parsons Gallery, New York, 1960

attach the new trends. Reinhardt's refusal of fabrication outside the studio, his dislike of taped edges and industrial surfaces, his antipathy to the Minimalists' "materialism," and his insistence on the highest moral and aesthetic standards for art and artist separated him from the younger generation's more pragmatic approach, which is, perhaps, more "American."[134]

If the art-as-life strain is inherent in American tradition, so is the art-as-art strain of which Reinhardt is probably the ultimate proponent. While Reinhardt was convinced that "esthetic values are inherent in all the activities of life,"[135] he would not accept its corollary. Malevich's position had been similar: "The mask of life hides the true countenance of art.... The Suprematists have deliberately given up objective representation of their surroundings in order to reach

the summit of the true 'unmasked' art and from this vantage point to view life through the prism of pure artistic feeling."[136] Reinhardt's version: "Art is always dead, and a 'living' art is a deception. 'The Love of Life is the Kiss of Death' in art."[137]

Reinhardt's general judgments on works of art seemed harsh and arrogantly narrow, tailored as they were to his, and only his, paintings. That was, of course, the point. Only an artist, and an artist who had risked and achieved as much as he, is permitted to make such judgments. Reinhardt was more honest than most about the fact that an artist sees all art and all life in terms of his own work. Even the worst painter, who has devoted his or her whole life to painting, is convinced that s/he is good, and that everyone who doesn't think so is wrong. Such an ego is the artist's only protection against a hostile society that does not consider art "work"; no artist survives without it. The black paintings are extreme products of such an ego, or such a *will*. In this they *are* typically American, for if there was one common characteristic of advanced American art from the forties through the sixties, it was a fondness for extremes, a cult of difficulty, a distaste for ease of communication. Such a position is rashly, youthfully egotistic, often ultra-romantic, but also fundamentally puritanical. It is part of the longing for total honesty and directness that characterizes American literature as well as art, and permits American critics to see virtue in crudity and awkwardness. In this sense all the best recent American art is purist; it seeks a purifying quality that may be as well expressed in expressionist, conceptual, or functional styles as in a six-foot black cube or a five-foot-square black painting. The English writer David Thompson has remarked:

> Radical extremism in art tends to be thought naive in Europe. In America it tends to be thought necessary; hence that extraordinary ability of American painting in the last twenty years to drive through again and again to what appear to be ultimate conclusions. 'It's too obvious' or 'It can only be a cul-de-sac,' the anti-Americans have said in turn of Pollock, Rothko, Newman, Johns, Louis, Noland, recoiling from the idea of being so uncompromising.
>
> Extremism is both a romantic indulgence and the strictest of disciplines. Perhaps that is why, being a paradox, it is not a bore, but a challenge, and why American painting can derive so much strength from it. Reinhardt is the embodiment of such a challenge, a sort of logical counterpart of Duchamp.[138]

A common factor running through all . . . motivations towards abstract art is protest. Protest against the established order of traditional perspective, naturalistic space and color, conventional subject matter. All modern, advanced-guard art movements have been protests, of course, but abstract art is the most protestant of all.—Andrew Ritchie, 1951[139]

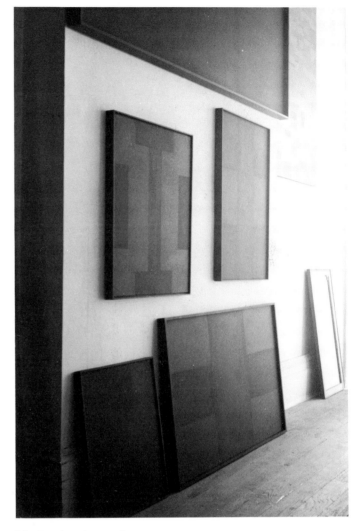

92. Reinhardt's studio, 1958–59

93. *Black Diptych*. 1958. Oil on canvas, 36 x 20".
Present location unknown

Art is too serious to be taken seriously.
Action painting speaks louder than voids.
The New York School is a nice place to visit but I wouldn't want to live there. A
cleaner New York School is up to you.—Ad Reinhardt[140]

The first definition of "protestant" in my dictionary is not a negative one. To be a protestant is "to state positively; affirm solemnly; assert"; only secondly does it mean "to make an objection to; speak strongly against."[141] Reinhardt's "protestant" moralizing, which continued until his death, had two targets: first, art—the maintenance of the highest aesthetic goals of past civilizations; and second, more polemically, the artist's position in society and image in the modern world. In the forties the major problem had seemed to be public recognition of the importance of high, pure, or abstract art. When this was accomplished, a brave new Mondrianesque world of aesthetically educated masses was supposed to emerge. Reinhardt's collaged *PM* cartoons in the forties were genuinely devoted to making people understand, as the black paintings were devoted to making people look, and see. During the fifties (and reaching in the sixties a peak which Reinhardt lived to see but not, entirely, to cope with), it became clear that both the abstract artist and abstract art could be exploited as commodities, easily digested entertainments co-opted by the mass media. Reinhardt's criticism became proportionally more bitter. For a decade he prose-lytized ceaselessly for the acceptance by artists of an ethic governing their comportment and lifestyle, an ethic that would satisfy the high standards set by the art itself. His self-appointed role as Official Thorn in the Art World's Flesh evolved from his devil's advocate role in the forties, in direct proportion to his formal divorce from Abstract Expressionism. Similarly, the less he seemed able to affect the world through his art, which during the fifties was entirely at odds with all that was fashionable and popular, the more he seemed determined to affect it by his ethics. Known and often heartily disliked as "the Conscience of the Art World," or, as he liked to call himself, "The Great Demurrer in This Time of Great Enthusiasms," Reinhardt insisted that an artist should not have to earn his living from his work, that art must stay free from the corruption of the world at large, the business world. To avoid being a "sellout" in the moral or commer-cial sense, he taught fulltime all his life, primarily at Pratt, Brooklyn College, and Hunter College. Ridicule, occasional ostracism, even a lawsuit instigated by Barnett Newman[142] did not deter him. "What's a good artist good at?"[143] he demanded. "Painters paint easel paintings to exhibit, not to sell, don't they?"[144]

By 1960 Reinhardt's attitude about the art world had become increasingly pessimistic. His "one-man campaign against the disreputable art-ideas of the time and unconscionable activities of artists as artists" was redirected into the totally aesthetic channels of the "Art-as-Art Dogma"[145] because "Art suddenly became an avant-garde business and huge entertainment, and the affairs of advanced artists moved out of their own hands into those of art-managers, the

94. *Black Diptych.* 1958. Oil on canvas, 60 x 30". Private Collection

mass-mediums and mass-museums."[146] In the fall of 1961, his self-organized retrospective at the two Parsons gallery spaces having failed to make its point, he decided not to show in New York for a while, "maybe as a one-man moral strike against New York and 'The New York School,'" and wrote that he intended "to make an assault on all those who accept the primitive-marketplace-relationships of the present to collectors, curators, dealers, etc."[147] His next New York show was the three-gallery exhibition in 1965, another attempt to form an alternate structure by passing up the museum system and breaking the single-gallery hold (today this "sharing" of an artist by several dealers is more widely practiced and seems, ironically, the epitome of big-time commercialism).

By then Reinhardt had come to hate the gallery system, though he never arrived at a valid alternative. The best he could do was not to play galleries off against each other like a "businessman" or for personal social reasons. His first dealer, Betty Parsons, was his last, though after 1965 he had more lucrative offers from several other prestigious galleries. He decided instead to donate his work to the world's greatest museums, most of which were "unable" to accept, though the Tate Gallery did acquire a black painting. "It is not right for artists to think that painting is like prostitution, that 'first you do it for love, then you do it for others, and finally you do it for money'."[148] "Does one not have to remove oneself from the business world in order to create 'fine' art or to exist as a 'fine artist'?" he asked. "Why does everybody think priests, artists, teachers should be better than businessmen? Because they aren't businessmen.... Art is not the spiritual side of business.... The artist as businessman is uglier than the businessman as artist.... Artists are responsible for ugliness."[149]

In 1965, when the art world was finally ready for Reinhardt's blue, red, and black geometric paintings and the work was becoming increasingly desirable, the frustration of applying his high standards to himself became a still more depressing, thankless, and baffling task. There are those, of course, who condemn him as a hypocrite because at the end of his life he reached a "compromise" with himself that allowed him to "compromise" with the system to the extent of accepting a retrospective at the Jewish Museum. Yet even he was amazed at the amount of hatred and antagonism he encountered at the time of this retrospective. Some of the courage needed to face it was derived from the long years of neglect and isolation through the fifties. Yet the foundation of his ethical code had been established by the mid-forties, when he had no reason to be any more dissatisfied with the system than anyone else. By 1960, having watched most of his friends and enemies allow their art to be used at various levels of commercialism and popularization,[150] he became aware that his own opportunity was passing rapidly and that it would have to be forced into existence.

The decision to have the Jewish Museum retrospective can be seen as part of a deliberate program to become a more effective irritant to the art world. Reinhardt realized that you can't reject something you haven't had, and that for

Colorplate 29. *Abstract Painting, Black*. 1956. Oil on canvas, 80 x 43". Yale University Art Gallery, New Haven, Conn.

95. Reinhardt and his daughter Anna, 1958

his rejection of "howling success" to really mean anything, he had to have that success first. Until then, refusals to be in exhibitions or to participate in self-publicity had gone unnoticed or had been marked off to sour grapes. Reinhardt chose now to gain a position he could *use* in order to destroy what he despised in the treatment of art. When Thomas Hess awarded him in *Art News* the "Run-with-the-Hare, Hunt-with-the-Hounds speed record (plus 30 Pieces of Silver) ...for agreeing after all those protestations to have a show in the Jewish Museum," Reinhardt replied: "Yes, T.B.H., this year I decide to sell out. My paintings are now available at the very highest prices. All museums are invited to show large exhibitions of my work. After a number of years I'm showing in Whitney Museum Annuals again, the Guggenheim showed one painting of mine once long ago, and the Jewish Museum never showed me even once before. All art historians, curators and critics are encouraged to accord me the fullest appreciation and widest recognition from this day on. Thank you, one and all, for all your kindnesses. P.S.: You forgot to give your T.B.H. a prize for the best line of art criticism of the year in his article on de Kooning's paintings in which he writes that the women in them seem 'calmer, prettier, blonder and more friendly this year.' "[151] Until his wife dissuaded him, he was going to have

his assistant paint a black canvas for the Jewish Museum show.[152] At the time of the show and all the concomitant publicity, such as a large color story in *Life*, he couldn't wait for the articles to appear so that he could embark on the destructive part of his "program."

However one interprets the events of Reinhardt's last two years, there seems little doubt that he was fully convinced of the importance of the paintings themselves. He didn't have to be reassured of their value as art, but he was appalled at the idea that they might not have the opportunity to count historically. The tender surface of the paintings might be read as a reflection of his own vulnerability. He didn't want to be a loser because it would have compromised the painting. This dilemma undoubtedly sharpened his diatribes. Some of his actions during the confused years between 1960 and 1965 can be attributed to the fact that no one cared. His ambivalence about the rewards the system could confer on art or artist was clear all along. At the end of his life he found that still very few people cared, that still he did not receive the attention he knew the work deserved. Write-ups of the Jewish Museum show in the mass and chic media did not alter the fact that the show itself was not finally taken by any other museum here or abroad (though the Tate and Amsterdam's Stedelijk were initially interested); nor that the director of the show had previously been opposed to most of what Reinhardt's art stood for (though his conversion might also be construed as a triumph).

Within the art world, Reinhardt represented the rare example of an abstract artist concerned with the external circumstances affecting his art, as well as with its internal relations. Despite its complexity, the position he took again and again was a strong one, and consistent enough to command respect. Reinhardt made his bed of self-imposed paradox and had the guts to lie in it, thereby exposing the core of the artist's dilemma in this society. When the Art Workers Coalition, an activist artists' group, was founded in 1969 as a "group conscience" to the art world, the shade and the spirit of Reinhardt's individual conscience were very much present. His strength as a holdout, his writings, and, peripherally, his modest but ceaseless political activity were, and are, greatly admired—as well as feared and despised by those who had reason to dislike the "watchdog" watching them.[153]

For Reinhardt, political activity would always be associated with the thirties, with the doctrines and ideals he had established for himself then. He continued to declare that "painting cannot be the only activity of a mature artist,"[154] and continued to contribute to endless benefit art auctions, to sign petitions, to march and demonstrate for civil rights, civil liberties, and political candidates supporting these issues. But Reinhardt's various activities—his writings on aesthetics and on the art world, and his political consciousness—should not be confused. They share only the stringently moral, puritanical aura that pervades the black paintings as well. Reinhardt was a highly formalized person. His intellect and his lifestyle were self-consciously compartmented and

Colorplate 30. *Abstract Painting, Black (A)*. 1954–59. Oil on canvas, 108 x 40". Collection Virginia Dwan, New York

clarified on all levels, and it is possible that, as Dale McConathy has observed, his public image, the way he chose to present himself, was far more important than what he suppressed.[155] He was in fact the "impersonal person" he wanted to be, though this should by no means indicate a lack of warmth or accessibility. Despite his acerbic insistence on "being right," and his unorthodox, often difficult teaching methods,[156] Reinhardt was open and available to a loyal following of younger artists, students, and admirers. Seated on his painting bench, dressed in old slacks cut raggedly off at the knees over dark socks and the ubiquitous black T-shirt, silhouetted against the round-cornered windows overlooking Broadway and Waverly Place, he spent hours discussing, persuading, lecturing, telling "the same old stories" over and over again.

This obviously involved man spoke as early as 1948 at the Club "against involvement and for detachment." He would have agreed with Alfonso Caso that only interested acts are immoral and that the morality of art is guaranteed by its disinterestedness. Writing, for example, was exempt from these strictures only because it was unimportant: "Words are not icons but images. I usually have to pun or do anything to make you see the word is not as apparent as it seems. I play with words all the time. I don't have any respect for words and that's why people call me a very clear writer.... I've never *explained* anything."[157] Reinhardt made rules for everything that affected his art. Among his best-known writings are "Twelve Rules for a New Academy" and "Thirteen Rules Toward a Code of Ethics for Fine Artists." He was constantly posing choices. A favorite lecture device was to compare William Blake unfavorably with Joshua Reynolds and the eighteenth-century Royal Academy: "As an artist you have to choose Reynolds; Blake was something else"[158]; that is, Blake was "humanizing" art in a manner Reinhardt found antipathetic to the identity of art. "Any meaning demeans the esthetic or the art meaning.... I could embrace more meaning than anybody if I wanted to, but what would that mean? I could embrace the seven great religions—you can't have more meaning than *that.*"[159] The separation, definition, compartmentation of all that affects how art is seen occupied Reinhardt wholly apart from the process of making art. He considered art a social responsibility and saw himself as an imperative force toward the formation of a type or class of American artist opposed to the current image. A certified liberal in regard to "life," i.e. all that is accidental and uncontrolled (including personal relationships), he was a dogmatist or a "conserver" in regard to art because art was, finally, what counted.

96. Reinhardt in his Washington Place studio, 1967

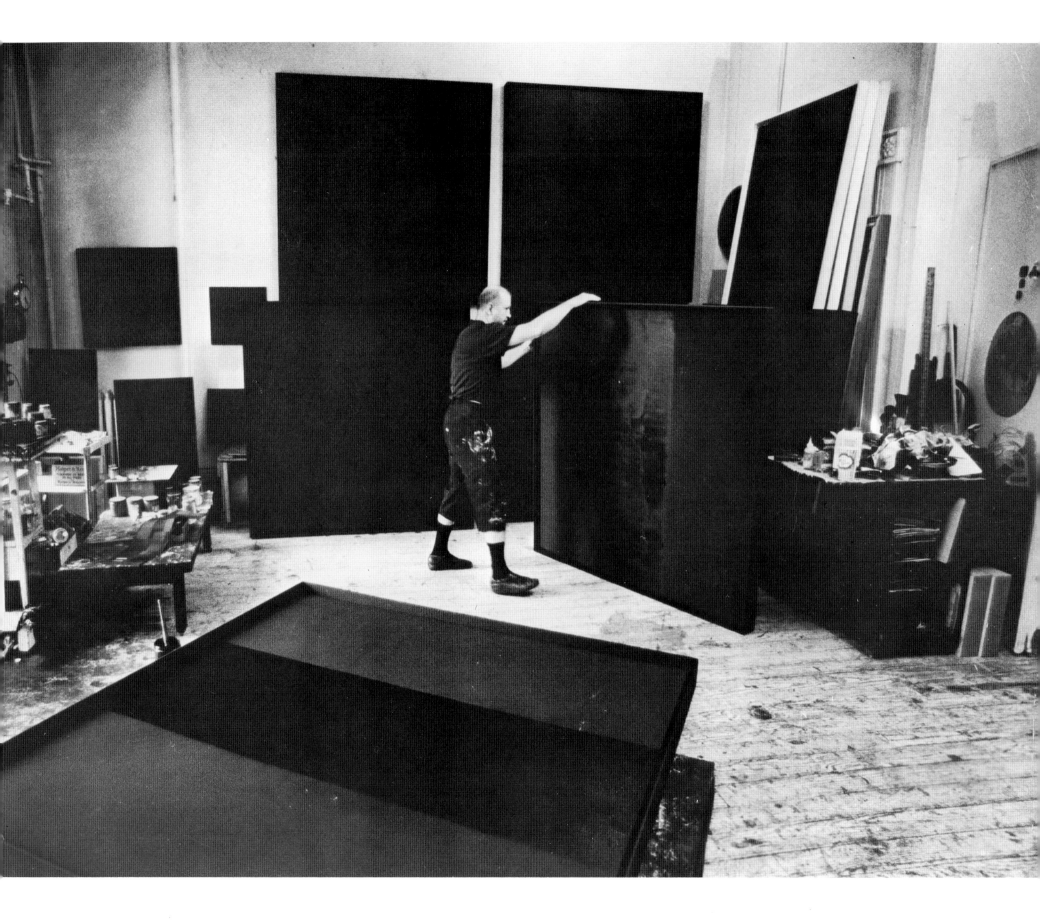

NOTES

1. Newtown High School Yearbook, Elmhurst, Queens, 1931.

2. "The artists older than me didn't go to school; the 'Club' was a bunch of illiterates.... I was a real all-American collegiate boy in high school and college, but I became a sniper pretty fast; then I couldn't get along with anybody." (Ad Reinhardt, in conversation with the author, 1966.)

3. Reinhardt saw Merton for the first time since 1940 when he visited the Abbey of Our Lady of Gethsemane in Kentucky around 1960; he claimed to have tried to talk his old friend out of becoming a Trappist monk, but later sent him a small black painting to hang in his cell. Their correspondence, however, was lengthy and specific, often dealing with art and a friendly rivalry between "the sacred and the profane." (See "Five Unpublished Letters from Ad Reinhardt to Thomas Merton and Two in Return," Artforum, Dec., 1978.)

4. Ad Reinhardt, lecture at the Skowhegan School of Painting and Sculpture, Skowhegan, Maine, July 21, 1967.

5. Henri Focillon, The Life of Forms in Art, first English edition, Yale University Press, New Haven, 1942; translated by Charles Beecher Hogan and by George Kubler, who had been a student of Focillon and whose ideas Reinhardt later espoused enthusiastically. Focillon's definition of Classicism was very much what Reinhardt's came to be: "It confers, so to speak, a solidity on the unstable aspects of experimentation (because of which it is also, in a way, a renunciation).... But Classicism is not the result of a conformist attitude. On the contrary, it has been created out of one final, ultimate experiment, the audacity and vitality of which it has never lost...." (p. 13.) It is also interesting (and little known) that Focillon was a committed Socialist.

6. Clive Bell, "Aesthetics and Post-Impressionism," in his Art, Capricorn Books, New York, 1958, p. 38. Almost all of Reinhardt's basic ideas are found in Bell's essay "The Aesthetic Hypothesis" in the same book (pp. 15–34), which was first published in 1913.

7. Meyer Schapiro, "Nature of Abstract Art," Marxist Quarterly, vol. 1, no. 1, Jan.-Mar., 1937, pp. 77–98.

8. André Malraux, The Voices of Silence, Secker and Warburg, London, 1956; first English edition, 1953.

9. Ad Reinhardt, "The 'International Style' of Architecture," a paper written for Professor E. H. Swift, Columbia University, 1935. As early as 1933 he had written in another paper of "a universal beauty which leads us from our world of sense and phenomena to something beyond, essences, impervious to time, space and change. Art is a whole, and a unit." ("The First Aesthetician," on Plato.)

10. Anonymous, introduction to the annual exhibition catalogue of The American Abstract Artists, 1940.

11. G. L. K. Morris, Prefatory Note to American Abstract Artists, Ram Press, New York, 1946.

12. George McNeil, "American Abstractionists Venerable at Twenty," Art News, vol. 55, no. 3, May, 1956, pp. 34–35, 64–66.

13. Irving Sandler, The Triumph of American Painting, Praeger, New York, 1970, p. 13.

14. Ad Reinhardt, leaflet for picketing of the Museum of Modern Art by the American Abstract Artists, Apr. 15, 1940.

15. The only work I have seen from this period is a skillful gray-green Analytical Cubist portrait of concrete poet Robert Lax, the whereabouts of which is now unknown. As an undergraduate, Reinhardt took occasional studio classes at Columbia Teachers College since they were not offered at the University, but he concentrated on the liberal arts program.

16. Reinhardt told me he was fired as the result of a labor dispute, but Thomas Hess also attributes it to the ironic content of the cartoons, which PM readers were taking straight, missing the satirical intent. In his fascinating text about this period, Hess describes PM as an "anti-fascist, anti-communist New York tabloid...founded by multi-millionaire Marshall Field to add a fresh voice to the national press that was almost wholly conservative, isolationist, anti-labor, anti-civil rights, anti-Russia, pro-capital punishment, in the days when America First flourished along with Eleanor Roosevelt jokes." (Thomas B. Hess, The Art Comics and Satires of Ad Reinhardt, Kunsthalle Düsseldorf and Marlborough Rome, 1975, p. 25.)

17. Ad Reinhardt, in conversation with the author, Aug. 15, 1966.

18. Jerome Klein, unsourced newspaper review of the 1938 AAA show, in the files of the Museum of Modern Art Library.

19. Léger was in America, mainly in and around New York, from 1940 to 1946, and had made extended visits in the thirties. Mondrian was in New York from September, 1940, until his death in 1944. Albers came in 1933 but went directly to Black Mountain College in North Carolina and was in New York infrequently until 1949, when he went to Yale. Moholy moved to Chicago in 1937 and joined the AAA in 1941, maintaining close relations with New York; Ozenfant came to New York in 1938, seven years after the first American publication of his seminal Foundations of Modern Art.

20. Holtzman already knew Mondrian well and his advanced knowledge and practice of abstract painting was important to Reinhardt at that time. Reinhardt and McNeil did demonstrations of their work for the audiences at Holtzman's lectures during the AAA exhibition at the World's Fair, New York, summer of 1940. Holtzman remembers Reinhardt doing a "broken-up collage" at one of these lectures.

21. Rosalind Bengelsdorf Browne has been quoted as saying that in the WPA/FAP "there was no serious prejudice against abstraction, even though its lack of 'social content' left it open to criticism," but Francis O'Connor adds to this: "Toward the end of the Project, this tolerance of abstract art—at least abstract styles diverging from the geometric abstraction of the American Abstract Artists—broke down. There is some evidence that a 'brushy' or 'blotchy' form of abstraction was frowned on and at one point Jackson Pollock left the Project...because his freely imagistic 'psychic automatist' style of abstraction was not acceptable." (Francis V. O'Connor, Federal Support for the Visual Arts: The New Deal and Now, New York Graphic Society, Greenwich, Conn., 1969, p. 101.) See also, for a slightly different account, Irving Sandler, op. cit., chap. I.

22. Ad Reinhardt, in an interview with Harlan Phillips, Archives of American Art, undated. "Hofmann's aesthetic dogmas appealed to the ideology-prone artists of the decade who had grown disenchanted with politics." (Sandler, op. cit., p. 21.)

23. Ad Reinhardt, in conversation with Irving Sandler.

24. Tony Smith, a night student at the Art Students League in the early thirties, was also making constructions and reliefs in the manner of Georges Vantongerloo.

25. Piet Mondrian (1926 essay on the principles of Neoplasticism), in Michael Seuphor, Mondrian, Harry N. Abrams, New York, 1956, p. 166.

26. Piet Mondrian, "Plastic Art and Pure Painting," in Plastic Art and Pure Plastic Art, Wittenborn-Schultz, New York, 1947, p. 19.

27. Harold Rosenberg, in conversation with the author, Dec., 1968.

28. Clement Greenberg, "The Late Thirties in New York," in Art and Culture, Beacon Press, Boston, 1961, p. 230.

29. The Artists' Union began as the Unemployed Artists Group in 1933, militating for the same "economic stability for artists" that became the Union's main platform. (See Stuart Davis, "The Artist Today: The Standpoint of the Artists' Union," *American Magazine of Art*, vol. 28, no. 8, Aug., 1935, pp. 476–78, 506; and *Art Front*, 1934–36.) The "Call for an American Artists Congress" was published in *Art Front* in the Nov., 1935, issue, but the 400 artists who signed it were not necessarily members of the Union. The keynote address at the first Congress was given by architectural critic Lewis Mumford. The Mural Artists Guild, founded in 1938, was typical in its makeup of the motley, trans-aesthetic artists' organizations of the period; it counted among its membership camps as different as those of abstractionists Diller, Michael Loew, and Gorky, and realists Rockwell Kent, William Gropper, and George Biddle.

30. Ad Reinhardt, Phillips interview, *op. cit.* This statement would certainly be challenged by many of his contemporaries.

31. Ad Reinhardt, paper for Professor Swift, *op. cit.*

32. Ad Reinhardt, unpublished draft for a talk to "an artists' group," c. 1941, Archives of American Art.

33. Ad Reinhardt, unpublished draft for a second talk to "an artists' group," c. 1941, Archives of American Art.

34. Ad Reinhardt, Phillips interview, *op. cit.*

35. Ad Reinhardt, in conversation with Irving Sandler, c. 1957–58.

36. Harold Rosenberg and Robert Motherwell, "Statement," *Possibilities*, no. 1, Winter, 1947–48, p. 1. This had been the establishment position in 1934, when an *Art News* editorial on "Art and Politics" stated that "the sincere artist will derive little benefit from identifying himself with the turmoil of political parties" (Oct. 13, 1934).

37. Ad Reinhardt, "How to Look at More than Meets the Eye," *PM*, Sept. 22, 1946.

38. Ad Reinhardt, in "Reinhardt," *Arts and Architecture*, Jan., 1947, p. 20.

39. Stuart Davis, quoted without source in Barbara Rose, *American Art Since 1900*, Praeger, New York, 1967, p. 151.

40. Meyer Schapiro, *op. cit.*

41. John Graham, *System and Dialectics of Art*, Delphic Studios, New York, 1937, pp. 23, 33.

42. El Lissitsky, quoted by Charmion von Wiegand in *The Journal of Aesthetics and Art Criticism*, vol. 2, no. 8, Fall, 1943, pp. 62–70.

43. Stuart Davis, "Abstract Art in the American Scene," *Parnassus*, Mar., 1941, p. 103.

44. *Ibid.*, p. 101.

45. Stuart Davis, "What About Modern Art and Democracy?" *Harper's Magazine*, Dec., 1943, p. 34.

46. "Chronology by Ad Reinhardt," in *Ad Reinhardt Paintings*, The Jewish Museum, New York, 1966–67, p. 30.

47. Ad Reinhardt, "Stuart Davis," *New Masses*, Nov. 27, 1945, p. 15.

48. Carl Holty, in conversation with Irving Sandler.

49. New York City Art Project 1940. It may have been painted in 1938 or 1939.

50. Ad Reinhardt, in *Arts and Architecture*, 1947, *op. cit.*, p. 20.

51. Apr. 16–May 15, 1943: Peggy Guggenheim held a collage show at Art of This Century, to which Reinhardt presumably contributed a recent, fragmented surface example, noted by Jean Conolly in *The Nation*, May 1, 1943. The exhibition as a whole stimulated the later development of a particular New York style in collage.

52. Ad Reinhardt, *ACA Magazine*, Feb., 1944, p. 6; statement on his Artists Gallery show.

53. This technique was also reflected in Reinhardt's notebooks, in his European journals of 1952 and 1953 (fig. 42), and in his teaching methods, in which he stressed apparently unrelated visual materials over facts and forced the viewers to do most of the work with their own eyes. He enjoyed Frederick Kiesler's company because he too "mixed things up." The process stimulated heightened awareness of formal perception, following Focillon, which culminated much later in Reinhardt's famous slide shows, wherein a huge number of slides (2,000 at one sitting), taken by the artist himself and bearing little outward relationship to each other, were shown very rapidly on the basis of (often humorous) visual sequence alone—one hundred "facade faces," one hundred buttocks or breasts, and so on.

54. *ACA Magazine*, *op. cit.*

55. The Hélionesque collage (pl. 3) was reproduced on the notice, which means either that it was made later than it has been dated (1939) or, more probably, that the show covered several years' work. This collage was apparently a favorite of the artist's and it reproduced well; Reinhardt himself dated a photograph of it "1943" despite the 1939 date on the work itself, but he often dated work according to when it was shown rather than made. The 1944 show included only collages and gouaches, indicating that the artist did not consider his most recent, and most tentative, experiments of that year ready for public display. *No. 1*, a gouache, was described by the *Art News* reviewer as "a warm-hued, well composed, relatively tri-dimensional affair.... While *No. 2*, with its suggestion of mechanized motion, and *No. 3* are the most successful of the collages" (Feb. 15, 1944, p. 23). Maude Riley, in *Art Digest*, noted "dancey effects" made by "pulling the background color over the multi-colored shapes, breaking up again the accident qualities of the original traceries" (Feb. 15, 1944, p. 20).

56. See, for instance, Tomlin's *Number 20—1949*, the Museum of Modern Art, reproduced in the catalogue of his 1957 retrospective there, p. 35; or Gottlieb's *Blue at Noon*, 1955, Walker Art Center, Minneapolis, reproduced in the artist's Whitney/Guggenheim catalogue, 1968, p. 63. The extent of direct influence on either of these painters is impossible to gauge, and the connection between Tomlin and Gottlieb alone has not yet been clarified. But these early oils do establish that Reinhardt's monochromatic, broken-beam calligraphies of 1948–50 derive from his own past rather than from anyone else's present.

57. Reproduced in Thomas Hess, *Willem de Kooning*, George Braziller, New York, 1959, figs. 50–52, 54.

58. Ad Reinhardt, "How to Look at a Gallery," *PM*, Dec. 1, 1946. This was two years before De Kooning's first one-man show.

59. Ad Reinhardt, draft of a letter to a Lieutenant McPeak, written from Anacostia, Jan. 4, 1945.

60. For instance, all of these artists were in one way or another involved in the work of Albert Ryder; Pollock via the Mexicans and Thomas Hart Benton; Rothko and Gottlieb via "The Ten."

61. Clement Greenberg, "The Situation at the Moment," *Partisan Review*, Jan., 1948, p. 82.

62. Clement Greenberg, "'American-Type' Painting," in *Art and Culture*, *op. cit.*, pp. 210–11.

63. For far more detailed information on the situation in the forties, see Irving Sandler's history of Abstract Expressionism, *op. cit.*, especially chaps. 2, 6, 17.

64. Tony Smith, in conversation with the author, 1968.

65. Tony Smith also remembers a gourd painting done by Gottlieb in New Mexico in the late thirties which represented a new breadth of scale.

66. Rivera had an exhibition at the Museum of Modern Art in 1931; his frescoes were shown there in 1933, the year the Rockefeller mural was done. Sam Hunter

has pointed out to me that Pollock's large mural for Peggy Guggenheim (now in Iowa) was installed around 1943–44 and was known to everyone in the New York avant-garde. Richard Pousette-Dart also showed a very large Surrealizing abstraction (*Symphony No. 1, The Transcendental*, 1942, 90 by 120 inches) at Art of This Century around that time; he remembers Rothko's coming to his studio and asking him why on earth he was painting so large (in conversation with the author, 1969).

67. Ad Reinhardt, in "Artists' Sessions at Studio 35 (1950)," *Modern Artists in America, No. 1*, Wittenborn-Schultz, New York, 1951, p. 15.

68. Ad Reinhardt, Phillips interview, *op. cit.*

69. José Ortega y Gasset, *The Dehumanization of Art*, Doubleday Anchor Books, Garden City, N.Y., 1956, pp. 9, 11, 12.

70. Joyce Kilmer, "Trees," first published in *Poetry*, Chicago, Aug., 1913.

71. Quoted in David Sylvester, "Painting as existence: an interview with Robert Motherwell," *Metro*, no. 7, 1962, pp. 94–97.

72. See, for instance, Still's *Jamais*, Rothko's *Slow Swirl by the Edge of the Sea*, Gottlieb's *Red Bird* (all of 1944), and Gorky's work. Similar images, though more abstract, are found later in Newman's paintings, such as *Genetic Moment–The Break* (1946) and *Genetic Moment* (1947). While this motif derived from the more poetic-illusionist side of Surrealism, from the work of men like Brauner, and later, Lam and Matta, it can be most directly traced to Max Ernst's early collages and *frottage* paintings. In addition, this motif contained the germs of the jagged verticality used first by Still, which later became such an integral part of the New York School sensibility.

73. Josef Albers, in an interview with Maude Riley, *Art Digest*, Jan. 15, 1945, p. 30.

74. The following artists had one-man shows at Art of This Century: Baziotes, Rothko, Pollock, Motherwell, Hofmann, Still, Pousette-Dart. Credit is due to Howard Putzel, who directed the gallery in its first years, as well as to Miss Guggenheim. The Parsons Gallery inherited the majority of these major figures, adding Reinhardt, Newman, and Herbert Ferber to its lists.

75. Reinhardt's *Bits of Information* (now titled *Number 18, 1949*, Collection the Whitney Museum of American Art, New York) was reproduced in the Dec., 1948, issue, p. 18.

76. Adolph Gottlieb and Mark Rothko, "Letter to the Editor," *The New York Times*, June 13, 1943.

77. These titles may have been inspired by Alonzo Lansford's review of Reinhardt's 1946 exhibition, in which the reviewer coined the title, "Dog Baying at Gypsy Rose Lee," a combined dig, perhaps, at Miró and Ernst. Irving Sandler suggests that Reinhardt temporarily abandoned this stance when he titled the two paintings in Barnett Newman's "Ideographic Picture" show at Parsons in 1947 *Dark Symbol* and *Cosmic Sign*. I suspect, however, that these were imposed, tongue-in-cheek, as a gesture of independence from the concept of the show (though certainly not from the work or the artists in it, with whom he was happy to be identified), rather than as a serious theoretical reversal.

78. Robert Motherwell, quoted by Ad Reinhardt in *Pax*, no. 13, 1960, in a list titled "Archives of American Art: CENSORED from 'It Is,' a Magazine of Abstract Art. 10 Quotations from the Old New York School."

79. Ad Reinhardt, "Thirteen Rules Toward a Code of Ethics for Fine Artists," from a paper read with some changes at the College Art Association meeting in New York on Thursday, January 28, and with more changes at the Artists Club on Friday, April 1, 1960. It is dedicated to the " 'seventeen irascible artists' of 1950 who have since successfully adjusted themselves to their non-environment" (typed on the manuscript by Reinhardt).

80. These cartoons were tremendously popular; Sinclair Lewis, among others, wrote Reinhardt a fan letter about them. The series was projected as a book several times, but not published until 1975 (see bibliography). Reinhardt also did innumerable spots and illustrations, and some political cartoons, for *PM* during the forties, in all of which he borrowed the Surrealist technique of found images and found quotations (especially Max Ernst's photo-engraving collages) and used them against Surrealism itself, by contending that these techniques were applicable only to commercial art.

81. Ad Reinhardt, "The Fine Artists and the War Effort," unpublished manuscript, 1943; this was not, of course, to say that he learned more about *art* from film than from painting. As Dale McConathy has pointed out, Reinhardt liked film for the same reason he liked novels; neither were considered on the same plane with essays and high art (in conversation with the author). Stuart Davis expressed similar ideas on the superiority of film in "The Audience," *Space*, vol. 1, no. 3, June, 1930, p. 22.

82. Robert Motherwell, "Notes on Mondrian and Chirico," *VVV*, no. 1, June, 1942, pp. 59–61. In all fairness it should be noted that Motherwell finished the essay by admitting that "beside Mondrian the other abstractionists seem dull and grey."

83. Reinhardt had previously shown under her auspices at the Mortimer Brandt Gallery, New York, in group shows.

84. A[lonzo] L[ansford], "Variations on Reinhardt," *Art Digest*, Nov. 1, 1946, p. 21.

85. The geometric framework and "watercolor" technique of many canvases from around 1947–50 are obviously related to the contemporary work of Rothko, who was a good friend (they both taught at the California School of Fine Arts, Reinhardt in the summer of 1950). At the same time, they are also the logical outcome of Reinhardt's gradual return to geometry and his atmospheric paintings from the mid-forties.

86. Ad Reinhardt, in conversation with Irving Sandler.

87. "Open Letter to Roland L. Redmond, President of the Metropolitan Museum of Art," May 20, 1950; the signatories were J. Ernst, Gottlieb, Motherwell, Baziotes, Hofmann, Newman, Still, Pousette-Dart, Stamos, Reinhardt, Pollock, Rothko, Tomlin, De Kooning, Sterne, Brooks, Kees, Bultman; and sculptors "supporting this stand": Ferber, Smith, Lassaw, Callery, Schnabel, Lipton, Grippe, Roszak, Hare, Bourgeois.

88. Ad Reinhardt, "Thirteen Rules...," *op. cit.*

89. Ad Reinhardt, in conversation with Irving Sandler, 1957–58.

90. *Ibid.*

91. Ad Reinhardt, in conversation with the author, 1966.

92. Claude Lévi-Strauss, *Tristes Tropiques*, Atheneum, New York, 1968, pp. 395–96.

93. Maude Riley, *Art Digest*, Dec. 1, 1944, p. 31.

94. Barnett Newman, "The Sublime is Now," *Tiger's Eye*, Dec. 15, 1948, p. 52.

95. Ad Reinhardt, "An Artist Asks," *San Francisco Art Association Bulletin*, Aug.–Sept., 1950.

96. Robert Motherwell and Ad Reinhardt, eds., *Modern Artists in America, No. 1*, Wittenborn-Schultz, New York, 1951.

97. By the artists themselves more than by any critic-historians; see, for instance, the virulent exchange between Motherwell and Newman in *Art International*, Sept., 1967, p. 51; Oct., 1967, p. 38; Nov., 1967, pp. 24, 27; and Jan., 1968, p. 41, at which point editor James Fitzsimmons, himself a veteran of the controversial period, called a halt.

98. Barnett Newman, *op. cit.*, p. 53.
99. Clement Greenberg on Rothko and Newman, " 'American Type' Painting," *op. cit.*, p. 226.
100. Motherwell and Reinhardt, *op. cit.*, pp. 19–20.
101. Ad Reinhardt, "Incidental Note," in *Reinhardt*, Betty Parsons Gallery, New York, Oct. 31–Nov. 19, 1949, p. 4. Reinhardt stayed with his friends the Gibneys in the Virgin Islands in the summer of 1949, while obtaining a divorce from his first wife, Pat Decker. Several of the paintings in this show were executed there.
102. Ad Reinhardt, in conversation with the author, 1966. Schapiro's theories on broken touch and color, which had interested him in college, are expounded briefly in relation to contemporary painting in "The Younger American Painters of Today," *The Listener* (London), Jan. 26, 1956, pp. 146–47.
103. Crampton's dark paintings were very poetic, and contained a fine network of lines. Newman's *Abraham*, 1949 (fig. 60), is black on a mottled gray-brown, the closeness of values somewhat modified by the difference in glossy and matte paint quality. Tony Smith and Edward Corbett also dealt with near monochrome around that time. Rauschenberg's black-on-black collage paintings were less radical than his later white panels, shown at the Stable Gallery in 1951.
104. Barnett Newman, *The Ideographic Picture*, Betty Parsons Gallery, New York, Jan. 20–Feb. 8, 1947, pp. 2–3. The idea that Newman was a theorist and talker rather than a "real painter" was, incredibly, still circulating at his death. When the first "stripe" paintings were shown in 1950 and 1951, including a white-on-white and a dark-on-dark canvas (both now in the collection of the Museum of Modern Art), they were greeted with condescension by some of the most knowledgeable viewers. Thomas Hess's review of the second show reflects this reaction: "Barnett Newman again wins his race with the avant-garde, literally breaking the tape. This genial theoretician filled a gallery with stripes and backgrounds—a thin white line surrounded by nothing at all; and a Cecil B. De Mille-size number in Indian red with five verticles [*Vir Heroicus Sublimis*] were some of the better ideas presented" (*Art News*, Summer, 1951, p. 47).
105. Albers was chairman of the School of Art at Yale from 1950 to 1958, and twice invited Reinhardt as "visiting critic" (1951–52). They had both been in the AAA before that, but had had little contact until 1949.
106. Josef Albers, in conversation with the author, New Haven, Nov., 1968.
107. See Albers' book, *The Interaction of Color*, Yale University Press, New Haven, 1963.
108. Reproduced in Kynaston McShine, *Josef Albers: Homage to the Square*, circulating exhibition catalogue, The Museum of Modern Art, New York, 1964, p. 17. This and *Dark* belong to the compositionally more elaborate series preceding the "Homage to the Square."
109. Thomas B. Hess, "Reinhardt," *Art News*, Nov., 1949, p. 50.
110. Ad Reinhardt, "Reinhardt," *Arts and Architecture*, *op. cit.*, p. 20.
111. Ad Reinhardt, "How to Look at Things," *PM*, July 7, 1946.
112. Rudolph Arnheim, "Gestalt and Art," *Journal of Aesthetics and Art Criticism*, Fall, 1943, p. 71.
113. Hilton Kramer, "Constructing the Absolute," *Arts*, May, 1960, p. 39.
114. Robert Goodnough, "Reinhardt," *Art News*, Summer, 1951, p. 47.
115. In a curious way, Reinhardt's work from 1946 to 1953 parallels Mondrian's development from 1913 to 1931. Both started out with a loosely knit, grid-based motif (Analytical Cubism), with distinct variations between the units; then the rectangles became more homogeneous and the integrated ground was replaced by an indeterminately floating field on which the units were irregularly spaced; the units then re-established contact with each other and became broad, flat, tightly interlocking color areas.
116. Fairfield Porter, "Reinhardt," *Art News*, Feb., 1952, p. 41.
117. James Fitzsimmons, "Reinhardt," *Art Digest*, Jan. 15, 1952, p. 20.
118. *Ibid.*
119. Martica Sawin, "Reinhardt," *Art Digest*, Dec. 1, 1953, p. 21.
120. Thomas B. Hess, "Reinhardt: The Position and Perils of Purity," *Art News*, Dec., 1953, p. 26.
121. Ad Reinhardt, in "Black," *artscanada*, Oct., 1967, p. 6.
122. Ad Reinhardt, "Twelve Rules for a New Academy," *Art News*, May, 1957, p. 56. He did, however, do occasional white paintings, one of which (now a promised gift to the Museum of Modern Art) is dated 1950 (fig. 50); another, later one is in the mature, trisected style, c. 1952, and belongs to the Estate, and a third is reproduced in plate 13.
123. Michael Fried, "New York Letter," *Art International*, Summer, 1964, p. 81. At another time, Fried wrote that "by the end of the century one finds in Mallarmé a kind of paradigm for the embodying of attitudes which can best be termed romantic in works and theories that are unmistakably purist in character. In our own time this process is perhaps best exemplified by the paintings and manifestos of Ad Reinhardt....Purism is, in its deepest aspirations, profoundly ahistorical. It aims at a kind of metaphysical validity, and proceeds as if on the assumption that by somehow distilling art down to its basic essence one can finally arrive at whatever it is that gives art the power to exist *sub specie aeteritatis.*" He goes on to distinguish between this and the "historical self-awareness" that makes Frank Stella and Barnett Newman not purists (*Art International*, Apr., 1964, pp. 58–59).
124. Lawrence Campbell, "Reinhardt," *Art News*, Mar., 1955, p. 52.
125. Thomas B. Hess, "Ad Reinhardt: Portraits of Ahab," *Art News*, Nov., 1956, p. 37.
126. There are occasional demands for a *catalogue raisonné* of Reinhardt's paintings. Between these facts and the invisibility of differences between the black square work in reproduction, it seems to me a hopeless task, though undoubtedly some masochistic scholar will undertake it sooner or later.
127. Alfred Barr, Jr. and James Thrall Soby, "Letter to the Editor," *Art in America*, vol. 51, no. 5, Oct., 1963, p. 143.
128. Frank Stella, memorial letter to *artscanada*, Oct., 1967.
129. The same year, Reinhardt remarked bitterly in a panel discussion: "Now if you think that things as they are are fine, if they don't make you unhappy, if they don't outrage you, I guess you have nothing to say. You can be as happy as a lark then....If there is any doubt that we have tastemaking, hidden persuasion, and operating, all these terms come from people who have been part of the system or the establishment—that's the problem to deal with. The situation is, as far as I can see, an oppressive situation. It's not free, not truly creative; it's maybe very well closed down, closed up ..." (*Scrap*, Jan. 20, 1961).
130. Clement Greenberg, *op. cit.*, p. 226.
131. From "Cycles Through the Chinese Landscape," *Art News*, Dec., 1954. The Museum of Normal Art paid homage to the Art-as-Art dogmas in 1967; a "Cool Art" show at the Aldrich Museum that year was dedicated to Reinhardt, and Carl Andre's contribution

to the Philadelphia showing of "American Sculpture of the Sixties" was painted black in Reinhardt's memory. Less public instances of homage since his death are still more numerous.

132. Elaine de Kooning, "Pure Paints a Picture," *Art News*, Summer, 1957, pp. 57, 86–87.

133. Camilla Gray, *The Great Experiment: Russian Art 1913–1922*, Harry N. Abrams, New York, 1962.

134. See Barbara Rose, "The Politics of Art: Part II," *Artforum*, Jan., 1969, pp. 44–49, on pragmatism versus idealism in the American tradition.

135. Ad Reinhardt, *Ralph Fasanella*, ACA Gallery, New York, Sept., 1947.

136. Kasimir Malevich, *The Non-Objective World*, Paul Theobald & Co., Chicago, 1959, p. 84.

137. Ad Reinhardt, in *Ad Reinhardt Paintings*, The Jewish Museum, New York, 1966, p. 12.

138. David Thompson, "Art: Americans in London," *Queen Magazine*, June 3, 1964, p. 17.

139. Andrew Carnduff Ritchie, *Abstract Painting and Sculpture in America*, The Museum of Modern Art, New York, 1951, p. 15.

140. Ad Reinhardt, unpublished notes, Archives of American Art.

141. *Webster's New World Dictionary*, College Edition, World Publishing Company, Cleveland and New York, 1956, p. 1171.

142. Newman sued Reinhardt for $100,000 for damaging his reputation, and the College Art Association for publishing Reinhardt's "The Artist in Search of an Academy: Who Are the Artists?" (*College Art Journal*, Summer, 1954), in which Newman (and twelve other artists, many close friends of Reinhardt's, as was Newman at the time), were humorously categorized as "the latest up-to-date popular image of the early fifties, the artist professor and traveling design salesman, the Art-Digest-philosopher-poet and Bauhaus exerciser, the avant-garde-huckster-handicraftsman and educational shop-keeper, the holy-roller-explainer-in-residence." The other artists were Albers, Bolotowsky, Chermayef, Diller, Ferren, Greene, Holtzman, Holty, Morris, Motherwell, Wolff, and Vytlacil. The suit was dismissed but Newman and Reinhardt never spoke to each other again.

143. Title of Reinhardt's "Annual April Fool's Day Talk," at the Artists' Club, Mar. 31, 1961.

144. Ad Reinhardt, "How to Look at Art Talk," *PM*, June 9, 1946.

145. The term "dogma" he adapted from Karl Barth.

146. Ad Reinhardt, quoted in Martin James, "Today's Art-

ists: Reinhardt," *Portfolio and Art News Annual*, 1960, p. 144.

147. Ad Reinhardt, letter to Betty Parsons, Sept. or early Oct., 1961.

148. Ad Reinhardt, "Wrongs," notes for a lecture at Woodstock, 1960; Archives of American Art. His distaste for any non-art use of fine art was expressed in a letter to the Miller Company in Meriden, Conn., dated April 21, 1948; they had bought a painting and asked him to sign a release for its use in promotion: "I value imaginative abstract painting as an end-in-itself and for its own content. It can be made intelligible through education but it loses or changes its meaning in an application to things with a different content or purpose....I'm very glad to have my painting included in your important collection of abstract art and have no objection to its exploitation in any way as a 'painting' or a 'fine-art-object' since it was created, exhibited, sold and purchased as such.

"However, I can't understand how it could be used or applied in the various ways that your release-form indicates, since it was not made for any of those purposes [advertisement, trademarks, promotion, etc.].'"

149. Ad Reinhardt, in conversation with the author, 1966; "Art-as-Art," *Art International*, Dec., 1962, p. 37; and in "Who is Responsible for Ugliness?" *American Institute of Architects Journal*, June, 1962, p. 61.

150. He objected to exhibitions like "Nature in Abstraction" at the Whitney, which made abstract art back into "picture art"; to articles like one in *Life* which juxtaposed Rothkos with sunset photos, Pollocks with grasses; to artists becoming chic enough to have their recipes written up by *Vogue*, etc. He once lectured at the Club with a bottle of sour grapes on the podium.

151. Thomas B. Hess, "Editorial: The Year's Most," *Art News*, Jan., 1966, p. 21; Ad Reinhardt, draft of a letter sent to Thomas Hess, Jan., 1966, Archives of American Art.

In 1954 (April 15), *Art Digest* had awarded Reinhardt "a medal for truculence" after he wrote a blasting (and very funny) letter opposing any kind of prize-giving. This had also been an issue in 1952 when the "Irascibles'" seven successors ridiculed a "free-for-all art contest" (*The New York Times*, June 30, 1952). In 1963 Reinhardt was awarded the $1,000 prize of the Art Institute of Chicago's annual exhibition of American Art, which he accepted publicly and returned privately so as not to make the refusal a publicity gesture. On January 31, 1963, he

simply wrote the director, John Maxon: "As you know I exhibit my paintings everywhere, but I do not participate in art competitions, and, as you must also know, I have objected to and satirized on many occasions, our system of prizes and awards in art. I am sure you understand then why I'm returning this award."

152. Thus obliquely admitting a distant kinship with Andy Warhol which critics had once tried to impose; see Barbara Rose, "The Value of Didactic Art," *Artforum*, Apr., 1967, pp. 32–36, and Max Kozloff, "Andy Warhol and Ad Reinhardt: The Great Accepter and the Great Demurrer," *Studio International*, Mar., 1971, pp. 113–17.

153. See the Art Workers' Coalition pamphlet distributed at the openings of the "First Generation New York School" show at the Museum of Modern Art, June, 1969.

154. Ad Reinhardt, *Arts and Architecture, op. cit.*, p. 20.

155. Dale McConathy, in conversation with the author, 1970. Reinhardt's clothes, his symmetrically arranged house, also reflected this image. But, as he wrote: "Everyman in the everydaytoday part of things lives like everyman. So do I. Part of myself is separate from my separate selves. Painting is special, separate." (*The New Decade*, Whitney Museum, New York, 1955, p. 72.) Reinhardt could separate art from life because his paintings were contemplative and his life was active. Neither could have stood up with such dignity without the other, yet they *were* separate.

156. No one seems to have felt they really knew him well or really were close friends of his, because of this compartmentalization; perhaps no one aware of the art world and its issues could be related to entirely as a human being.

157. Ad Reinhardt, Skowhegan, *op. cit.* Henri Focillon had noted that "the struggle between purism and verbal 'impropriety' may be interpreted in two ways: either as the effort toward the greatest semantic energy, or as the twofold manifestation of a hidden travail from which spring forms that are untouched and uninfluenced by any of the fickle changes in meaning" (*op. cit.*, p. 6).

158. Author's notes from a Reinhardt lecture at the Jewish Museum, Jan., 1967. "Art is communion, not communication," he said in an interview with Owen Lewis, *Greensboro Daily News*, Apr. 26, 1964.

159. Ad Reinhardt, Skowhegan, *op. cit.*

PART TWO

Colorplate 31. *Abstract Painting, Black*. 1960–66. Oil on canvas, 60 x 60". Marlborough Gallery, New York

Looking isn't as simple as it looks. Art teaches people how to see.
—Ad Reinhardt, 1946[1]

Human perception is best suited to slow modifications of routine behavior. Hence invention has always had to halt at the gate of perception where the narrowing of the way allows much less to pass than the importance of the messages or the need of the recipients would justify.—George Kubler[2]

The one work for a fine artist now, the one thing in painting to do, is to repeat the one-size-canvas—the single-scheme, one colour-monochrome, one linear-division in each direction, one symmetry, one texture, one formal device, one free-hand-brushing, one rhythm, one working everything into dissolution and one indivisibility, painting everything into one overall uniformity and non-irregularity.—Ad Reinhardt, 1962[3]

After 1956, the stylistic or developmental aspect of Reinhardt's paintings becomes negligible. From then on their importance lies in their appearance as paintings, or art-as-art. The nature of the black paintings—their "blackness" and their "sameness"—raises critical problems involving physiological and psychological perception more than historical or formal considerations. And certainly the description of superficial retinal responses and standard literal reaction is insufficient for such a subtly cohesive body of work. Art like Reinhardt's has largely evaded critical attempts to come to terms with its non-relational and non-referential qualities, relation and reference being the critic's chief supports.

These issues began to be raised when "perceptual abstraction" or Op art enjoyed a flurry of attention via the Museum of Modern Art's "Responsive Eye" exhibition in 1965, though most of the works shown were pleasing designs or illustrations of elementary scientific phenomena planned to disrupt rather than to extend the usual placid retinal response to color and pattern. Reinhardt's magnificent red canvas, as well as color paintings by Albers, Stella, Poons, and a few others, were the exceptions. As a long-standing adherent of open, clear color space, Reinhardt should have shared the honors of influencing a younger generation in the early sixties, when the obvious trend away from Abstract Expressionist principles toward an impersonal, often

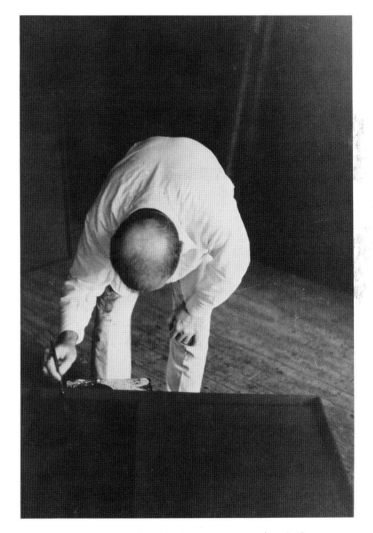

97. Reinhardt painting a black canvas, March, 1962

geometrically symmetrical art of thinly painted, saturated, or close-valued color seemed established as the latest step in modernist tradition. It could and should have been Reinhardt to whom Clement Greenberg was referring in 1962, when he wrote:

> The rectilinear is open by definition; it calls the least attention to drawing and gets least in the way of color-space.... Size guarantees purity as well as the intensity needed to suggest indeterminate space: more blue simply being bluer than less blue.... Let it suffice to say that by the new openness they [Rothko, Newman, and Still] point to what I would risk saying is the only way to high pictorial art in the near future.[4]

Reinhardt had by that time fully rejected color for light, an area then understood by few critics or artists. Whereas his prophetic "Twelve Rules for a New Academy" had been published in 1957, they only became rules with the actual advent of the new academy around 1965, when a group of younger "rejective" artists accepted most of his strictures to a greater extent than had Reinhardt himself in his own work. The rules, in summary, are:

1. No texture. Texture is naturalistic or mechanical and is a vulgar quality.
2. No brushwork or calligraphy. Hand-writing, hand-working and hand-jerking are personal and in poor taste.
3. No sketching or drawing. Everything, where to begin and where to end, should be worked out in the mind beforehand.
4. No forms. "The finest has no shape."
5. No design. "Design is everywhere."
6. No colors. "Color blinds." "Colors are aspects of appearance and so only of the surface," and are "a distracting embellishment." Colors are barbaric, unstable, suggest life, "cannot be completely controlled" and "should be concealed." No white. "White is a color, and all colors." White is "antiseptic and not artistic, appropriate and pleasing for kitchen fixtures and hardly the medium for expressing truth and beauty." White on white is "a transition from pigment to light" and "a screen for the projection of light" and "moving" pictures.
7. No light. No bright or direct light in or over the painting.
8. No space. Space should be empty, should not project and should not be flat. "The painting should be behind the picture frame." The frame should isolate and protect the painting from its surroundings. Space divisions within the painting should not be seen.
9. No time. "Clock-time or man's time is inconsequential." "There is no ancient or modern, no past or future in art. A work of art is

always present." The present is the future of the past, not the past of the future.

10. No size or scale. Breadth and depth of thought and feeling in art have no relation to physical size. Large sizes are aggressive, positivist, intemperate, venal and graceless.
11. No movement. "Everything is on the move. Art should be still."
12. No object, no subject, no matter. No symbols, images or signs. Neither pleasure nor pain. No mindless working or mindless no-working. No chessplaying.[5]

The main obstacle to the establishment of a date for the "first" black painting is simply the impossibility of determining the exact nature of a "black painting." Anyone can say, "Well, those aren't what *I* mean by black," and say it of works done up until Reinhardt's death. The degree of invisibility is clearly relative, governed by personal vision and experience as well as by historical perspective. For along with increased intellectual acceptance, advanced art engenders increased perceptual acceptance. This is particularly true of rejective or Minimal art, which initially appears empty, devoid of image or any other evocative component. When Reinhardt's first dark paintings were shown, they probably looked as dark to viewers then as the far darker ones of the late sixties do to us now.

A tautological approach like Reinhardt's expands visual perception. Ten years ago the black paintings were "seen" largely as empty stages on which the observer could act out his or her own interpretive fancies. Today, they are more visible because of the mental conditioning acquired by observers through art which "advanced" in the interim. This conditioning is the result of rapidly changing styles, of constantly replaced actions and reactions to the avant-garde, each of which leaves its mark on the art community as well as on the public. The average observer thinks he or she has pored over a picture if s/he spends two minutes looking at it. Reinhardt's black paintings concede very little in such a short period. As late as 1960, Dore Ashton wrote of them: "It takes a good ten minutes for the first impression to register."[6] No one else has admitted to quite such an extreme gap between confrontation and delectation, but reviewers of Reinhardt's work since 1956 have used most of their allotted space to describe their own experience of gradual revelation from black to color, from blank to structured surface. Some writers have described this experience as though it were utterly unique to them; indeed, enough disparities among accounts turn up to prove that it *is* a unique experience, felt strongly and personally enough to provoke each viewer to analyze his or her own responses. Only the most impatient or the most ill-disposed commentators see nothing but a solid black surface, and in such cases it is clear that they have not looked long enough to see anything else—that they do not want, or likely do not know how, to look.

The black paintings provide a more exaggerated period of perceptual lag than most art. Monotonal paintings exist in time as well as space. The eye is accustomed to colors, images, divisions to help it move across a surface; when

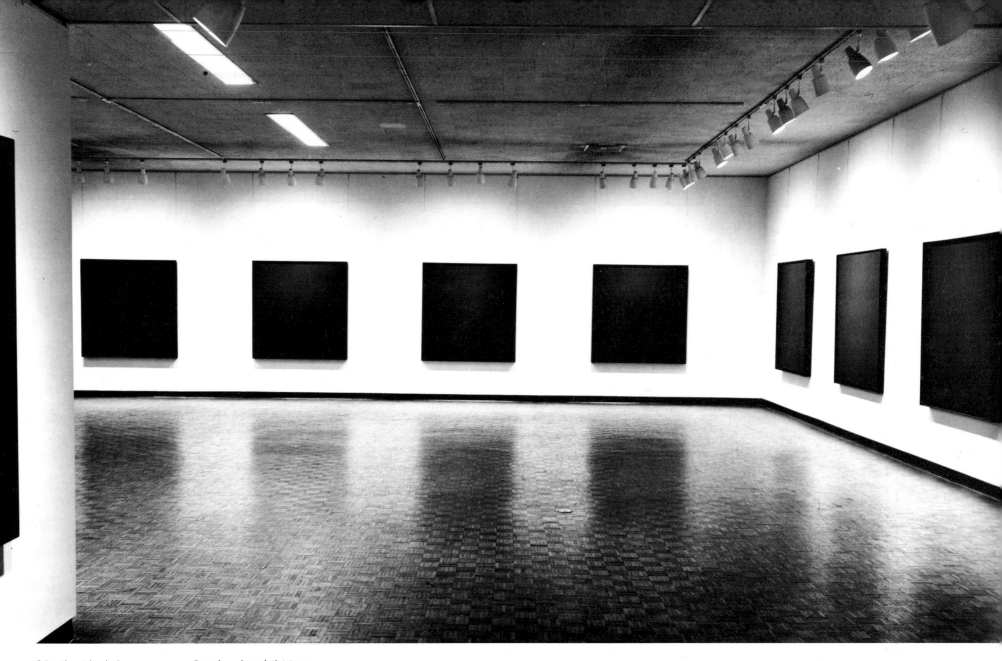

98. The Black Square room, Reinhardt exhibition,
The Jewish Museum, New York, 1966–67

these are absent, or hermetic, the visual comprehension process takes longer. Simpler things are not necessarily easier to perceive. The "empty" canvas is more difficult to "see" than the relatively crowded one, and it is still more difficult to see than sculpture, which even in its simplest manifestations offers different views and thereby a more acceptable heterogeneity of form. "Obviously resolved surfaces are simply decorative and do not engage the viewer's intellectual attention. Contradiction and frustration (within limits) act as stimuli and paradoxically make 'dull' work more interesting than complicated work."[7] Only by exploring the black paintings' repetition is it possible to perceive the variety. One can *become* the painting; one's perception and mood must be slowed to the pace of such obdurate surfaces. The observer must become almost

99. *Abstract Painting, Black.* 1960–61. Oil on canvas, 60 x 60". The Museum of Modern Art, New York

as passive as the object, a feat increasingly difficult in this day and age. This is so rare an experience that it can have curious psychic effects, which explains the frequent association of the black paintings with religious and mystical experience. Aldo Tambellini has called the color black "the state of being blind and more aware."[8] Priscilla Colt described her experience in terms of a psychedelic event: "Identity with Reinhardt's unnameable absolute will be attained only through a suppression of goal-seeking and egocentric activism."[9]

All art originates in the human mind, in our reaction to the world rather than in the visible world itself.... The willing beholder responds to the artist's suggestion because he enjoys the transformation that occurs in front of his eyes.—Ernst Gombrich[10]

To think effectively in terms of relations of qualities is as severe a demand upon thought as to think in terms of symbols, verbal and mathematical. Indeed, since words are easily manipulated in mechanical ways, the production of a work of genuine art probably demands more intelligence than does most of the so-called thinking that goes on among those who pride themselves on being "intellectuals." —John Dewey[11]

The entire process of experiencing one of Reinhardt's black paintings is a ritual in itself and shares the timeless quality of all ritual. On entering a room where there are one or more black paintings, the first impression is of the most general nature. One sees a black square hanging on the wall. One approaches and sees that it is not a metal, wooden, or plastic relief but an oil-painted canvas, set into a matte-black shadow box (intended for protection though it also adds another degree of aloofness). The effect is already cool, the black so matte that it appears grayed—the source of a curious effect unique to Reinhardt's work in which the light seems to derive from the surface itself as well as from the colors hidden within. A black Reinhardt holds its surface and edges and appears neither as a window into a dark space nor as a window into a dimly lit space. Its size is not overpowering, not so large that it would be difficult to see the whole surface at once. The quality of pervasive luminosity belongs sequentially to the first instants of viewing time, but it lingers throughout the following stages, during which perception becomes more detailed. The hermetic light source is an integral part of the surface and as such holds the picture plane despite a simultaneous atmospheric effect which is in turn anchored by the stable trisection.

After a period of looking at the dull glow, one begins to perceive its non-blackness, though at first one can be no more specific than that about its nature. Then the extremely muted colors begin to emerge (usually tones of blue, red, and green, sometimes taken to purple, ochres, maroons, olives, and a wide range of other "black" variations), and with them, but lagging a little, comes the

Colorplate 32. *Abstract Painting, Black.* 1960–66. Oil on canvas, 60 x 60". Marlborough Gallery, New York

trisection, which looks like a cross until the two overlapping bands (the horizontal over the vertical) separate themselves from the four square corners of ground. When the viewer's vantage point changes, edges and contrasts appear, are stressed, and are replaced by others. At first sight, the mind demurs and the eye busies itself with appearing and disappearing edges and contrasts, a harmless enough spectator sport that compensates many viewers for the absence of pictures and story-telling images. Resisting these temptations, one is eventually drawn by anticipation and curiosity beyond boredom to speculation, thought, and a direct aesthetic/sensory enjoyment of the particular object. At this point, the infinite ambiguities inherent in any work that aspires to "nothingness" begin to operate. "I try to lose the forms," Reinhardt said; "then color and overlapping are irrelevant."

If one is lucky (one rarely is), the paintings are well lit. Because internal light is so important an element of the black canvases, the way they are externally lit is proportionately significant. They demand a different illumination from other paintings and are often incompatible with anything else in group shows; their invisibility seems to cast aspersions on the bright color and surface activity of other work (much as Reinhardt's writings in their wit, spareness, dignity, and assurance make anything else sound like overblown rhetoric). Ideally, Reinhardt demanded "dim, late afternoon non-reflecting twilight" or a reasonable artificial facsimile. Bright, direct light, rather than clarifying the dim structure and color, almost totally obscures them. Museums and galleries are hard put to meet the artist's conditions. (Overlighting can even be physically damaging, for the more invisible the forms within, the more impatient with the surface the viewer becomes. One sees nothing and feels constrained to touch instead of look; noses and fingers are often rubbed against the surfaces, destroying the paintings.)

The oil-drained surface, so susceptible to damage, nevertheless seals the light within the plane, rather than allowing it to reflect and be acted upon by its environment. Reinhardt disliked glossy, reflective black because of its instability: "It's quite surreal. If you have a look at a shiny black surface it looks like a mirror. It reflects all the activity that's going on in a room. As a matter of fact, it's not detached then. The idea about darkness, I guess, is that there are less distractions and less intrusions, than color or light or other things might make."[12] Gloss also obscures the colors within the black. Martin James has observed that "The more light the topmost stratum reflects, the less of it illuminates the pigment below....The difference in value between the adjoining planes in Reinhardt's recent work is so slight that it can be ambiguously ascribed either to surface or to pigment."[13]

Since Reinhardt is the only artist so far to have carried the viewing experience successfully to such extremes, his paintings have, according to James, "a color-phenomenology all their own."[14] Although the schematic possibilities of the red, green, blue trisection are exhausted in only six combinations (one color

for ground, one for vertical divisions, and one for horizontal), the black paint-
ings exhibit a broad range of color from brown to purple, warm to cool. On the
other hand, the subtler the use of these colors became, the more they ap-
proached a nearly colorless light. "There is something wrong, irresponsible and
mindless about color," Reinhardt could declare in 1960, "something impossible
to control. Control and rationality are part of any morality."[15]

In 1954, Reinhardt had announced that he didn't want to go to heaven if he
had to go with "them guys" (everybody else).[16] I suspect that the moral basis of
his rejection of color was due not to a dislike of color per se (he continued to use
it, albeit ultrasubtly), but to his dislike of the kind of art which had become
known for its color, from the brash cacophonies of Op and Pop to the hedonist
vagueness of much stained and sprayed painting. Color had come to represent
for him a diluting agent in the controlled and single-minded, unified art-as-
synthesis he had by the later fifties established as his goal. It had also come to
represent the vulgarities of "life," which he was determined to eliminate from
the inner world of art. "After all," he pointed out, "whole books are written on
color without mentioning fine art. They don't need it, they can refer to any-
thing."[17]

Reinhardt's assumption that color (bright, contrasting color at least) was
unnecessary to painting and could be employed more satisfactorily in other
mediums was supported by a small but prophetic book called *The Future of
Painting,* written in 1923 by Willard Huntington Wright. Wright distinguished
between the "art of painting" and the "new art of color." The former included all
traditional, chiaroscuro painting, and the latter all "modernist" painting from
1800 on. He contended that the two arts could coexist, since their goals were
entirely divergent, but that the art of painting was obsolete:

> Now that painting has lost its emotional efficacy, a new optical
> stimulus is needed.... The art of painting is not an art of color. Color,
> indeed, had practically nothing to do with the aesthetic evolution of
> painting.... All the activities of "modern painting" have had one
> object for their goal—the solution of the problems of color.[18]

In this context, Reinhardt could say with some justification that he was
"painting the last painting anyone can paint,"[19] though the "art of color" would
continue. In the latest, and most extremely black paintings, color differentiation
is really imperceptible. One senses rather than sees it. And at this point, in order
to retain the necessary armature, the major element becomes chiaroscuro rather
than equally valued color juxtaposition, the darker area becoming shadows,
the others "low-lights." "I made fun of chiaroscuro once," he said in 1966, "but
maybe that's where I am again."[20]

Color-light alone, sustained by a minimal formal vehicle, has not greatly
interested nonobjective painters until recently, largely because it so often

destroys surfaces, and the linear theory of modernist evolution demanded consistent assertion of surface, edge, and support. Rothko and Reinhardt are the only two major painters of their generation to have concentrated on light, and their approaches differed considerably. Rothko's atmospheric light does not so much disintegrate as unite with the floating rectangles and their definition in space; at the same time, the blurred, scumbled edges imply a diffused differentiated light source hidden in some shallow recess behind the picture plane. To some extent Rothko's light, or light source, is *depicted*, whereas Reinhardt's is a steady, almost uninflected presence, an intangible gloom held tightly on a tangible plane by the absolute symmetry of its armature. Reinhardt seems to have arrived at the geometrical phenomenon of perception that Lawrence Gowing noted in Turner's late paintings—a "natural symmetry of light" and "an incandescent central axis."[21] A wholly even light seems impossible. Reinhardt's light is a gathering darkness.

Martin James sees the central axis drawing attention like a crucifix or an altar, serving "as a support for secondary phenomena, the reverse of stable inversions of the spatial effect, flickering illuminations of the perceptual field, involuntary shifts in the relative brightness of the two halves, enigmatic relations of the color scale, which afford no dominant place of rest."[22] Unimportant as form, the trisection provides the necessary scaffolding (related to the Cubist grid) so that the painting remains a painting and is not experienced as a black relief. Within it, the faint differentiations of color, or of tone, of warmth and coolness, exist as a reminder of the work's identity—*painting* as painting. The barely perceptible divisions, although contradicting his written theories, were crucial to the strength of Reinhardt's painting premise. Since the areas of information content are so greatly reduced, the eye seeks and finds the centralized division as a necessary visual cue; once found, it can be ignored and another sort of focus can be established.

In 1949, José Ortega y Gasset constructed a perceptually oriented view of art history which is worth summarizing here because it emphasizes light as a unifying agent and offers a new perspective on Reinhardt's black paintings. It also offers an alternative to the strictly historical theories of painting's evolution by treating internal experience as well as external events. Ortega traced painting's evolution in terms of point of view, from depicting things to depicting sensations to depicting ideas. He used the physiological terms "proximate" and "distant" vision. Proximate vision sees bulk, makes surfaces convex, as in Giotto; distant vision makes surfaces concave and seeks empty space, as in Velásquez. With chiaroscuro or an overall light source, proximate vision gives way to distant vision; the eye is no longer forced to hop from one complete object to another; the common surfaces of objects are emphasized rather than their disparate volumes. "The individualistic primacy of objects is finished."[23] Hollow space and air are inserted between the observing eye and the pictured objects, which become areas of light and color rather than imitation volumes.

Proximate vision analyzes and distinguishes; distant vision synthesizes, combines. Impressionism and Neo-Impressionism fulfilled the prediction of distant vision that Ortega attributed to Velásquez[24] as the first artist to focus upon the empty space, or background, rather than the foreground volumes and space in tangible Renaissance perspective. When the central ray of the eye moves straight ahead, for direct vision (*in modo recto*), one sees concavity. When the pupil sends out other rays at oblique angles (*in modo obliquo*), dimension disappears and the whole field of vision becomes surface. Oblique vision characterizes modern art, which eliminates tactile and corporeal effects, atomizes and disintegrates parts. The artist no longer paints objects, but the experience of seeing.

Ortega is unlikely to have known Pollock's drip paintings, nor could he have predicted the subsequent development of an all-over and field painting unified by form and surface as well as by light. Today the homogeneous surface is traced back to Impressionism (particularly Pissarro, the late Monet,[25] and Seurat's drawings), to the merger of object and surface within the shallow but indeterminate space of Analytical Cubism, and to Mondrian's theory of "equivalents." Ortega's thesis of disintegration and ultimate "distance" from the spectator, where light as the agent of open space overwhelms volume and shapes, where the whole overcomes the parts, can serve as a macrocosmic view of Reinhardt's own development from planar to atmospheric to planar/atmospheric. The surface, the nature of the two-dimensional plane, remains intact; a painting is still a painting even after all subject has been dissolved in light or gloom.

Ortega coined the phrase "intrasubjective states" for Cubism and post-Cubism, succeeding the Impressionists' concern with subjective states, or sensation:

> Not halting even at the cornea, the point of view crosses the last frontier and penetrates into vision itself, into the subject himself.... Ideas, then, are subjective realities that contain virtual objects, a whole specific world of a new sort, distinct from the world revealed by the eye, and which emerges miraculously from the psychic depths.[26]

Ideas are ideal objects, the retina "a tenuous frontier between external and internal," or sights perceived and the mind. The black paintings stand between the objective, intellectual basis of Cubism and the subjective, sensory basis of Impressionism. They insist on the Cubist relation of object to surface while they simultaneously insist on color and light independent of form. This is commensurate with Reinhardt's previous all-over, non-hierarchical styles, in which he rejected naturalist, conceptual, and psychological contents alike; in which parts of the surface are virtually undifferentiated from the others, and the part *is* the whole. Such an equilibrium between mind and eye, what Malevich called the

"concretization of sensibility," amounts to a purist's Impressionism, an art of physiological sensation that is absolutely abstract and can be associated with nothing except the pure sensation of a single "black."

One color has a greater power than a combination of two, and a mixture of three impairs that power still more. —Heinrich Füseli[27]

The word "black" is related to the word "blanch"; "black" is descended from the Middle English "blaec," cognate with "blac" meaning white or shining. —Lawrence Campbell[28]

Do not imagine that white objects derive the snowy aspect they present to your eyes from white atoms or that black objects are composed of a black element. And in general do not believe that anything owes the colour it displays to the fact that its atoms are tinted correspondingly. The primary particles of matter have no colour whatsoever. —Lucretius[29]

Light, the most intangible element of painting, is made an instrument for measuring the most universal definition of painting its relationship to visibility. —Alfred Neumeyer[30]

Darkness in Reinhardt's painting is a form of light, not illumination or chiaroscuro but an aspect of form — what might be called total light. — Sidney Tillim[31]

Aye, on the shores of darkness, there is light. —John Keats[32]

Black is not as black as all that. —Paul Valéry[33]

Reinhardt's development from about 1949 to 1960 traces the process of draining color from light, so that in the last works, light practically replaced color. This is a feat, because black is considered the absence of light. Black, white, and gray are called achromatic colors. Black is caused by a complete absorption of light rays, and gray by an incomplete absorption of these rays. (The black paintings are, in fact, gray, not quite lightless, just as they are not quite colorless and not quite formless.) Their colors have little chroma, or color intensity, but Reinhardt achieved an extraordinarily refined intensity by using color almost invisibly as the basis of the blacks. The graying glow does at times lack visible color, but the quality of its grayness is dependent upon its color component. A high degree of light-absorbence is not the same as total absence of light. The light has been taken in rather than rejected; the opaque black surfaces have paradoxically become transparent containers of light. Theoretically there is absolute clarity, but ambiguity exists in the eye of the beholder.

It is possible for the black paintings to be both colored and colorless (black) because these two conditions are not perceived simultaneously. The black-gray glow initially perceived is the result of the unseen colors comprising it; once the eye becomes accustomed to this light, it begins to analyze—the result is color. This we know after the fact because we know how the paintings evolved and how they are constructed. But Edwin Land's experiments have also proved that "the eye can build colored worlds of its own out of informative materials that have always been supposed to be inherently drab and colorless,"[34] so that this phenomenon can be experienced without prior knowledge of Reinhardt's technique. Land achieved a whole spectrum with only two color filters; this was predicted by Leonardo, who found that red light gives bluish shadows, as well as by the Impressionists with their colored shadows, their contention that black does not exist optically. The Purkinje phenomenon demonstrates that the spectral sensitivity of the eye shifts to shorter wavelength for low illumination.

Even after he rejected obvious color, Reinhardt remained with sensation, color, and light. His black is an Impressionist black, an all-colored shadow. (In fact, it was in the effort to discover a richer black that Eugène Chevreul became interested in the study of juxtaposed colors which was to have such an effect on the Impressionist painters. As a chemist at Gobelins, he made a series of color wheels with different proportions of black added to the colors for a study of hue and value.) Black is both inclusive and exclusive, a condition bound to appeal to Reinhardt's sense of paradox.

Ironically, the differences between each of the "identical" black paintings are often accidental. Each was resolved according to what happened in the drying. It was only at the very end of his life that Reinhardt could predict and thereby fully control the drying process, which depended on the weather, the mixing of the paints, and even the canvases, which, in his words, "never handled the same way twice."[35] These are not literally easel paintings; they were executed flat on a low bench-table. The colors do not show through from under a layer of blacks but were mixed beforehand with Mars black, a carbon. Each pigment demanded a different amount of black. For instance, ultramarine blue and cadmium reds have tremendous tinting qualities; a minute touch of yellow or white also makes a great difference in a black. The darkest reds Reinhardt used were usually alizarin crimson-based. For the most part he used three parts of black to one of red, and equal amounts of blue and black.

To minimize the tactile aspects of a painted surface, and make it an unblemished and single vehicle for color-light, Reinhardt always painted thinly, avoiding even the slightest relief or obvious brushstrokes which might catch the light as an edge (and also might attract attention to the "hand of the artist" syndrome of Abstract Expressionism). The trisection was measured off precisely, then filled in by hand. He never taped a line for added precision, as do most hard-edge painters, because the tape would cause a minute ridge. Thus there is in all of his work a very slight roughness of touch, a deliberate archaism

or vestige of painterliness that precludes what he considered the easy tensions of an over-mechanical optical vibration. For while Reinhardt de-emphasized gesture and process, he applied the paint itself quite sensuously, if understatedly. One is aware of a *painted* surface. Insisting that the maker is inseparable from the creator of a work of art, he contended that only in the double act of conceiving *and* fabricating does the artist have any stake in his own work; and while he disliked the idea of painting as a *trade* ("The painter isn't a professional, a glorified craftsman; he is an artist"[36]), he also disliked the idea of an artist sending his work out to be fabricated, as many younger sculptors were doing, and thereby persisted in the individualistic attitude typical of the New York School: "The one way in art comes from art-working."[37]

Painting is overtaken by time and the painter is a prejudice of the past.... The closer one gets to the phenomenon of painting, the more the source (objects) lose their system and are broken, setting up another order acceptable to the laws of painting. The artist who wants to develop art beyond its painting possibilities is forced to theory and logic. —Kasimir Malevich[38]

Every new form limits the succeeding innovations in the same series. Every such form is itself one of a finite number of possibilities open in any temporal situation. Hence every innovation reduces the duration of its class.... No formal sequence is ever really closed out by the exhaustion of all its possibilities in a connected series of solutions. The revalidation of old problems in new circumstances is always possible and sometimes actual. —George Kubler[39]

The trouble with most contemporary painting is that it lacks monotony.... The value of monotony is yet to be ascertained.... Activity is the ultimate impurity. —"Pure" (Elaine de Kooning)[40]

However meaningless or repellent the uninitiated may find it... this very uniformity, this dissolution of the picture into sheer texture, sheer sensation, into the accumulation of similar units of sensation, seems to answer something deep-seated in contemporary sensibility. It corresponds perhaps to the feeling that all hierarchical distinctions have been exhausted.... It may speak for a monist naturalism that takes the world for granted and for which there are no longer either first or last things. —Clement Greenberg[41]

The black paintings are unities, but as entities, and as a group, they are also uniform. Unity has long been a major aesthetic goal, in painting and in the other arts. Uniformity, on the other hand, has been considered an "anti-aesthetic notion."[42] Both qualities deal with the unit; both result in oneness, singleness, wholeness. Yet the former is traditionally desirable, and the latter is

not. Unity implies the harmonious bringing together of potentially unharmonious elements, while uniformity is supposedly "easy," bringing together identical or near-identical parts which already, by nature, agree. Unity is, however, static, in the sense that, once brought together, the parts must stay together to continue the condition of unity, whereas uniformity is a more temporal concept, implying consistency in activity as well as in appearance or constitution.

The history of modern painting, like that of many other arts not touched upon here, has demonstrated a clear tendency to develop from unity toward uniformity. While a great variety of styles and intentions has characterized the modern period, individual artists have tended toward uniformity within their own development and in their work. This uniformity can be either chaotic or patterned. The close-valued hues of Goya, Turner, Whistler, Constable, and the Impressionists (Monet in particular) tend toward a monotonal surface. The single textures of Monet, of Analytical Cubism, even of Soutine's Céret period (where flesh, paint, and earth are tactilely indistinguishable), of Dubuffet's Soils and Texturologies, Pollock's skeins of paint, and Reinhardt's monochromes, to mention only a few examples, tend to dissolve distinctions, to forego the delicate balances and hardy battles of unity for the finalizing (even terminal?) solution of uniformity. With the advent of Minimal art, uniformity came out in the open as a positive element, whereas previously, all-over, uniform surfaces had usually been justified solely in terms of their refinement of variety. Uniformity in recent art is considered by some to be the discouraging product of a conformist society, proof of mid-century decadence as contrasted to turn-of-the-century robustness; it is resisted on the basis that there is nothing to see in it, that "its objects fail to evince what we have over the centuries come to regard as an essential ingredient in art: work, or manifest effort."[43]

Reinhardt's dogmas are explicit on the subject of redundancy, or uniformity:

> The one direction in fine or abstract art today is in the painting of the same form over and over again. The one intensity and the one perfection comes only from long and lonely routine preparation and attention and repetition.
>
> The one thing in art left to do is repeat the one-size-canvas, the single scheme, one-color monochrome, one linear-division in each direction, one symmetry, one texture, one formal device, one free-hand brush-working, one rhythm—into one dissolution and indivisibility, into one overall uniformity and regularity.... Everything into irreducibility, unreproducibility, imperceptibility.[44]

In an auto-interview in 1965, Reinhardt asked himself, "Are you still saying the one thing you say needs to be said over and over again and that this thing is the only thing for an artist to say?" and he answered, "Yes."[45]

It might seem that the result of such a sensibility could only be a single painting. At least one critic did see the black canvases at the Jewish Museum as "one painting" which consisted of a *solution* rather than a work of art.[46] Previously, another had attacked the black paintings as a mere illustration of the artist's position, "not, in the end, intelligible in its full meaning outside of the polemical context in which it has been conceived."[47] It is in some ways unfortunate that the wit of Reinhardt's frequent writings had such a broad appeal. The dogma was more entertaining than the paintings and distracted from them. Had Reinhardt not written and spoken publicly so much, the paintings would have had to be seen for themselves rather than as a platform. But though their goals were the same, Reinhardt the painter always remained separate from Reinhardt the dogmatist. When he said the black paintings were all alike, he meant they looked alike. Of course, they are not identical. Each "ultimate" painting invoked another: "The more an artist works the more there is to do."[48] For Reinhardt was not, despite all his influence on later trends, a "Conceptual" artist. (Here again the terminology can be confusing. All good artists are conceptual; one cannot conceive of a work of art, however "accidental" or "intuitive" one intends it, without intention, which involves an inordinate amount of thought, whether or not it is ever articulated, and therefore follows a conception.) The idea of *pre*-conception in art is an ancient one; only the most extreme Surrealists, Action painters, and anti-formists have advocated full suspension of the pre-existing idea in favor of process, and few of them, if any, have ever achieved automatism in any pure state.

One of Reinhardt's "Twelve Rules" reads: "In painting—the idea should exist before the brush is taken up." This has been misconstrued as a statement of the predominance of idea over subject, which was certainly not Reinhardt's intention; another rule was "no idea." Like other artists, he destroyed unsuccessful works. He pre-conceived everything except the final effect of the painting; that mysterious factor emerged while it was being painted. In such a rejective idiom, every minute change is charged with unexpected importance. With each work, Reinhardt tried to come closer to complete pre-conception, or a "finished" work. He kept on painting "the same old thing over and over again" precisely because he had *not* reached a solution. If he had indeed been an "idea artist," he would have been satisfied from the start with a program: one hundred black paintings, or the six in which his "color" permutations are exhausted. A less optimistic and more "scientific" artist would simply have stopped painting when he reached the "ultimate painting" instead of going on to *Ultimate Painting No. 38*, *No. 39*, and so on.

Reinhardt's reply to the question of why he kept painting the "ultimate" painting over and over again was that it still involved him. At the very end of his life, however, the involvement was decreasing and the climax, or immolation point, may have been imminent. For the first time he had begun to feel that he had mastered his intentions, that he had discovered how, in fact, to make one

black painting over and over. He was considering the possibility of having someone else paint one canvas which would, by implication, be the last. If he found that his helper (a young painter named Gary Reams) could make that ultimate painting as well as he himself could, he spoke of leaving painting for film, which had always fascinated him, and which he considered "incomparably greater than all previous picture arts thrown together." Even so, one senses that Reinhardt realized there is no such thing as pure, only the uncompromising *effort* to be pure. The last black painting would not finally be ultimate. His notes on "the end of painting as an art" end with the words: "A return/Last Word must always be secretly the first."[49]

If art is anything, it is everything, in which case it must be self-sufficient, and there can be nothing beyond it.—Alain Robbe-Grillet[50]

True art, pure art, never enters into competition with the unattainable perfection of the world, but relies exclusively on its own logic and its own criteria, which cannot be tested by standards of truth or goodness applicable in other fields of activity.—Ananda Coomaraswamy[51]

The concept of a "non-relational" art, the impetus for primary structures and Minimal or rejective painting in the mid-sixties, found a natural vehicle in geometric shapes, which have been the favored forms for symbolic and schematic propositions in every civilization because "they provide the most clear-cut images of the basic configurations of forces that continue to underlie man's life and therefore man's thinking, even in refinement and complexity."[52] Not only do geometric forms seem more rational and predetermined than organic shapes, but they lend themselves to the kind of neutrality recently sought by artists rebelling against the balancing and juggling of shapes associated with European geometric art of the thirties. What Anton Ehrenzweig calls an "or-or" structure, and advocates for broad application to all areas of thought and perception,[53] also constitutes the attraction of modular concepts for younger artists. Their employment of formless, neutral units (Stella's early negative stripes, Noland's bands, Andre's plaques, LeWitt's cubes, Judd's boxes), like Reinhardt's trisections, rejects the "either-or" structure of traditional composition:

> It is an attribute of geometric figures that they possess more inherent redundancy than any others. It is also curious that to procure an image that is most indeterminate or in conflict [conflict being generally accepted as the source of aesthetic "emotion"] it is often necessary to rely on the most determinate and planned procedure.... Shapes that are redundant, such as two-dimensional, closed outline shapes with properties of symmetry, simplicity, good continuation, good closure

and other forms of regularity are associated with the Gestalt concept of figural *goodness*. [54]

There was at one point in the mid-sixties a good deal of talk in New York criticism about "post-geometric" art, though it was never established what made a geometric shape, no matter how non-relationally employed, non- or post-geometric. Younger artists tended to accept geometric shapes by default, rather than out of any particular interest in their past uses or their classical rationality. Don Judd, for example: "The main virtue of geometric shapes is that they aren't organic, as all art otherwise is. A form that's neither geometric nor organic would be a great discovery." [55]

The geometric shape with the most equilibrium, or neutrality, is the square. The circle, although perfect, and cornerless, was rejected by Reinhardt because it is also an organic shape; it implies a rolling, spinning, sun-moon image and other natural or symbolic impedimenta. The square, on the other hand, seems a patently man-made form. It is found in nature only rarely (in the salt crystal and iron pyrites, for example). Its total equality, symmetry, and stasis also provides the only painting surface that seems to be surface first and noticeable shape second. Vertical and horizontal rectangles have associations of their own. (Reinhardt's earlier verticals were attributed to his urban environment and compared to skyscrapers.) For the same reasons, however, there are some symbolic interpretations of the square that are not altogether inappropriate to Reinhardt's goals. Robert Fludd, a seventeenth-century Rosicrucian mystic, pictured a black square, five by five inches, with "*et sic infinitum*" written along each side;[56] an ancient Chinese adage defines infinity as "a square without angles," which might indeed be post-geometric.

For better or worse, the term "non-relational" is now fixed in the critical vocabulary. "Non-formal" might have been a better term for works that abolish internal relationships between forms. Reinhardt was in no sense a formalist, as Thomas Hess noted when he wrote that he was an inventor of patterns rather than forms, though Hess could not have foreseen in 1950 that Reinhardt's close-valued geometric paintings would provide an alternative (or counterpart) to Pollock's all-over expressionist manner and that both would be the pioneers of a new concept of uniformity, or modular pattern. Uniformity, by distracting attention from form to color and light, produced a kind of anti-formity; though this word is now used to denote a very different kind of art, the bases are the same. The concept is implicit in the development of classical abstraction, and is important to American art in general. From 1945 to 1965, American painters escaped form by moving from closed images to open elements in an all-over scheme, then by moving from a scheme to a device, from fragmentation to unity, and to a fragmented unity that is actually uniformity.

Before his death, Mondrian had already seen a revolt taking place against the then dominant expression of reality:

100. *Abstract Painting, Black.* 1960. Oil on canvas, 60 x 60". Collection Arnold Glimcher, New York

We see the culture of the form ending in a struggle for the deliverance from the limitations of form. [If forms appeared as entities separated from the whole] in order to establish universal unity, their proper unity has to be annihilated.... Similar forms do not show contrast but are in equivalent opposition. Therefore they annihilate themselves more completely in their plurality....The pure plastic way is thus the transformation of limiting forms into a more or less neutral form.[57]

Predicting that "the research for good *forms* was the work of the past; the research for good *relations* is the gleam of the present,"[58] Mondrian also applied the idea to a premonition of Reinhardt's trisection:

The vertical and horizontal in the rectangular relationship produce a plastic expression of inner strength and repose. When united in the "appearance" of a cross, these lines express a form—although abstractly; but, in Neoplastic composition they are really opposed, thus annihilating all form.[59]

If Reinhardt's black paintings neutralize relations between forms, they are still extraordinarily sensitive to relations between the various polarities in which he dealt—color and no color, form and no form, surface, light. More radically equivalent than the flickering rhythms of Mondrian's last "Boogie-Woogie" paintings, their roots are similar. Yet there can be no such thing as a wholly non-relational painting, simply because painting must always reconcile its surface with its objectness.

If one does not perceive how a work repeats itself, the work is almost literally not perceptible, and therefore, at the same time, not intelligible. Until one has grasped, not the "content," but the principles of (and balance between) variety and redundancy in Merce Cunningham's Winterbranch *or a chamber concerto by Charles Wuorinen or Burroughs'* Naked Lunch *or the "black" paintings of Ad Reinhardt, these works are bound to appear boring or ugly or confusing, or all three.*—Susan Sontag[60]

Peekaboo here I come again, just when most needed, like the square root of minus one, having terminated my humanities.—Samuel Beckett[61]

I'm just making the last paintings which anyone can make.
—Ad Reinhardt, 1966[62]

It might seem that by destroying color, form, and image, Reinhardt had also destroyed style. Yet theoretically passive and self-contained as the black paintings are, their surfaces give off a unique kind of energy. By choosing

Colorplate 33. *Abstract Painting, Black.*
1960–66. Oil on canvas, 60 x 60".
Private Collection

symmetry and virtual monotony in order to de-emphasize distinctions between elements on the canvas, and by choosing a consistent format to de-emphasize distinctions between the paintings themselves, Reinhardt neutralized the distinction between variety and redundancy. The senses tend to meet the challenge of the intellect, and vice versa. If no one but the artist could perceive specific differences between each one of the black paintings on the first floor of the Jewish Museum retrospective, this does not preclude an individual style, for of course repetition is necessary to the development of a style in the first place. An artist's or a period's style is often not fully recognizable until it has been brought to the verge of redundancy. Non-relational art is redundant in a particular way. "Equal strength of whole and parts creates ambiguity, and ambiguity creates oscillation.... Such oscillation makes it possible to present identity without losing duality."[63]

Reinhardt himself maintained a fusion of polarities—purism and impressionism, subjectivity and objectivity, color and colorlessness, uniformity and individuality. Non-relational art cannot be evaluated or justified by individual consideration of the parts balanced within the whole. Each canvas must be taken as a complete field relatable only to other paintings, by the same or other artists. As such it demands a different sort of evaluation, one that focuses upon hitherto invisible or unthinkable diversities. The eye can discern a million differentiations between light and dark. We know that any sensory field will be activated by sufficiently lengthy scrutiny and that there is, therefore, no such thing as an entirely homogeneous surface or an entirely empty painting. There is a perceptual disorder inherent in *any* seen area.[64]

The principles of variety and redundancy upon which the black paintings are based probably have a broader range than we know. Experiments are now being made on the extent of the "perceptual deprivation" experienced by astronauts, which may also be pertinent to the perception of monotonal painting. Jack Vernon's extensive research shows that Sensory Deprivation (S.D.) subjects pick up imperfections in a group of slides unnoticed by a non-confined group; now and then S.D. subjects see colors in black-and-white drawings.[65] Vernon concludes that "man's jaded sensory world takes on a new meaning as a result of S.D. The ordinary, the usual, the almost unnoticed of our everyday world become, under S.D., very desirable experiences, and perhaps for the first time we come to appreciate the value of our ever-changing stimulus world."[66]

Many scientists believe that mental acts such as thinking are really physiological.[67] Perception incorporates percepts from the outer, physical world and the inner physical world; the latter can be divided into "intracerebral percepts" (thoughts, desires, memories, imagery) and "extracerebral percepts" which are "sensed" physiologically.[68] In art-viewing the former usually overwhelm the latter. There is a common tendency to associate immediately an unfamiliar work of art with a familiar "feeling." The curiosity which should be at the core of any vital aesthetic experience is thus neutralized. The layperson

101. *Abstract Painting, Black.* 1960–66. Oil on canvas, 60 x 60". The National Gallery of Australia, Canberra

moves on for another spark of titillation which will also be doused with facile explanations: "I don't know anything about art but I know what I like"; Reinhardt's 1946 answer to this cliché was, "Yeah, isn't it nice that the obligation to be intelligent doesn't extend to the field of art?"[69]

The answer to the question "what does it mean?" will come from much looking at good pictures rather than answers received to the questions.
—Stuart Davis[70]

There is no neutral surface, no neutral discourse, no neutral form. Something is neutral only with respect to something else....To be looking at something that's 'empty' is still to be looking, still to be seeing something—if only the ghosts of one's own expectations. In order to perceive fullness, one must retain an acute sense of the emptiness which marks it off; conversely, in order to perceive emptiness, one must apprehend other zones of the world as full.... If only because the art-work exists in a world furnished with many other things, the artist who creates silence or emptiness must produce something dialectical: a full void, an enriching emptiness, a resonating or eloquent silence.—Susan Sontag[71]

Any art of psychic sensation, no matter how rejective, no matter how united in form and content, no matter how impersonally or objectively it is handled, does evoke a psychic state. Analysis of such a state need not, however, depend on Freudian theory. Representational painting, because of its high information output, is always open to a certain amount of iconographical hypothesis and associational interpretation from both expert and layperson. There has been a carry-over of such content-hunting into non-objective art criticism. Freudian analyses of the artist's private life are not uncommon, nor are allusions that clearly bear on nothing but the writer's own private life. The black paintings, and non-relational or "boring" art in general, constitute strong protests against easy or "entertaining" art. The aloof and apparently hostile character of much art in the sixties, Reinhardt's included, comprises a weapon against interpretive indulgence on the part of the viewer, who is in turn driven back to metaphorical allusions, resorting to literary and symbolic terms to elucidate his or her experience of an abstraction. A very subtle work, or a particularly obdurate one, in which there is "nothing" to look at, stymies the common urge to literary interpretation. As a result it can produce a kind of overcompensation on the part of the viewer, who is more often irritated than challenged when confronted by art that does not land immediately in his or her interpretive lap.

The obvious incompatibility of non-objective art and conventional symbolism and "meaning," and the search for a word or concept that encompasses both remain the unsolved issues at hand. So far the best proposal has probably been the Gestalt psychologists' assumption of an actual *structural* resemblance

Colorplate 34. *Abstract Painting, Black.* 1960–66. Oil on canvas, 60 x 60". Marlborough Gallery, New York

between visual symbols and their corresponding philosophical notions. While the philosophical bases of the black paintings are problematic, the physical fact of their existence, their presence, is a very real point of departure. The notion of abstract art as real, or as concrete as any other object, goes back, of course, to Malevich, Mondrian, and Kandinsky. Reinhardt was one of the major advocates in America of this still not wholly accepted approach.[72] "If you think that every painting should look like something real," began the first of his "How to Look" cartoons, "then you live in that century (long gone) that believed the real world was a matter of what things look like. . . . A Cubist painting is not a 'picture' or a window-frame-hole-in-the-wall, but a new object hung on the wall and is part of the early twentieth century's overturning of traditional ideas of time and space."[73] His most famous cartoon image, one he used repeatedly, was based on an idea of Wolfgang Paalen. It showed a man laughing at an abstract painting and saying, "Ha ha, what does this represent?" The painting points back at him and says, "What do *you* represent?"

Of course the idea that a painting can be seen as a painting rather than as a container for meaning does not in itself encourage uniformity. Yet historically it provided the immediate impetus for such a notion. As soon as a painting was considered an autonomous object, it lost its obligation to be a container. Painting as container needs illusion and images to imitate the world around it, and needs meaning to be included in the entire (literary) intellectual tradition of "appreciation." A concrete painting can and must concentrate upon its own nature; the result is an immediate and drastic refinement, an acceleration of the process of achieving the plane that has constituted the history of modernist art. As soon as painting was freed from the demands of representation, the idea implicit in Monet's serial work, in Cézanne's apples, or in Cubist still lifes, and explicit in Mondrian's reduction to primary colors and right angles, led toward uniformity.

Since around 1965, it has often been said, seriously and semi-seriously, that painting is dead.[74] Reinhardt, insisting that he was painting the "ultimate" painting, had apparently rejected all that could be rejected; he had reached an ultimate conformity that could be extended only by having someone else paint his work or by giving up painting altogether. His "Twelve Rules" had ruled out everything that seemed to distinguish one painting from another. Yet at the same time, he proved that uniformity is no more an anti-aesthetic notion than any other, if one can see beyond the traditional aesthetic into the nature of contemporary painting and the contemporary sensibility. In a world that is increasingly international and potentially uniform, within which rapid change threatens to level out quality distinctions, or rather to establish new and broader criteria for quality, one of the salient questions is: If variety is no longer the spice of life, what replaces it?

The very proliferation of "boring" artistic phenomena all over the world is significant. The apparent redundancy of acid rock, electronic music, Beckett's

102. *Abstract Painting, Black.* 1960–66. Oil on canvas, 60 x 60". Private Collection

novels, Pinter's plays, or Reinhardt's paintings implies the extension of aesthetic stimulation beyond obvious contrast. There are both optimistic and pessimistic approaches and reactions to this situation.[75] Paul Tillich felt that a new religious art was emerging because abstraction had made it possible: "He who can bear and express meaninglessness shows that he experiences meaning within his desert of meaninglessness."[76] Others see the inseparability of form and content as the final step in robbing visual art of any relevance to society. Wylie Sypher predicts an "unstructural state of equilibrium," which corresponds to the formlessness of the black paintings, as a terminal entropy, a loss of energy and absence of events; and the revolution in Western philosophy as "a final deromanticizing of man's view of himself; it suggests that any surviving humanism must be based upon a negative view of the self, if not a cancellation of the self."[77]

Doomsayers have for years been predicting the end of art and the end of the world. Meanwhile, scientists are constantly discovering areas in which human knowledge has barely scratched the surface. Marshall McLuhan, Herbert Marcuse, and George Kubler have all asserted art's potential as a predictive science. Reinhardt's "ultimate" painting may have marked the end of one approach to art, but at the same time it provided fertile ground and great influence on the younger artists coming after him, whose goal of exploration beyond the visible properties of things fundamentally differ from his.

An insistence on purity and oneness, on the essential, which can encourage exaggeration and bypass immediate comprehensibility, often characterizes societies (and art) in the process of radical change. Life becomes so complex that periodic purification rites become necessary for organic survival. Elementary geometric forms, huge size, avoidance of ornament were also the ideals of the so-called "Visionary Architects" of pre-revolutionary France; they reappeared in Suprematism and Constructivism at the time of the Russian Revolution. Harold Rosenberg, who was unsympathetic to a purist aesthetic, contended that "every Utopian society, from the Mormons to Hitler, tends to disintegrate the notion of art." Yet at the same time, he remarked on the irony of the negative attitude, the fact that each anti-art movement produces a new art. For art is "*declared* by artists. At any moment it may turn out that there is no more art. The next day some fellow wakes up in the morning and declares art all over again. In the twentieth century art has gotten to be something which is always on the verge of ceasing to exist. And is redeclared by the artist who stubbornly says: regardless of conditions I am convinced that I can do it. This is what you might call the permanently precarious condition of art."[78] Similarly, Hilton Kramer called the black paintings "a cry of despair disguised as a Utopian manifesto."[79] (It is significant that, like Rosenberg, he professes to see nothing in them.) But it is precisely upon that paradoxical, if extremely understated, fusion of hope and despair, end and beginning, that the aesthetic of the black paintings rests. As the paintings became more demanding and difficult in the late fifties, the

Colorplate 35. *Abstract Painting, Black.* 1960–66. Oil on canvas, 60 x 60". Private Collection

world's corruption seemed increasingly outrageous. At the same time, Reinhardt's dogmas became increasingly transcendental, increasingly committed to "one art" and one way; and the paintings, which to some seemed to be disappearing into darkness, also offered an increasingly hermetic beauty to those who saw them (to those who, by implication, had hope). Berdyaev wrote that "the bourgeois is precisely the person who invariably prefers the visible to the invisible," palpable to void, large to small.[80]

The Tao is through and through mysterious and dark.—Ad Reinhardt[81]

No one will take No for an answer.
Freedom is a negative; it's freedom from something.—Ad Reinhardt, 1964[82]

Post Impressionism is accused of being a negative and destructive creed. In art, no creed is healthy that is anything else.—Clive Bell[83]

The destructive element is too little emphasized in modern art.
—Piet Mondrian[84]

The important thing is the painting out. If you want to be left with nothing, you can't have nothing to begin with. You can only make something by taking things apart.—Ad Reinhardt, 1965[85]

All art is, of course, destructive to a degree; even the most photographic realism is a matter of endless choice and elimination. Reinhardt's emphasis on destruction dates from about 1940, when he began to paint out the closed geometric forms of Synthetic Cubism and to shatter his hitherto integrated surfaces by such techniques as washing them under the faucet and using collage, which, as Martin James observed, "is by nature in a sense already destroyed."[86] Reinhardt's negativism, however, was diametrically opposed to that of Duchamp, who eliminated all but the elements of choice and chance. Elimination of form and color by formal and chromatic equilibrium is not the same thing as elimination of form and color by a single gesture — such as a canvas painted solid black with no particular surface, paint, or light qualities. Reinhardt's negativism was materialist, anti-metaphysical, and anti-literary. "If you're absolutely negative," he said, "you leave yourself open to some positive thing not possible to pin down anyway. It's always more clear to say what it wasn't than what it was."[87] The less visually oriented viewer, however, is less likely to perceive the positive element. "Within these canvases the work of destruction has been ruthlessly complete," wrote the philosopher Richard Woll-

103. *Abstract Painting, Black.*
1960–66. Oil on canvas, 60 x 60".
The Tate Gallery, London

heim of the black paintings, "and any image has been so thoroughly dismantled that no *pentimenti* any longer remain."[88]

As Baudelaire remarked in regard to Ingres, there is an element of sacrifice in all "classical" art. By risking the good for the great, one loses something only in the hope of gaining something still more precious. The end Reinhardt had in mind was pragmatic, not nihilist (a word which in a strict sense can be used only in a political context). The classical tradition has always endeavored to destroy those elements not "high" and pure enough for art; the romantic tradition has had its own purgative methods. No valid art accepts more than it rejects. Only imitators are uncritical of the recent past. Even the Dadas, who rejected art by accepting the whole world as art, accepted art as an agent of total reform. The difference is perhaps that the classical artist, rather than flailing out at all barriers, picks a precise way over those in his or her path, discreetly discarding excess baggage rather than heaving it all at once at the enemy. Reinhardt set himself firmly on the side of Ingres, Poussin, Seurat, Malevich, and Mondrian, unequivocally rejecting the fusion between art and life that characterizes an acceptive aesthetic, whether it was Dada, Pop art, or the periodically revived "New Image of Man" syndrome. According to him, art provided its own, aesthetic, emotions, which had nothing to do with the ordinary emotions of everyday life. In this regard he often quoted Clive Bell, whose *Art* was published the year Reinhardt was born and whose ideas had greatly influenced him: "Representation is a sign of weakness in an artist. A painter too feeble to create forms that provoke more than a little aesthetic emotion will try to eke that little out by suggesting the emotions of life....To seek, behind form, the emotions of life is a sign of defective sensibility always. It means that his aesthetic emotions are weak, or imperfect."[89]

Reinhardt wanted his work to be "a clearly defined object, independent and separate from all other objects and circumstances... whose meaning is not detachable or translatable."[90] It is ironic that translation and detachment of meanings inevitably accumulate around its implacability. One of the most delicate problems inherent in the black paintings is their mystical or transcendental quality. Although Reinhardt vehemently denied any such intention, some viewers have placed it at the core of his aesthetic. The color black, the internal, flickering trisection (read as a cross), the ritual repetition of a single surface, and the slowed pace by which the black paintings demand to be viewed are equally responsible. Black has traditional connotations difficult to discard and Reinhardt himself rather perversely enjoyed listing its common associations, some of which he accepted for his own, though on a superficial level. He considered the choice of black a moral choice, and liked the idea that black is worn by ministers and priests, who represent a "solemn token of absolute principles," as well as by Puritans who were "self-righteous, self-critical." Black is negation, "infinite and inevitable, the complete insoluble

Colorplate 36. *Abstract Painting, Black.* 1960–66. Oil on canvas, 60 x 60". Pace Gallery, New York

mystery." A determined underdog himself, Reinhardt noted Western culture's bias toward white over black and listed in his notes such idioms as "black-hearted, black-list, blackmail, black sheep." He quoted Shakespeare: "Black is the badge of hell, the hue of dungeons, and the suit of night," but saw those who disliked black because of its morbidity and despair as "clinging to life, naiveté, superstitiousness, fear."[91]

Personally, he saw black as representing privacy, passivity, the "withdrawal of the recluse, rebirth in seclusion . . . inner, subterranean," and finally, "the other side, transcendent." Black was "intellectuality and conventionality," the "medium of the mind" (Redon), "the divine dark" (Meister Eckhardt), the Tao "dim and dark" (Lao Tzu). Not averse to noting that the *Kaaba* in Mecca was a black cube, Reinhardt still wanted to "eliminate the religious ideas about black" and replace them with strictly aesthetic notions. During a symposium on black just before his death, someone noted that architects seldom used black because "black destroys scale. When you destroy scale you disorient yourself."[92] Reinhardt enjoyed the challenge of limiting the all-engulfing black, the illimitable "dark of absolute freedom," and set himself the task of compressing it into a five-foot square. Yet he was also aware of "the visible object as incomplete, part of something larger; whole is only partly present, objects also, parts, hidden parts."[93] Thus, in a typically paradoxical manner, he noted the necessity of singleness while conceding a greater multiplicity.

Reinhardt was fascinated by the reconciliation of opposites and he constantly returned to ideas like Paul Tillich's "the negative lives from the positive it negates" or Lao Tzu's "being is the product of non-being." His own art, to employ a typical listing device, is: conceptual/intuitive, cerebral/sensuous, colorful/colorless, flat/atmospheric, precise/painterly, classic/romantic, idealist/materialist, academic/individualist, passive/active, impersonal/personal, sparse/rich, destructive/constructive, absolute/ambiguous, static/vibrating, clear/invisible, anti-humanist and conceived in human scale ("high as a man, as wide as a man's outstretched arms")—humanist, that is, in the broad sense rather than in the personalized, anthropomorphized sense of an expressionist humanism.

Above all, Reinhardt considered again and again, in his paintings and in his notes, the resolution of dark and light: "a luminous darkness, true light, the undifferentiated unit, oneness, no divisions, no multiplicity, no consciousness of anything, no consciousness of consciousness."[94] He called painting a ritual process, his writings dogmas, and did not hesitate to equate the artist (himself) with God, who "takes something and can make nothingness of it." Combined with his trisection and the other-worldly glow of his surfaces, such statements have an irresistibly religious ring. Tillich called Reinhardt's work religious "in its non-representational expression of mystic depths of experience."[95]

Ritual pervades every aspect of the black paintings, from the slow and

104. *Abstract Painting, Black.*
1960–66. Oil on canvas, 60 x 60".
Private Collection

exacting process of their execution by the artist to the equally slow and exacting process of their perception by others. Ritual provided the physical counterpart or end to the rules that formed the intellectual framework within which Reinhardt made art. This was ritual, however, for ritual's sake, unconnected to theological dogma other than his own art-dogma, and arising directly from the paintings themselves. As Barbara Rose has pointed out, the mystical and humanist elements in Reinhardt's work are undeniable, despite his own disclaimers and silences on the subject. Even though these elements exist in an unfamiliar context, there is always an "insistence on the privacy and intimacy of the communication between artist and viewer." Within the context of Western as well as of Eastern mysticism, "the function of the black paintings as objects of disinterested contemplation—demanding not merely a different order of perception but inducing a qualitatively different state of consciousness from normal consciousness — becomes clearer."[96]

This experience must be registered on a non-literary, even non-verbal level different from that of the art Reinhardt wanted to replace. For the most part he succeeded in wrenching what we call, for lack of another term, the religious or mystical elements out of their standard literary context and making them state something separate about his art, about the goal of a single, imageless, colorless, lineless, timeless surface. Similarly, the most subjective borrowings from mystical writings are incorporated into his dogmas and become matter-of-fact descriptions of objects; the black painting, in a strictly perceptual sense, also "becomes pure by detaching itself from everything . . . a luminous center of light in which all controversies are understood, trans-subjective."[97] His attitude corresponded to that of Alain Robbe-Grillet (quoting Joë Bousquet): "We must, finally, guard against allegorical constructions and against symbolism. . . . Each object, each event, each form is in effect its own symbol. *'Do not say that there are wooden crosses and the sign of the cross.* There would be an unreal sign and a thing signified, which would be real. One and the other are, simultaneously, realities and signs.'"[98]

As the activity of the mystic must end in a via negativa, *a theology of God's absence, a craving for the cloud of unknowingness beyond knowledge and for the silence beyond speech, so art must tend toward anti-art, the elimination of the "subject" (the "object," the "image"), the substitution of chance for intention, and the pursuit of silence. . . . Therefore, art becomes estimated as something to be overthrown. A new element enters the art-work and becomes constitutive of it: the appeal (tacit or overt) for its own abolition—and, ultimately, for the abolition of art itself.* —Susan Sontag[99]

Formless art thou, and yet thou bringest forth many forms, and then withdrawest them to thyself. —The Bible[100]

Colorplate 37. *Abstract Painting, Black.* 1960–66. Oil on canvas, 60 x 60". Pace Gallery, New York

[Mula-Prakriti is] the pure void, for only as such can it contain a pure fullness. But in the act of reaction in space and time it becomes a matrix of forms, in which three qualities or tendencies appear. In the void of Mula-Prakriti these qualities are not distinguishable because they balance each other perfectly. Only in the realm of visible nature is this balance no longer perfectly maintained. Again, at the universal dissolution, all are withdrawn and return to the First Cause, Avyakata, the unmanifested One which is Mula-Prakriti.
—Ajit Mookerjee[101]

Reinhardt was a moralist, not a religious man in terms of any organized religion (which he saw as "just another gadget for everyday life"[102]). But implicit in his writings is the unspoken assumption that all wholly uncompromising conviction is "religious." He was not anti-clerical, although progressively disillusioned by his favorite "religious writers," whom he listed in an undated letter to Thomas Merton — Suzuki, Coomaraswamy, Tillich, Maritain, Merton; Buber was the exception. Reinhardt was intellectually interested in ritual and in religious philosophies, particularly in "negative theology," such as Buddhism, which he saw as more of an aesthetic than a religion. "The idea of negativity is not a bad idea any more, whereas once the positive seemed great and the negative terrible."[103] He saw religion in the broad sense indicated by Clive Bell, who distinguished between the ordinary observer who looks at pictures as sources of information and those "artists and educated people of extraordinary sensibility and some savages and children[who] feel the significance of form so acutely that they know how things look....For the mystic, as for the artist, the physical universe is a means to ecstasy. The mystic feels things as 'ends' instead of seeing them as 'means.' ... The religious spirit is born of a conviction that some things matter more than others. To those possessed by it there is a sharp distinction between that which is unconditioned and universal and that which is limited and local."[104] Or, as the Reinhardtian dogma has it: "The one question, the one principle, the one crisis in art of the twentieth century centers in the uncompromising 'purity' of art, and in the consciousness that art comes from art only, not from anything else."[105]

Fundamentally, Reinhardt's interest in theology and the history of religious traditions arose from his consuming interest in history itself, the cyclical repetition of forms and ideas which he hoped to synthesize, and thus culminate, in his own art. His view of history corresponded with his view of art, and with the physical appearance of the black paintings, which include all by excluding all. "The one content and one matter of the art-historical-process is the doctrine of ahistorical immaterialism. Art is a superstructure, a grand pattern and noble manner and quiet grandeur and will never wither away."[106] He saw art history in the context of a continuing civilization where the material or art object is primary and recurrent, and the immaterial or idea is secondary, deriving from the art-as-art:

105. *Abstract Painting, Black.* 1960–66.
Oil on canvas, 20 x 20". Collection
Mr. and Mrs. Irving Sandler, New York

The history of art is a constant course, always follows a predetermined pattern and unfolds a pre-established form. The history of fine art is a straight line moving up and down, progressing onward and upward in cycles and spirals, moving back and forth, in and out, but mainly the history of art is a fixed point, essentially unmoveable, changeless, square, dark, unreflecting, timeless. Its space is in the mind and in the museum.[107]

The one history of painting progresses from the painting of a variety of ideas with a variety of subjects and objects, to one idea with a variety of subjects and objects, to one subject with a variety of objects, to one object with a variety of subjects, then to one object with no subject, and to one subject with no object, then to the idea of no object and no subject and no variety at all. There is nothing less significant in art, nothing more exhausting and immediately exhausted, than"endless variety."[108]

Accordingly, the new is explicable only by comparison with the old, as a variant of the old not previously extended. To the postwar art world, hungry for novelty, Reinhardt offered an avant-garde that is a repetition of the old — precedented and potentially repeatable—not a popular position. By 1962, he was supported in his conviction that there is nothing new under the sun by the historian George Kubler, whose *The Shape of Time* Reinhardt much admired. When the book appeared in paperback he gave it to numerous friends, thereby injecting it into the intellectual consciousness of the art world; and he reviewed it in *Art News*, paraphrasing Kubler and reinforcing his own contention that art history, in its prevailing biographical, iconographical, and stylistic forms, is inadequate to deal with art-as-art:

> The history of art is the history of art not the history of the universe or the history of the earth or the history of man or the history of society or the history of individuals or the history of history. The history of art is the history of art-forms, art-projects, art-worlds, art-artists.[109]

Reinhardt welcomed Kubler's suggestion of a history based on aesthetics alone, a system of series, sequences, classes; since he claimed not to believe in originality, which he considered the opposite of history, he particularly endorsed Kubler's still more radical suggestion:

> Perhaps all the fundamental technical, formal and expressive combinations have already been worked out at one time or another, permitting a total diagram of the natural resources of art. . . . Instead of our occupying an expanding universe of forms, which is the contemporary

Colorplate 38. *Abstract Painting, Black.* 1960–66. Oil on canvas, 60 x 60". Collection Gilman Paper Co.

artist's happy, but premature assumption, we would be seen to in-
habit a finite world of limited possibilities, still largely unexplored....
Instead of regarding the past as a microscopic annex to a future of
astronomical magnitudes, we would have to envisage a future with
limited room for changes, and these of types to which the past already
yields the key.[110]

These theories are also applicable to the development of Reinhardt's indi-
vidual paintings, for "just as artists come from artists and art-forms from
art-forms, painting comes from painting."[111] Black paintings come from red
and blue paintings and then black from black. The latter constitute a "timeless"
or "post-historical" period. In his notes Reinhardt predicted that the "late black
square uniform five-foot timeless trisected evanescences of the late sixties"
would be succeeded by "Archaic black square uniform five-foot timeless
trisected evanescences of the early seventies,"[112] completing the cycle from
archaic to archaic. His art — the "last paintings anyone could paint" — was to
have progressed from nothing to nothingness. "But the end is always a begin-
ning. The drama is to attempt instantly to reach the end that you can never really
reach."[113]

*Where painting has reached divinity there is an end of the matter
(material).* —from the Chieh Tzǔ Yüan [114]

*Where European art naturally depicts a moment of time, an arrested action
or an effect of light, Oriental art represents a continuous condition.... A
democracy, which requires of every man to save his own "face" and soul,
actually condemns each to an exhibition of his own irregularity and imperfec-
tion, and this implicit acceptance of formal imperfection only too easily
passes over into an exhibitionism which makes a virtue of vanity and is
complacently described as self-expression.* —Ananda Coomaraswamy[115]

Nowhere is Reinhardt's view of history as "that pre-ordained, timeless
'stylistic art-cycle' of every time and place"[116] clearer than in his writings on
Asian art, which he studied at New York University and taught at Brooklyn
College and Hunter from 1947 to his death. As his studies progressed (and they
never ceased) he became increasingly aware of correspondences between his
own aims and ideas and those of certain periods of Eastern culture. Naturally,
he found correspondences between certain Western periods and artists as well;
there is no basis for considering the black paintings solely in terms of either East
or West. Like most artists, Reinhardt tended to see *everything* in terms of his own
art and its ideals. In an essay on Khmer art, for example, he described the

106. *Timeless Painting.* 1960–65.
Oil on canvas, 15 x 15". Collection
Raymond L. Dirks, New York

Cambodian temple-tomb palace as "a structure 'of four aspects,' an architectural mandala in stone, a magic diagram and 'chronogram,' square, cruciform."[117] "If there is one thing to say about Asian art, then," he wrote, "it is about its timelessness, its monotony, its inaction, its detachment, its expressionlessness, its clarity, its quietness, its dignity, its negativity."[118]

The importance of oriental art for Reinhardt's own art does not lie in any direct physical resemblances. The slowly developing but vital aesthetic of Chinese painting to the fourteenth century, of the classical Indian and Islamic arts, the search for perfection within the apparently narrow confines of a traditional academy and iconic set of conventions, dualism without contradiction, "a manifestation of an undifferentiated whole, interacting in perfect equilibrium,"[119] the divorce of art from the petty ordeals of daily life (sometimes from the image itself), and the extended time sense derived from such ritual serenity—these were ideas particularly suitable to Reinhardt's own temperament and to his convictions about what art and artist should be.

The black paintings are in part reactions or bulwarks against notions of "originality" and the rapid pace of the postwar world. In Asia, Reinhardt wrote, somewhat nostalgically, "standard forms and identical patterns are repeated and refined for centuries. The intensity, consciousness and perfection of Asian art comes only from repetitiousness and sameness, just as true originality exists only where all artists work in the same traditions.... Real freedom in art, and the absolute essence that makes art the thing it is, can be realized only through the formula; in Asia this has been understood."[120] The Chinese concept of *hsiang*, for example, states that "the more abstract and unparticularized the pictorial forms, the nearer they approach to the true form." The long and short lines of the *pa kua* (a basic trigram from which the sixty-four hexagrams are formed) "are only one step removed from the complete undifferentiation of the Great Ultimate, they approach as near as is possible to constituting its outward and visible symbol."[121] Both Mondrian's and Reinhardt's programs correspond to such a systematized but non-hierarchal concept.

Islamic art was the subject of Reinhardt's last concentrated study in the oriental field. In 1958, he made a pilgrimage to Isfahan,[122] where he was attracted by the theological denial of nature and schematic denial of the third dimension, the "all-over" or "interminable" ornament, Islam's dematerialized, unworldly spirit, the high degree of non-interpretive abstraction, and the apparent "monotony" of Islamic art. Yet, as Kenneth Clark has observed, "Syrian iconophobia was based on purity of *sensation*, in which the sensuous immediacy of art gained force by being deprived of recognition and the complex train of associations which the figure arts arouse. But although we cannot call imageless art puritanical, we can properly call it anti-catholic, something outside of the main classical tradition and, to a large extent, something revolutionary, militant and intolerant."[123]

Colorplate 39. *Abstract Painting, Black.* 1960–66. Oil on canvas, 60 x 60". Private Collection

Reinhardt deplored "the inability of art historians to accept artists' imagelessnesses and meaninglessnesses at any time or place not to speak of all times and places," and found it:

> ...nowhere more hilariously exposed than in histories or surveys of classic Islamic nonfigurative art. An interlaced triangular pattern is forced to represent the starry heavens, a circular design must mean the solar disc, overlapping circles are seen as thistles and lotus buds, flowers and the ancient tree of life, arabesques confronted and reversed are only understood as vases of the waters of life, every almond or leaf form however conventionalized or stylized is the oasis, symbol of life in the desert, the garden of paradise, every vault is a dome of heaven, every dome is a vault of heaven. Why have Islamic artists done all this work? To escape flogging? As slaves to generals, warriors, aristocrats? For the Glory of God? When have fine artists anywhere not done everything they've done except for the glory of God? Except for its own sake, the work of art as art, as art from art-as-art?[124]

In Kubler's terms, by which art is classified by type rather than by time and place, Reinhardt's paintings and those of the early Chinese become like points at like curves in an endless spiral which includes both East and West. Perhaps it is only now, when the West has acknowledged the impersonal as well as the personal qualities of art, that such a drawing together is possible. It has been observed that the Eastern "One" is impersonal and the Christian God is a person. Something of that distinction remains (and has been adopted by the East), for Western art is usually committed to the individual part (or ego) rather than to a generalized whole. But an abstract art for art's sake, by denying the importance of any outside factors, becomes common ground for perceptual/ intellectual pleasure. What Reinhardt and the East both admitted, and what is anathema to the conventionally rational Western mind, is "the unconditional and infinite character of the Ultimate, and the impossibility of identifying it with anything particular that exists."[125] Mondrian, Klee, Kandinsky, and Tobey all had strong ties with Eastern thought and this was a factor in their formal attempts to transcend the parts in favor of the whole. If, for the time being, Reinhardt's ideals of monotony and repetition are sources of antagonism and anxiety for the average Westerner, an increasingly accepted refutation of the lineal theory and the justifiable contention that the West is approaching the East, and vice versa, bodes otherwise for the future.

Colorplate 40. *Timeless Painting.* 1960-65. Oil on canvas, 60 x 60". Private Collection

There is just one art, one art-as-art.

There is just one fine art, one abstract art, one free art.

There is just one museum of fine art everywhere.

There is just one art history, one art evolution, one art progress.

There is just one aesthetics, just one art idea, one art meaning, just one principle, one force.

There is just one truth in art, one form, one change, one secrecy.

There is just one artist always.

There is just one artist-as-artist in the artist, just one artist in the artist-as-artist.

There is just one art process, just one art invention, just one art discovery, just one art routine.

There is just one art-work, just one art-working, just one art-non-working, one ritual, one attention.

There is just one painting, one brushworking, one brush-overworking.

There is just one painting everytime.

There is just one direction, one directionlessness, one size, one sizelessness, one form,
 one formlessness, one formula, one formulalessness, one formulation.

There is just one image, one imagelessness, one plane, one depth, one flatness, one
 color, one colorlessness, one light, one space, one time, one timelessness.

There is just one repetition, one destruction, one construction, one dissolution, one evanescence.

There is just one abstraction, one rhythm, one eloquence.

There is just one style, one stylelessness, one matter, one sequence, one series, one convention, one tradition.

There is just one qualitylessness, one object, one subject, one standard.

There is just one participation, one perception, one invisibility, one insight.

There is just one edge, one framework, one ground, one existence, one fabric, one focus.

There is just one way, one side, one vision, one freedom.

There is just one problem, one task, one obligation, one struggle, one victory, one disciple.

There is just one negation, one value, one symmetry, one monochrome, one touch, one energy.

There is just one shape, one square, one execution, one transcendence.

There is just one method, one manner, one interlace, one overall, one overlap, one
 order, one rule, one thought, one spontaneity.

There is just one material, one materiality, one density, one presence, one absence, one disembodiment.

There is just one simplicity, one complexity, one spirituality, one uselessness, one meaninglessness.

There is just one statement, one technique, one texture, one importance, one silence, one texturelessness.

There is just one reason, one means, one emptiness, one irreducibility, one end.

There is just one art-morality, just one art-immorality, one art-enemy, one art-indignity, one art-punishment,
 one art-danger, one art-conscience, one art-guilt, one art-virtue, one art-reward.

107. Ad Reinhardt, 1958

There is just one art, one artlessness, one painting, one painterliness, one painterlilessness.

There is just one difference, one sameness, one consciousness, one nothingness, one
 rightness, one indivisibility, one essence, one fineness.

There is just one thing to be said, one thing not to be said.

—Ad Reinhardt[126]

NOTES

1. Ad Reinhardt, "How to Look at Things," *PM*, July 7, 1946.
2. George Kubler, *The Shape of Time*, Yale University Press, New Haven, 1962, p. 124.
3. Ad Reinhardt, "Art-as-Art," *Art International*, Dec., 1962, p. 37.
4. Clement Greenberg, "After Abstract Expressionism," *Art International*, Oct., 1962, p. 29.
5. Ad Reinhardt, "Twelve Rules for a New Academy," *Art News*, May, 1957, pp. 37–38, 56.
6. Dore Ashton, "Art," *Arts and Architecture*, Dec., 1960, p. 4.
7. Rudolph Arnheim, "Emotion and Feeling in Psychology and Art," *Confinia Psychiatrica*, vol. 1, no. 2, 1958, p. 79.
8. Aldo Tambellini, in "Black," *artscanada*, Oct., 1967, p. 5.
9. Priscilla Colt, "Notes on Ad Reinhardt," *Art International*, Oct., 1964, p. 34.
10. Ernst Gombrich, *Art and Illusion, A Study in the Psychology of Pictorial Representation*, Pantheon (Bollingen Foundation), New York, 1959, p. 12.
11. John Dewey, *Art as Experience*, Capricorn Books, New York, 1958, p. 46. This book was first published in 1934 and the ideas therein much impressed Reinhardt, who quoted them in the cartoons.
12. Ad Reinhardt, in "Black," *op. cit.*, pp. 7–8.
13. Martin James, "Today's Artists: Reinhardt," *Portfolio and Art News Annual*, 1960, p. 140.
14. *Ibid.*
15. Ad Reinhardt, in "The Philadelphia Panel," *It Is*, no. 5, Spring, 1960, p. 38.
16. Ad Reinhardt, "Artist in Search of an Academy, Part II: Who Are the Artists?" *College Art Journal*, Summer, 1954, p. 315.
17. Ad Reinhardt, in conversation with the author, 1966.
18. Willard Huntington Wright, *The Future of Painting*, B.W. Huebsch, New York, 1923, pp. 20, 21.
19. Ad Reinhardt, interviewed by Bruce Glaser, *Art International*, Dec., 1966, pp. 18–21.
20. Ad Reinhardt, in conversation with the author, 1966.
21. Lawrence Gowing, *Turner, Imagination and Reality*, The Museum of Modern Art, New York, 1966, p. 27.
22. Martin James, *op. cit.*, p. 59.
23. José Ortega y Gasset, "On Point of View in the Arts," *Partisan Review*, Aug., 1949, p. 830.
24. Reinhardt told friends to read Ortega on Velásquez for "a picture of a pure painter."
25. Reinhardt said that Rothko and Still were the first to "talk about Monet," presumably in the forties; "They bypassed Cubism" (in conversation with Irving Sandler).
26. Ortega y Gasset, *op. cit.*, p. 833. "The Intrasubjectives" was an early term for the Abstract Expressionists, and the title and lead quotation for the show of that name at the Kootz Gallery in 1949 were taken from this article. The participants were Baziotes, De Kooning, Gorky, Gottlieb, Graves, Hofmann, Motherwell, Pollock, Reinhardt, Rothko, Tobey, and Tomlin.
27. Heinrich Fuseli, quoted in *Art News*, May, 1966, p. 67.
28. Lawrence Campbell, *Art News*, Oct., 1968, p. 59. Reinhardt was once asked, at a Fogg Museum forum, what he thought of when one said "black." He answered: "I think of white" (reported by Emily Genauer, *New York Herald Tribune*, Apr. 29, 1951).
29. Lucretius, *The Nature of the Universe* (Book II, 740), translated by Ronald Latham, Penguin Books, Baltimore, 1951, p. 81.
30. Alfred Neumeyer, review of *Über das Licht in der Malerei*, by Wolfgang Schöne, *Art Bulletin*, Dec., 1955, p. 303.
31. Sidney Tillim, "Ad Reinhardt," *Arts*, Feb., 1959, p. 54.
32. John Keats, "To Homer."
33. Paul Valéry, *Jeune Parque*.
34. Edwin Land, "Experiments in Color Vision," *Scientific American*, May, 1959, p. 84.
35. Ad Reinhardt, in conversation with the author, 1966. Most of his life Reinhardt made his own stretchers, sized his own canvases with rabbit glue, framed them in self-constructed shadow boxes. On another level, his notes on the "creative process" are informative: "reception of data—impressions—impact of world/social milieu—raw experience—external matter/memory, recollection, selection, imagination and judgment, stimulation/postulates, ideas, feelings, insights, beliefs/conceptions, restrictive conditions/ 'what' is to be done: /revision in psyche—storehouse, beliefs, cumulative/learning, chaos, confusion, meeting-place/unconscious, combined, distributed, assimilated, new/connections, breeding-ground/ 'how' is it to be done—method: / conscious reaction—sudden seizure, revelation,/ excitement, madness, unconscious spills over into consciousness/application, physical, objective/ making of object—whole being—intensity, devotion,/effort—conscious/conclusion: exhaustion, emptiness and accomplishment/relief, let-down, disinterest" (unpublished manuscript, Archives of American Art). He had written in *PM* ("How to Look at Things Again," Aug. 25, 1946): "Art is not a bag of trade-tricks or hack-skills, a property of the few, but a dangerous propaganda for changing and controlling the world so that everyone can be creative."
36. Ad Reinhardt, in conversation with the author, 1967; similarly, he boasted that he had belonged to all artists' groups except Artists Equity, which tried to make a profession of art; he maintained that the Artists' Union and such groups "had to do with politics" (Skowhegan lecture, 1967).
37. Ad Reinhardt, "Art-as-Art," *Art International*, Dec., 1962, p. 37.
38. Kasimir Malevich, from the catalogue of "The Tenth State Exhibition. Abstract Creation and Suprematism," Moscow, 1919; in Camilla Gray, *The Great Experiment*, Harry N. Abrams, New York, 1962, p. 283.
39. George Kubler, *op. cit.*, pp. 54, 44.
40. Elaine de Kooning, "Pure Paints a Picture," *Art News*, Summer, 1957.
41. Clement Greenberg, "The Crisis of the Easel Picture," *Partisan Review*, Apr., 1948, pp. 481–84; not the revised edition in *Art and Culture*.
42. *Ibid.*
43. Richard Wollheim, "Minimal Art," *Arts*, Jan., 1965, p. 30.
44. Ad Reinhardt, "Art-as-Art," *Environment*, Autumn, 1962, p. 53. Redundancy interested Reinhardt from the beginning. In one of the *PM* cartoons, he catalogued all the different eye shapes used by Klee, Picasso, and Miró; notes from his graduate study included pages of schematic drawings of the nearly identical mountain, tree, cloud, or water motifs found in early Chinese art; on his first trip to Europe he noted in his journal, with handsome line drawings, all the different types of telephone and electric poles in the various countries visited (fig. 42).
45. Ad Reinhardt, "Reinhardt Paints a Picture," *Art News*, Mar., 1965, p. 40; he claimed this was a self-interview because no one else would do it. The summer he died, I was supposed to go to Skowhegan to hear Reinhardt lecture and couldn't make it at the last minute (ironically because I couldn't drive in the dark—due to night blindness); over the phone he said that was too bad because I was really going to miss something new and exciting. "What? What?,"

I said. He laughed and conceded proudly that I shouldn't worry—"It's just the same old thing over and over."

46. John Perreault, "Art," *Village Voice*, Dec. 22, 1966, p. 12.

47. Hilton Kramer, *The New York Times*, Nov. 27, 1966.

48. Ad Reinhardt, talk to "an artists' group," 1943.

49. Ad Reinhardt, unpublished notes, Archives of American Art.

50. Alain Robbe-Grillet, *For a New Novel*, Grove Press, New York, 1965, p. 39.

51. Ananda K. Coomaraswamy, *The Transformation of Nature in Art*, Dover, New York, 1956, p. 46.

52. Rudolph Arnheim, "Perceptual Analysis of a Symbol of Interaction," *Confinia Psychiatrica*, vol. 3, no. 4, 1960, p. 215.

53. Anton Ehrenzweig, "Conscious Planning and Unconscious Scanning," in Gyorgy Kepes, ed., *Education of Vision* (Vision + Value Series), George Braziller, New York, 1965, p. 30.

54. Frank Hewitt, "Perceptual Conflict and the New Abstraction," *Anonima*, I/2 [1964], p. 19.

55. Donald Judd, in Lucy R. Lippard, "Homage to the Square," *Art in America*, July—Aug., 1967, p. 56.

56. Robert Fludd, *Utriusque cosmi maiores et minoris historia*, Oppenheim, Frankfurt, 1617, p. 26.

57. Piet Mondrian, "A New Realism," *American Abstract Artists*, Ram Press, New York, 1946, n.p.

58. Piet Mondrian, copy of undated letter to Moholy-Nagy, Reinhardt papers, Archives of American Art.

59. Piet Mondrian, "Home-Street-City," 1926, in Harry Holtzman, ed., *Mondrian*, Pace Gallery, New York, 1970, p. 13.

60. Susan Sontag, "On Style," *Against Interpretation*, Delta Books, Dell, New York, 1967, p. 35.

61. Samuel Beckett, quoted in George Steiner, "Of Nuance and Scruple," *The New Yorker*, Apr. 27, 1968, pp. 164–74.

62. Ad Reinhardt, Glaser interview, *op. cit.*

63. Rudolph Arnheim, "Perceptual Analysis . . .," *op. cit.*, p. 207.

64. Frank Hewitt, *op. cit.*, p. 16.

65. Jack Vernon, *Inside the Black Room; Studies of Sensory Deprivation*, Clarkson N. Potter, New York, 1963, pp. 49, 58.

66. *Ibid.*, p. 203.

67. *Ibid.*, p. 25.

68. Rudolph Arnheim, "Emotion and Feeling . . .," *op. cit.*, p. 77.

69. Ad Reinhardt, "How to Look at an Artist," *PM*, Apr. 7, 1946.

70. Stuart Davis, *Stuart Davis*, American Artists Group, monograph no. 6, New York, 1945, p. 26. Davis goes on to say: "'What is it,' and 'What does it mean' are questions extremely familiar to the modern artist. There is no simple answer to these pesky questions because in reality they are not questions about art at all. They are in fact demands that what the artist feels and explicitly expresses in his work be translated into ideas that omit the very quality of emotion that is the sole reason for its being. In this process, the preconceived idea of the questioner emerges to take the place of the idea expressed by the picture."

71. Susan Sontag, "The Aesthetics of Silence," *Aspen Magazine*, no. 5–6, Fall–Winter, 1967, sect. 3.

72. The Museum of Modern Art presented "The Art of the Real" as a historical/vanguard concept as late as 1968.

73. Ad Reinhardt, "How to Look at Cubist Painting," *PM*, Jan. 27, 1946.

74. Donald Judd is supposed to have initiated this statement.

75. Samuel Beckett and Reinhardt, for instance, differ acutely in that Beckett's disintegrative view implies that only the body endures, while Reinhardt's synthesizing view offers the work of art as the only enduring element.

76. Paul Tillich, "Protestantism and the Contemporary Style in the Visual Arts," *The Christian Scholar*, Dec., 1957, p. 311.

77. Wylie Sypher, *Loss of the Self in Modern Literature and Art*, Vintage Books, New York, 1962, pp. 74, 77.

78. Harold Rosenberg, "The End of Art," *Art Voices*, Summer, 1966, p. 106.

79. Hilton Kramer, *The Nation*, June 22, 1963, p. 534.

80. Berdyaev, quoted by Richard Gilman, *The New York Times Magazine*, Jan. 31, 1971, p. 42.

81. Ad Reinhardt, unpublished manuscript, Archives of American Art.

82. Ad Reinhardt, in "On the Negative Side of Art" by Beverly Wolter, *Winston-Salem Journal and Sentinel*, Apr. 26, 1964, p. D4.

83. Clive Bell, *Art*, Capricorn Books, New York, 1958, p. 43.

84. Piet Mondrian, in James Johnson Sweeney, "An Interview with Mondrian," *Mondrian*, The Museum of Modern Art, New York, 1948, pp. 15–16.

85. Ad Reinhardt, from notes taken by a student (E.B.R.) at a lecture at Bennington College, Nov. 5, 1965; corrected by Reinhardt.

86. Martin James, *op. cit.*, p. 57.

87. Ad Reinhardt, in conversation with the author, Aug. 15, 1966.

88. Richard Wollheim, *op. cit.*, p. 32.

89. Clive Bell, *op. cit.*, p. 29.

90. Ad Reinhardt, "Three Statements," *Artforum*, Mar., 1966, p. 35.

91. All quotes about black, here and below, taken from Ad Reinhardt, unpublished notes on "black," Archives of American Art.

92. Harvey Cowam, in "Black," *artscanada*, *op. cit.*, p. 4.

93. Ad Reinhardt, unpublished notes, Archives of American Art.

94. *Ibid.*

95. Paul Tillich, in "Art," *Newsweek*, Aug. 23, 1954, p. 53.

96. Barbara Rose, in *Ad Reinhardt*, Marlborough Gallery, New York, 1970, p. 19.

97. Ad Reinhardt, unpublished notes, Archives of American Art.

98. Alain Robbe-Grillet, *op. cit.*, p. 107. In one sheet of his notes, Reinhardt made a cross by writing "mysticism" vertically, with "historical" crossing it horizontally.

99. Susan Sontag, "The Aesthetics of Silence," *op. cit.*

100. "The Bible," quoted by Reinhardt in unpublished notes, Archives of American Art.

101. Ajit Mookerjee, *Tantra Art, Its Philosophy and Physics*, Kumar Gallery, New Delhi, New York, Paris, 1966/67, pl. 95.

102. Ad Reinhardt, Skowhegan, *op. cit.*

103. Ad Reinhardt, in conversation with the author, 1966.

104. Clive Bell, *op. cit.*, pp. 62–63.

105. Ad Reinhardt, "Art-as-Art," *Art International*, *op. cit.*, p. 37.

106. Ad Reinhardt, unpublished notes, Archives of American Art.

107. *Ibid.*

108. Ad Reinhardt, "Art-as-Art," *op. cit.*

109. Ad Reinhardt, unpublished notes, Archives of American Art.

110. George Kubler, *op. cit.*, pp. 125–26.

111. Ad Reinhardt, unpublished notes, Archives of American Art.

112. *Ibid.*

113. *Ibid.*

114. From the Chieh Tzǔ Yüan, quoted by Coomara-

swamy, op. cit., p. 44.

115. Ananda K. Coomaraswamy, op. cit., pp. 48–49, 52.
116. Ad Reinhardt, unpublished notes, Archives of American Art.
117. Ad Reinhardt, "Angkor and Art," in Khmer Sculpture, Asia House, New York, 1961, p. 6.
118. Ad Reinhardt, "Timeless in Asia," Art News, Jan., 1960, p. 33.
119. Michael Sullivan, "Pictorial Art and the Attitude Toward Nature in Ancient China," Art Bulletin, Mar., 1954, p. 5.

120. Ad Reinhardt, "Timeless..." op. cit., p. 34.
121. Sullivan, op. cit., p. 2.
122. Reinhardt traveled a good deal, especially in the Near and Far East. In 1953 he went to Greece; in 1958 to Japan, India, Persia, and Egypt; in 1961 to Turkey, Syria, and Jordan; in 1966 to Japan; he also visited Europe several times beginning in 1952.
123. Kenneth Clark, "The Value of Art in an Expanding World," The Hudson Review, Spring, 1966, p. 18. Islamic mosques are also "square, cruciform," and the centralized building, where the glance wanders over equalized surfaces, is directly opposed to the Christian basilica, which stresses a definite direction in accord with the historical narrative tendency favored by the West (Otto Demus, Byzantine Mosaic Decoration, London, 1947, p. 16).
124. Ad Reinhardt, unpublished notes, Archives of American Art.
125. Paul Tillich, "A Christian-Buddhist Conversation," Jubilee, Mar., 1963, p. 45.
126. Ad Reinhardt, "There is Just One Painting: Art-as-Art Dogma, Part XIII," Artforum, Mar., 1966, p. 35.

POSTSCRIPT

N.B. This book was written from 1966 to 1969. Due to publication delay, I added this postscript around 1971, since I felt that attitudes toward Reinhardt's ideas had been crystallizing, times had been changing, and critical issues had been raised that did not belong in the body of a book focused on the black paintings, the historical situations from which they came and in which they were made. Nevertheless, given the context of paradoxes that surrounded Reinhardt's contribution and its relationship to newer art during his lifetime (paradoxes which continue to inform its place in the history of modern art), I thought his effect on the art of the '70s should at least be mentioned. Little did I know at the time that another decade would elapse before this book actually appeared. Since a postscript written in 1980 would almost demand a new book, I decided to let this one stand. The issues it raises, though no longer as sharply defined as they once were, are an integral part of the art of the '70s, and cannot be entirely irrelevant to the '80s.

I first became fully aware of Reinhardt's work in 1960, when I saw his "retrospective" at Betty Parsons' galleries in New York and a group of red, blue, and black paintings at the Iris Clert Gallery in Paris. I met him only in 1966, after writing enthusiastically on his three-gallery show the previous year. In the interim, I had been attracted to the spareness and extreme position of the black paintings, to the wit of the writings, and to the tabula rasa implied by both, in which I saw links to various personal interests, such as Zen and Indian philosophies, and even Dada. Later on I had misgivings, as did Reinhardt, about the validity of a romantic like me writing accurately on such an avowed classicist; but whatever synthesis emerged seemed to operate no more or less confusedly than any other combination. My interest in the work has continued to be twofold. I derive the greatest aesthetic satisfaction (exhilaration being perhaps too lively a word for that experience) from the black paintings; and I derive much intellectual pleasure from their paradoxes, from their implications for recent art in general.

If Reinhardt did not make the first of the last abstract paintings, he made the last of the first abstract paintings. His work constitutes a summing-up and a wry comment upon the modernist treadmill which so many artists were forced to ride through the sixties at increasing speed and reductivism. He never failed to emphasize that the end is the beginning, and I see the "ultimate paintings" as the small end of a funnel, an outlet for the narrowing-down process that characterized abstract painting in the sixties. But just as the black paintings were a point of arrival, they were also a point of departure.

While there is no question that good paintings can and will continue to be

made, Reinhardt closed out a specific series that began with Cubism (or perhaps with Impressionism or perhaps with Malevich and Mondrian). At least that is what he did in theory, and theory has been all-important to modernism. In any case, toward the end of his life Reinhardt was brought into the "mainstream" of modern art, complaints by those who found his solution too radical not-withstanding. The black paintings closed out, in one decisive blow, what might have been a more gradual reductive process shared among several artists over a five- or ten-year period. Their exemplary dogmatism even closed out those works which formally or programmatically could go "beyond" them (i.e., one hundred solid black, or transparent or whatever, paintings, empty rooms, blank films, etc.).

As a result, and once their didactic content was understood, Reinhardt's black paintings triggered changes in accepted art ideas. For some people they demonstrated the impossibility of painting anymore at all and opened the way to alternatives by closing off that exit. For others, they restored the history of painting to the makers of paintings, slowing down the single line of "progress" by proving and simultaneously dismissing the progressive or evolutionary theory of art history. Reinhardt showed how "easy" the "final" goal of demonstrating "the nature of painting" could be, and thus made it possible for painters to paint within the tradition of painting, without having to surpass or bypass that tradition. By achieving that goal (for himself at least), he supported his own contention that there is only one art, that there was only one thing he could do with his life, one way to talk about it. He made the making of one painting over and over again a triumph instead of a surrender.

Reinhardt's "one art" was painting, not sculpture (which he defined as "something you bump into when you back up to look at a painting"[1]). Yet those younger artists affected by his conclusions were often the "primary structure" makers, or Minimal artists working in three dimensions. Many of them in turn had gained from the ideas of Frank Stella, who bought one black Reinhardt in 1960, and a second one later; Stella's influential premise of "non-relational" painting may have derived from Pollock and Johns, but no one had solved its problems through abstraction better than Reinhardt. Stella once sketched out for a friend the evolution of his own first major paintings (the black negative striped series from which his important shaped canvases emerged). The biaxially symmetrical, cross-shaped Die Fahne Hoch (1959) ends the series of sketches and is marked "the final solution."[2] I don't intend to suggest that Reinhardt was Stella's sole source, or perhaps even a direct one,[3] simply that Reinhardt's paintings and writings were more public by 1960 than they had been in the fifties, and that several artists now associated with Minimal art found their impact unavoidable.

In fact, the historical relevance of Reinhardt's ideas became clear only after Minimal art had demonstrated that they were applicable to art other than his own black paintings. The rise of Minimal art brought Reinhardt in from the

sidelines he had occupied so vociferously for so long. It is typical of the art world that a single voice, no matter how timely, is considered ineffectual or ridiculous until it is joined by a chorus of echoes. No one was more aware than Reinhardt of the crucial importance of time in life and history, of timelessness in art—and of timing in the art world. His concern with the public image of his art and of his ideas had to do with all three. Art is judged historically by how much power it wields, that is, by how much it influences and engenders other art. The black paintings broke into the larger art-world consciousness around 1965, with the three-gallery show, rather than in 1960 with the two-gallery show, which was appreciated by only a few acute viewers. This was because by 1965 Minimal art had provided the context, the climate. Of course the black paintings did not *break into* the art world in 1965, but had been ensconced there since 1956; they already had their own small coterie of admirers, but they became identifiable to the greater public only when they could be identified with something else.

That this situation was frustrating to Reinhardt, especially in the late fifties, goes without saying. The art dogmas, beginning in 1957 with the "Twelve Rules for a New Academy," probably constituted another attempt to bring the black paintings, or at least their preparatory ideological framework, before the greater public provided by the art press. The writings brought out the paintings' outrageousness where the paintings themselves had not. Maybe they were too beautiful for their theoretical radicalism to penetrate. This is a fundamental paradox in Reinhardt's work. While it is tempting, for instance, to relate Don Judd's blunt and laconic writing style and content to Reinhardt, Judd remembers finding in the black paintings "a certain degree of tonality" he disliked and found somewhat retrograde: "By the time you got through the Twelve Rules for a New Academy, you knew very well it was a one-man academy."[4] Yet both Reinhardt and Judd were particularly vehement about the exclusion from art of picture-making and illusionism, as once were Stella and Robert Morris.[5] All four were targets of those formalist critics who considered "literalism" anti-aesthetic. Carl Andre, too, recalls that "Reinhardt was quite an influence. I think it was through his painting that the idea of spectators doing the work in order to recover the nature of painting came about, because with a Reinhardt even I today have to work to see it, which I've found is very rewarding.... His various doctrines about what art is not about, all those no's, were very helpful, and essentially very true, because art doesn't carry messages that way.... Reinhardt stripped down the cultural assumptions about art and I think that was a very important work."[6]

Through the fifties, Reinhardt's ideas had seemed highly eccentric; he was outside the circle despite his prolonged participation. His position as a loner had become, if not dear to him, at least comfortably familiar by the mid-sixties, and I think he was alarmed (maybe pleasantly) to find the circle finally moving out to encompass him. While he approved the so-called Minimal program, the "cool" approach, and welcomed the personal admiration and exposure that accom-

panied its art-world acceptance, he was unenthused at the prospect of his ideas, his weapons, being weakened by application to work he didn't fully identify with. His personal relationships with several of the younger artists (notably Stella, Morris, and Smithson) were good, but publicly Reinhardt remained aloof from the "new academy" he had helped to spawn. He couldn't reject it, however, any more than he could reject his retrospective at the Jewish Museum, or the modish portraits and eulogies that appeared simultaneously in *Vogue* and *Harper's Bazaar*.

Reinhardt's relationship to Minimal art was primarily a formal (or more accurately an anti-formalist) one based on a common urge toward a "post-geometric" art which would command a unified, single response from a public currently preoccupied with a "commercial" art of color, audience participation, narration, emotionalism—all "non-art" to him. His relation to so-called Conceptual art, of which he lived to see only the prologue, was informal, but his influence here may have been more direct. After his death, a young admirer named Joseph Kosuth, who had written a term paper on Reinhardt, hung the art-as-art dogma over the desk of the short-lived Museum of Normal Art, where the first public indications of a radically "dematerialized art" emerged. [7]

The implications of the ultimate paintings were clear to those artists turning to unsubstantial and even at times invisible art materials, who thought, as did Douglas Huebler in 1968, that "the world is full of objects, more or less interesting; I do not wish to add any more." [8] Reinhardt himself would not have agreed, of course: "You'd have to define a fine artist as someone who *makes* something, otherwise it's too open," he said, admitting at the same time, "there's no question that there's something a little dumb about making an object. I think all artists are aware of that." [9] He would probably not have liked much of the art for which his has become a precedent. The openness he opposed (and disliked in Surrealism, and in Pollock) has since led many artists to reabsorb elements he spent years getting rid of. "No Idea" was one of his twelve rules. The differences between him and his Conceptual successors is epitomized by the writings of Kosuth, who for several years titled his work "Art as Idea as Idea": "Why I regard Reinhardt as the most important artist of his generation is not because of the beautiful objects he made but because he stood for the idea of art.... The generality—not the specifics—of his work is what makes him important.... What is interesting about formalist art (Mondrian) is what it leaves out and chooses not to deal with, rather than the actual elements used.... Everything Reinhardt said about art leads one to the conclusion that art is a useless theoretical level of thinking." [10]

Much art now categorized for better or worse as Conceptual fuses art and life in a manner Reinhardt totally opposed. At the same time, many of the original Conceptual artists tend to be specifically concerned with art alone, with their work as an art-about-art, using the materials of life or non-art generally, as Reinhardt used paint and canvas. In this sense, Kosuth's "Investigations," Ian

Wilson's "Oral Communication," Lawrence Weiner's referential words and phrases, Robert Barry's definitions of the undefinable, engage the nature of art in as abstract a manner as the black paintings, but do so, like the black paintings, outside of the critically imposed structures of modernism. Theoretically, the "ultimate" paintings precluded anyone's being able to make art after Reinhardt. Certainly no one person has taken that stricture literally, but undeniably Reinhardt's position forced many artists to think past the conditions that had prevailed before the black paintings. Thus Reinhardt's idea of having "no idea" (in an art that so obviously incorporated an essential idea) implied extensions he himself would not have conceived. Not that the development of Conceptual art would have surprised him; he never postulated the end of *art*; he was fully aware that even if he were taken at his word about the end of painting (which was unlikely enough), civilization would not be able to forego so integral an element and survive. Conceptual art can also be seen as paralleling rather than replacing painting and sculpture, just as Reinhardt conceded that the black paintings might be seen as paralleling an "art of color."

The two artists historically most pertinent to Conceptual art are Reinhardt and a colleague of whom he often said: "I've never approved or liked anything about Marcel Duchamp. You have to choose between Duchamp and Mondrian."[11] Duchamp represented all that Reinhardt considered weak in the Western tradition, epitomized by his desire "to get away from the physical aspect of painting," "to put painting again at the service of the mind."[12] Yet Reinhardt's own paradoxes, his occasionally Zen-inspired attraction to the metaphysical, shared extremes with Dada. The dissimilarities between Reinhardt and Duchamp are so clear that it is particularly interesting to conjecture about the ways they complement each other precisely by representing such extremes.

Duchamp's influence is pervasive in recent art because of his initial dictum that anything is art if an artist says it is. Reinhardt is important to some of the same artists because of his insistence that nothing but *art* is art and consequently only one art is possible. If Duchamp's pluralism makes everyone a potential artist, Reinhardt's single-mindedness would make everyone the same artist, make only one timeless artist possible: "There's only one artist and he works the same in all times and places."[13] But if the position is taken that that "one artist" is each person making art, the two principles meet behind each other's backs.[14] An art of awareness, a potentially unsalable and intangible art, emerges from the combination of Duchamp's assertion that anything in the world is an art material and Reinhardt's assertion of non-hierarchical equivalences and the moral commitment to uselessness.

Their differences, obviously, are also myriad. Duchamp thumbed his nose at the past and Reinhardt thumbed his nose at the myth of the new, at the future. Yet both made younger artists aware of the limits of art and, simultaneously, of perceptual and conceptual extensions of the art experience. Jasper Johns once

told Reinhardt that he envied him because he "could never make a bad painting." Duchamp couldn't make a bad readymade either, though late in his non-career, during the period when he was supposedly not making any art at all, he did make some very bad objects of *art*. Reinhardt once noted that there couldn't be a book titled "The Success and Failure of Mondrian."[15]

Reinhardt's own success was based on his failures, on the paradoxes by which he lived and made art. He represents a curious fusion of the romantic and the classic. His public image, the important one (composed of the information he allowed the public to have about himself and his work), was totally rejective and classical. And it gave onto, turned back upon, the opposite extreme—the mystical, acceptive element, the beginnings absorbed into art and ideas purportedly dealing only with endings. The black paintings achieved "nothing" because they absorbed everything, as black is both no-color and all-color. Reinhardt's rules and dogmas called for no ideas, no size, no color—that is to say, no object; yet the paintings incorporated all of these elements, if in doses so small that for some people they are nonexistent. At the same time, by neutralizing color, size, and idea, and confining these elements to the *same* color, size, and idea over and over again, Reinhardt did succeed in abolishing them, although only a sympathetic viewer would accord him that success. Perhaps what Reinhardt accomplished in the eyes of the majority was more important. His paintings and his writings were never reconciled. Through the abyss between the artwork and its theoretical aura he acknowledged the irreconcilability of object and idea. Thus he made public, in a way no one else had, the artist's basic dilemma.

NOTES

1. Ad Reinhardt, in conversation with the author (and others).

2. Carl Andre, *Passport*, Dwan Gallery/Seth Siegelaub, New York, 1969, unpaged. When Reinhardt died, Stella contributed the following note to *artscanada* (Oct., 1967): "Ad was his own man. He saw things his own way. But he didn't keep it to himself. He said what was right about what he did and what was wrong about what other people did. People tolerated his work and polemics, but nobody liked it. The only way to deal with Ad was to make an ultimate evaluation. And it was severe — a gifted minor artist. This kind of vicious game-playing at the heart of the matter was right down Ad's alley. He can't play the game anymore, but nobody can get around the paintings anymore either. If you don't know what they're about you don't know what painting is about."

3. William Rubin, in his book *Frank Stella* (The Museum of Modern Art, New York, 1970) doesn't even mention Reinhardt in this context.

4. Donald Judd, in an unpublished interview with the author, Apr., 1968, Archives of American Art.

5. Morris took a course in oriental art from Reinhardt at Hunter College around 1963.

6. "Carl Andre: Artworker," interview by Jeanne Siegel, *Studio International*, Nov., 1970, p. 179.

7. Kosuth and Christine Kozlov, when both artists were students at the School of Visual Arts in New York City, wrote a paper on Reinhardt entitled "Ad Reinhardt: Evolution into Darkness — The Art of an Informal Formalist; Negativity, Purity, and the Clearness of Ambiguity" (May, 1966), through which they became acquainted with him. A contemporary account of the beginnings of Conceptual art can be found in John Chandler and Lucy R. Lippard, "The Dematerialization of Art," *Art International*, Feb., 1968. Kosuth, Kozlov, and Michael Rinaldi were the founders-directors of the storefront Museum of Normal Art, New York City.

8. Douglas Huebler, in *January 5–31, 1969*, Seth Siegelaub, New York, 1969, n.p.

9. Ad Reinhardt, Skowhegan lecture, 1967.

10. Joseph Kosuth, letter to the author, Apr., 1968.

11. Ad Reinhardt, Skowhegan, *op. cit.*

12. Marcel Duchamp, in an interview with James Johnson Sweeney, *The Museum of Modern Art Bulletin*, New York, vol. xiii, no. 4–5, 1946.

13. Ad Reinhardt, Skowhegan, *op. cit.*

14. Einstein said that if you looked far enough (infinity), you would see the back of your head. Duchamp and Reinhardt resolutely standing back to back would look into each other's faces; an oblique reference can be made to Reinhardt's interest in matter and antimatter. Octavio Paz has compared Duchamp to Mallarmé, remarking of *Un coup de dès*...(In *Marcel Duchamp or the Castle of Purity*, Cape Golliard and Grossman, London, New York, 1970) that "it is a critical poem" that not only contains "its own negation but this negation is its point of departure and its substance....The critical poem resolves itself in a conditional affirmation—an affirmation that feeds on its own negation.... Mallarmé inaugurated a poetic form which contains a plurality of readings — something very different from ambiguity or plurality of meanings..."; he might have been talking about Reinhardt too.

15. Ad Reinhardt, Skowhegan, *op. cit.* He was referring to *The Success and Failure of Picasso* by John Berger, which he read and assiduously underlined.

CHRONOLOGY

Entries in italic are excerpted from Reinhardt's own "Chronology" of 1966, published in bibl. 76, or are taken from his chronological notes.

Ad Reinhardt as an infant, 1914

1913: Christmas Eve, born in Buffalo, N.Y., *nine months after the Armory Show.* Father, Frank Reinhardt, a life-long socialist, had emigrated from East Prussia in 1907 and later became a member and organizer for the Amalgamated Clothing Workers in New York. Mother, Olga, had come to America from Germany in 1909. One brother, born in 1915.

1915–17: *Gets crayons for second birthday, copies "funnies," Moon Mullins, Krazy Kat, and Barney Google. Cuts up newspapers. Tears pictures out of books.*

1919–28: In Public Grade School No. 88, Ridgewood, Queens; *wins watercolor flower painting contest,* silver medal for ASPCA poster contest, $1.00 prize for drawing in yearbook, *medal for*

pencil portraits of Jack Dempsey, Abraham Lincoln and Charles Lindbergh; copies Old English and German Black-Letter printing.

1928–31: In Newton High School, Elmhurst, Queens; works as a dishwasher in an ice-cream parlor; summer jobs with advertising agencies; illustrates *Voice and Speech Problems* (Prentice-Hall, 1931); does drawings for school paper and yearbook; graduated as president of two honor societies, honors in mathematics, *prizes for art and citizenship; makes stylized drawings of knights, heraldry, shields, stars, battleflags.*

1931: Enters Columbia College, having rejected several art-school scholarships.

1932–35: *Paints studies of Michelangelo's Sistine Ceiling for literature class of Raymond Weaver, who suggests courses with Meyer Schapiro, who suggests joining campus radical groups; becomes fellow-traveler; anti-war anti-fascist demonstrations; falls asleep in Irwin Edman's aesthetics lectures; is intra-mural 135-lb. wrestling champion before being thrown off team for not keeping in training; illustrates Jester and Columbia Review; studies painting at the Teachers College with "a Miss Ruffini"; close friends are Robert Lax and Thomas Merton; is elected to Student Board on campaign promise to abolish fraternities; makes "cubist-mannered" cartoon of "rectilinear" President Nicholas Murray Butler beating "curvilinear" babies with a big club, censored by Jester editor Herman Wouk but printed in Spectator by editor James Wechsler, becomes city-wide "academic freedom" issue; becomes editor of Jester,* elected to All-American staff of College Comic Editors. Summer of 1932, works for Warner Bros. art department; summer of 1935, makes menus for cafeteria at Teachers College where he studies painting.

1936: *Studies painting with Karl Anderson and John Martin at the National Academy of Design; studies book design with Robert Josephy, helps organize Book and Magazine Guild; works with Russell Wright in industrial design, assists Crockett Johnson in cartoon-illustration.* Begins to work for a wide variety of employers as designer and illustrator.

1936–37: Studies painting with Carl Holty and Francis Criss at The American Artists School.

1937: Joins Artists' Union and American Abstract Artists (member of latter until 1953). *Hired on Federal Art Project by Burgoyne Diller; works with Lewis Jacobs on special assignments.*

1938: Seventh Avenue studio is next to, and shares fire escape with, that of Stuart Davis; *listens to Davis' loud ragtime jazz records, looks at his loud colored shirts on clothes-line; begins series of bright-colored paintings.* First group exhibition, with AAA.

1939: Eight paintings at the New York World's Fair; demonstrates collage technique for Harry Holtzman's lectures there; *joins all-night picket lines and sit-downs to save government art projects; is on Grievance Committee of Artists' Union.*

1940: Exhibits at American Artists' Congress; *helps AAA publish pamphlet against art critics, and organize demonstration against the Museum of Modern Art. Writes first Letter to the Editor (of the* New Republic, May 20) *in reaction to article by Wyndham Lewis saying "abstract art is dead." Debates social-protest painters about "Art of the Museums" vs. "Art in the Streets." Starts to break up geometric paintings.*

1941: *Attacked by Mike Gold in Daily Worker;* painting sent to Moscow Art Festival by Baltic Cultural Council. Fired from Federal Art Project. December: Makes mural for the Newspaper Guild Club (with Charles Martin).

1942: Begins working for newspaper *PM*. Shares 38 East 9th Street loft with George McNeil and Harry Bowden; *has arguments with them about soft and hard abstract art. Designs base-ball magazines for New York Yankees and Brooklyn Dodgers.*

1943: In collage exhibition at Art of This Century. Makes cartoon illustrations for Ruth Benedict's *The Races of Mankind;* the navel on Adam becomes a nationwide issue. December: Exhibition of paintings and collages at Columbia Teachers College.

1944: February: *First Art Gallery show at the Artists Gallery,* run by

Ad Reinhardt in the United States Navy, c. 1944

Ad Reinhardt in his studio, New York, 1947

Frederika Beers, with Clive Bell, Meyer Schapiro, and James Johnson Sweeney among the sponsors. *First museum purchase (Philadelphia). First "newspaper artist" to use collage technique.* Political cartoons exhibited at Teachers College.

1944–45: April: Enters the Navy, goes to Pensacola NAS, then Anacostia, D.C. NAS for photo-lithography school; photographer's mate on U.S.S. *Salerno Bay* in the Pacific. Marries Pat Decker.

1946: March: Honorably discharged from San Diego Naval Hospital. "How to Look" cartoon art series published in *PM* (Jan. 27, 1946–Jan. 5, 1947). Lives at 30 Gansevoort St., New York; through his wife meets Robert Motherwell. One-man show at the Brooklyn Museum School (April). *Fired from newspaper PM with 30 other Guild members* (is head of local for American Newspaper Guild). First one-man show at the Betty Parsons Gallery (exhibits there in 1947, 1948, 1949, 1951, 1952, 1953, 1955, 1956, 1959, 1960, 1965). On GI Bill begins some six years of Asian art history studies

with Alfred Salmony at the Institute of Fine Arts, NYU; *paints midnights to mornings.*

1947: In "Ideographic Picture" show at Betty Parsons. Signs letter to Truman and Marshall protesting State Department cancellation of art exhibition. 1947–67: Teaches at Brooklyn College. Continues "Persian Rug" paintings, and "Chinese verticals."

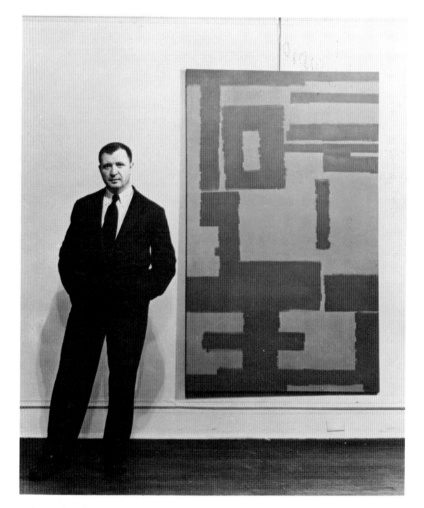

Ad Reinhardt at one-man exhibition, Betty Parsons Gallery, New York, c. 1950

1948: Does mural at Cafe Society Downtown, Sheridan Square. Lives at 7 Washington Place (until 1952). May 5: Is in "Forum. The Modern Artist Speaks" at The Museum of Modern Art. *Helps found Artists Club but doesn't help paint walls or sweep floors.* Gives talk there "against all involvements."

1949: Does a "free-standing partition painting." With Robert Lax visits Nancy Flagg and Robert Coibney in the Virgin Islands, where he makes temporary shell collages, paints watercolors, and waits for a divorce. Exhibits in "Intrasubjectives" at the Kootz Gallery.

1950: First "art-world cartoon" published in *trans/formation*. Takes part in Studio 35 symposiums. *Protests with "Irascibles" against Metropolitan Museum for being against avant-garde art.* Summer: Teaches at California School of Fine Arts, San Francisco.

1951: Edits *Modern Artists in America* with Robert Motherwell and Bernard Karpel. Exhibits in "Abstract Painting and Sculpture in America" at The Museum of Modern Art, and in the 9th Street Exhibition. First trisected geometric paintings. Summer: Teaches at the University of Wyoming in Laramie and has one-man show there. *Argues with John Sloan about Jackson Pollock in Taos.*

1952: Seven-artist boycott of Metropolitan Museum, following up Irascibles' protest. In "American Vanguard Art for Paris," Galerie de France, Paris, organized by Sidney Janis, and "Contemporary Religious Art and Architecture," Union Theological Seminary. Participates in "Expressionism," "Abstract-Expressionism" and "Purists' Idea" panels at Artists Club. First trip to Europe, with Martin James.

1952–53: Visiting critic at Yale School of Fine Arts, directed by Josef Albers.

1953: Whitney Museum acquires *No. 18, 1950. Last bright-colored paintings; gives up principles of asymmetry and irregularity.* Sabbatical from Brooklyn College; visits Spain, Greece, Amsterdam, London, Paris, Glasgow, Rome, Munich, Nürnberg; takes slides. Marries painter Rita Ziprowski.

Ad Reinhardt in Paris, 1953

202

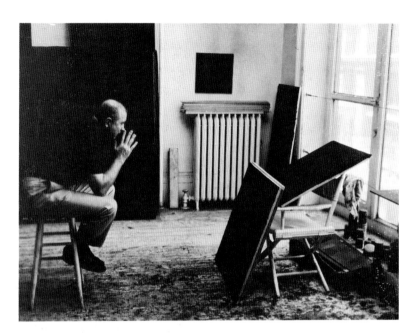

Ad Reinhardt in his Broadway studio, New York, late 1950s

1954: Daughter Anna born. Is sued by Barnett Newman for $100,000 but suit is thrown out of court.

1955: Exhibits in "The New Decade," Whitney Museum. *Listed in Fortune magazine as one of top twelve investments in art market.* One-man show at Betty Parsons includes black paintings.

1956: Makes mandala cartoon (*Art News*, May 1956).

1957: *Forms SPOAF (Society for the Protection of Our Artist Friends) (from themselves), after reading "Nature in Abstraction" statements.* Fall: Retrospective show at Syracuse University. Death of both parents.

1958: Is not included in "New American Painting," The Museum of Modern Art; is included in Brussels World's Fair. Takes world tour to India, Japan, Iran, Iraq, Egypt. Oct. 10: "An Evening of Slides: The Moslem World and India," shows 2,000 slides at the Artists Club (Part II: Jan. 23, 1959).

1959: Sends painting to Thomas Merton at Trappist monastery. Begins teaching at Hunter College (through 1967). Applies, and is rejected, for Guggenheim Fellowship.

1960: "25 Years of Abstract Painting" at Betty Parsons Gallery and Section II, after Whitney Museum's refusal to do a retrospective. Begins to make only black square paintings, five-by-five feet. One-man show at Iris Clert, Paris. Travels in Europe. Frank Stella buys a black painting.

1961: *Visits Turkey, Syria, Jordan. Protests Guggenheim Museum's "Abstract Expressionist and Imagist" history.* Exhibits at Städtische Museum, Leverkusen; Arthur Tooth Gallery, London. "Attack"—1961," Reinhardt vs. Resnick at the Artists' Club. Refuses to sign artists' protest against John Canaday. Refused to participate in São Paulo Bienal, organized by The Museum of Modern Art.

1962: Visits Mexico, the Yucatan. Protests Whitney Museum's

Ad Reinhardt at the Museum of Modern Art, New York, c. 1960

"Geometric Abstraction in America" history. Exhibits in Seattle World's Fair, organized by Sam Hunter (protests that history). One-man show at the Dwan Gallery, Los Angeles. Charles Carpenter projects an "Ad Reinhardt Museum." *Speaks at First Conference on Aesthetic Responsibility*.

1963: In "Americans, '63" at The Museum of Modern Art; paintings have to be roped off from the public. One-man show at Iris Clert, Paris. Is not included in "Black and White" at the Jewish Museum. Is defended by Alfred Barr and James Thrall Soby against Ralph Colin's charges of "fake and fraud." *Dissents from Dissent magazine's dissent from "Artists' Committee to Free Siqueiros" from prison*. Teaches at University of Oregon, Eugene, and has one-man show there. Returns $1,000 check to the Art Institute of Chicago, prize for 66th Annual American Exhibition. Promoted to full professor at Brooklyn College. Vice-chairman for Student Non-Violent Coordinating Committee. The Museum of Modern Art buys a black painting (first Reinhardt in its collection).

1964: One-man show at the ICA, London; three paintings at the Tate Gallery are damaged. Active in Artists' Tenants Association. Visits Thomas Merton in Trappist, Ky.

1965: Is awarded "The Special Award...for forcing the point: ...for 'Abstract Painting,' which is blacker than ever" by John Canaday in *The New York Times*. Three-gallery show at Parsons (black), Stable (blue), and Graham (red) of geometric paintings (1951–65). Is in "Responsive Eye," The Museum of Modern Art; "The New York School," Los Angeles County Museum; and "The Inner and the Outer Space," Stockholm. *Signs protest against Vietnam War* and becomes active in peace movement.

1966: To Tokyo for "American Painting: 1945–65," organized by The Museum of Modern Art. Sends statement to Destruction in Art Symposium, London. November: Retrospective exhibition of 126 paintings opens at the Jewish Museum.

1967: Receives Guggenheim Fellowship. Becomes ill and is hospitalized. *Takes SS Raffaello to Rome for rest*, July. Lectures at Skowhegan School, travels in New England, Montreal. Dies in studio, August 31.

Ad Reinhardt, c. 1960

BIBLIOGRAPHY

The following bibliography is a revised and greatly augmented compilation of my two previous Reinhardt bibliographies: in the Los Angeles County Museum New York School catalogue and the Jewish Museum Reinhardt catalogue (bibls. 402 and 170) and of Bernard Karpel's supplement in Barbara Rose's collection of Reinhardt's writings (bibl. 87). I should like to thank Nanette Hayes and Jill Dunbar for research assistance.—L.R.L.

I. BY REINHARDT (listed chronologically)

N.B.: A good many of Reinhardt's statements, especially the "Dogmas," have been printed in more than one place, often simultaneously; in many cases, each version is slightly different; book illustrations and commercial work are not included.

1. *The Reinhardt Archive*, Archives of American Art, Washington, D.C.: "The bulk of his papers consists of printed material and of his illustrated notes, outlines, and charts on the art history of the East and West. The collection also included correspondence from 1930 to 1967, with letters from Corey Ford, S. I. Hayakawa, Hilaire Hiler, Sinclair Lewis, Thomas Merton, Robert Motherwell, George Rickey and Frank Sullivan, many of these relating to his work on the newspaper *PM* in the mid-1940s. Reinhardt was an active joiner of organizations and contributor to causes and his papers reflect these interests as well as his student work in high school and at Columbia University. They also include address books, calendars and travel notes." (Quoted from McCoy, Garnett, *Archives of American Art: A Directory of Resources*, New York: Bowker, 1972. See also section on Archives of American Art, p.3.)
2. "Editaurus," *Columbia Jester*, Sept., 1935, p.9.
3. "How Modern is the Museum of Modern Art?" (broadside for the American Abstract Artists when they picketed the museum; dated Apr. 15, 1940).
4. "Abstract Art Turns Over," *New Republic*, May 20, 1940, p. 674 (letter to the editor).
5. *The Art Critics——!* American Abstract Artists, New York, June, 1940 (pamphlet designed and partially compiled by A.R.).
6. "About Artists by Artists: Stuart Davis," *New Masses*, Nov. 27, 1945, p.15.
7. "How to Look" (cartoon series reprinted in bibl. 86): "How to Look at a Cubist Painting," *PM*, Jan. 27, 1946, p. M5; "How to View High (Abstract) Art," *PM*, Feb. 24, 1946, p. M6; "How to Look at Low (Surrealist) Art," *PM*, Mar. 24, 1946, p. M6; "How to Look at an Artist," *PM*, Apr. 7, 1946, p. M6; "How to Look at Space," *PM*, Apr. 28, 1946, p. M7;

"How to Look," *PM*, May 12, 1946, p. M6; "How to Look at Modern Art in America," *PM*, June 2, 1946, p. M13; "How to Look at Art-Talk," *PM*, June 9, 1946, p. M6; "How to Look Out," *PM*, June 23, 1946, p. M6; "How to Look at Things Through a Wineglass," *PM*, July 7, 1946, p. M6; "How to Look at Looking," *PM*, July 21, 1946, p. M13; "How to Look at a Good Idea," *PM*, Aug. 4, 1946, p. M12; "How to Look at Things Again," *PM*, Aug. 25, 1946, p. M17; "Hey, Look at the Facts," *PM*, Sept. 8, 1946, p. M7; "How to Look at More Than Meets the Eye," *PM*, Sept. 22, 1946, p. M14; "How to Look at Art and Industry," *PM*, Oct. 6, 1946, p. M7; "How to Look at Iconography," *PM*, Oct. 20, 1946, p. M9; "How to Look at the Record," *PM*, Nov. 3, 1946, p. M9; "How to Look at It," *PM*, Nov. 17, 1946, p. M12; "How to Look at a House," "How to Look at a Gallery," *PM*, Dec. 1, 1946, p. M13; "How to Look at Creation," "How to Look at 3 Current Shows," "How to Look at a Theme," *PM*, Dec. 15, 1946, p. M12 (see also bibls. 124, 176).
8. "Hey, E.E. Cummings Don't Do That to Krazy," *PM*, Nov. 10, 1946, p. M9 (book review).
9. "Political Cartoon," *Critique*, Oct., 1946, p. 13.
10. "Neo Surrealists Take Over a Gallery," *PM*, Mar. 11, 1947, p. 10.
11. *Paintings by Ralph Fasanella*. New York: ACA Gallery, Sept. 15–27, 1947 (catalogue preface).
12. Signatory, with other so-called "Irascibles" [open letter to Roland L. Redmond, President of the Metropolitan Museum of Art, protesting the American Painting exhibition there]. Mimeographed original dated May 20, 1950 (appeared in *Art News*, Summer, 1950, p. 15; covered in *Time*, June 5, 1950, and *Life*, Jan. 15, 1951).
13. "Museum Landscape," "Museum Racing Form," "Art of Life of Art," *trans/formation*, no. 1, 1950, pp. 30–31; no. 2, 1951, pp. 88–89; no. 3, 1952, pp. 148–49 (cartoons; reprinted in bibl. 86).
14. [Statement on drawing], *Junior League Magazine*, Dec., 1950.
15. [Statement], *Réalités nouvelles*, no. 4, 1950.
16. "Imaginary Museum 1951 Modern Art in

America," *Art d'aujourd' hui*, June, 1951, p. 3 (cartoon; reprinted in bibls. 86, 304).
17. Co-editor, with Robert Motherwell, *Modern Artists in America*. New York: Wittenborn-Schultz, Inc., 1952 (editorial statement, pp. 6–7; "Artists' Sessions at Studio 35 (1950)," pp. 8–22; "Introduction to the Illustrations," p.40).
18. "Our Favorites," *Art News*, Mar., 1952, pp. 28–29 (cartoon; reprinted in bibl. 86).
19. [Statement], *Contemporary American Painting*. Urbana: University of Illinois, 1952, p. 226 (reprinted in bibl. 87).
20. [Letter to the editor], *Art News*, Apr., 1953, p. 6.
21. "Artist in Search of an Academy," *College Art Journal*, Spring, 1953, pp. 249–51 (excerpt from a panel discussion on "The Education of the Artist in Colleges," at the annual C.A.A. meeting, Cleveland, Jan. 31, 1953). "Part II: Who Are the Artists?" Summer, 1954, pp. 314–15 (from Aug., 1953 symposium, Woodstock, N.Y.). (Both reprinted in bibl. 87.) "Reply to Ad Reinhardt" by Sibyl Moholy-Nagy, Fall, 1954, pp. 60–61.
22. [Statement as juror], exhibition *Momentum Midcontinental 1953*. Chicago: Gallery at Werner's Books, May 4–30, 1953, p. 3 (reprinted in bibl. 87).
23. [Statement on a painting], *College Art Journal*, Fall, 1953, p. 24.
24. [Letter to the editor], *Art News*, Mar., 1954, p. 6 (reply by Parker Tyler, *Art News*, Summer, 1954, p. 6).
25. "Prize Peeve," *Art Digest*, Apr. 15, 1954, p. 3 (letter to the editor).
26. "Foundingfathersfollyday," *Art News*, Apr., 1954, pp. 24–25 (cartoon; reprinted in bibl. 86).
27. "Cycles Through the Chinese Landscape," *Art News*, Dec., 1954, pp. 24–27 (reprinted in bibls. 87, 167).
27a. [Statement], *The New Decade: 35 American Painters and Sculptors*. New York: Whitney Museum of American Art, 1955, pp. 72–73.
28. [Letter to the editor], *Art News*, Jan., 1956, p. 6.
29. "A Portend of the Artist as a Yhung Mandala," *Art News*, May, 1956, pp. 36–37 (cartoon; reprinted in bibls. 86, 361).

30. "The Art-Politics Syndrome: A Project in Integration," *Art News*, Nov., 1956, pp. 34–35 (selection of newspaper political cartoons with art subject matter, "collated" by A. R.).

31. *Eleven Young Painters*. New York: Mills College of Education Gallery, Apr. 2–30, 1957 (statement on the exhibition; selected by A. R.).

32. "Twelve Rules for a New Academy," *Art News*, May, 1957, pp. 37–38, 56 (reprinted in bibls. 87, 167).

33. [Letter to the editor], *Art News*, Apr., 1958, p. 6.

34. "44 Titles for Articles for Artists Under 45," and "25 Lines of Words on Art," *It Is*, Spring, 1958, pp. 22–23, 42 (reprinted in bibl. 87).

35. "Is Today's Artist With or Against the Past?" *Art News*, Summer, 1958, pp. 26–28, 56–58 (contribution to an inquiry).

36. "Panel: All-Over Painting," *It Is*, Autumn, 1958, pp. 72–77 (participants: A. R., Elaine de Kooning, Martin James).

37. "The Carnegie International," *Arts*, Jan., 1959, p. 7 (letter to the editor).

38. [Letter to the editor], *Art News*, Apr., 1959, p. 6.

39. "Discussion: Is There a New Academy?" *Art News*, June, 1959, p. 34 (contribution to a symposium; reprinted in bibl. 87).

40. "Seven Quotes," *It Is*, Autumn, 1959, p. 25.

41. "Timeless in Asia," *Art News*, Jan., 1960, pp. 32–35 (reprinted in bibls. 87, 167; corrections in letter to the editor, Feb., 1960, p. 6).

42. Sandler, Irving, and Pavia, Philip, eds., "The Philadelphia Panel," *It Is*, Spring, 1960, pp. 34–38 (panel on "The Concept of the New," Philadelphia School of Art, Mar., 1960, with A. R., P. Guston, H. Rosenberg, J. Tworkov, R. Motherwell; reviewed by John Canaday, "Word of Mouth," *The New York Times*, Sunday, Apr. 3, 1960; excerpt reprinted in bibl. 87).

43. "Documents of Modern Art...," *Pax*, no. 13, 1960, 2 pp. (includes reprint from *It Is*, bibl. 34; "censored from *It Is*," and "The New Decade anthology of quotations...").

44. "Neither Love nor Hate," *Newsweek*, Nov. 7, 1960, pp. 118–19 (primarily interview).

45. [Letter to the editor], *Art News*, Dec., 1960, p. 6.

46. "The Insiders," *Jubilee*, Jan., 1961, p. 48 (a pictorial collage-review of book by Selden Rodman).

47. "Resnick, Reinhardt Attack: 1961," *Scrap*, Jan. 20, 1961, pp. 1–2 ("*Scrap's* version of the first half" of the 3-hour discussion between R. and R. at the Artists' Club, Jan. 26, 1961; reprinted in bibl. 87).

48. [Letter to the editor], *Art News*, Apr., 1961, p. 6.

49. "How to Look at Modern Art in America," *Art News*, Summer, 1961, pp. 36–37 (two cartoons; 1946 version reprinted from *PM*; both reprinted in bibl. 86).

50. "Angkor and Art," in *Khmer Sculpture*. New York: Asia House Gallery, 1961, pp. 5–10 (reprinted in *Art News*, Dec., 1961, pp. 43–45, 66–67; bibl. 87).

51. [Statement, reprinted], in Rodman, Selden, *Conversations with Artists*. New York: Capricorn Books, 1961, pp. 98–99.

52. [Three statements, 1955–61], *Pax*, no. 18, 1962 (broadside, reprinted in bibls. 64, 87).

53. "Report from the Club: Session of 4/6/62," *Scrap*, June 14, 1962, p. 5 (includes quotations from "What's Wrong," talk by A. R.).

54. "Who is Responsible for Ugliness?" *American Institute of Architects Journal*, June, 1962, pp. 60–61 (contributions to "First Conference on Aesthetic Responsibility," Plaza Hotel, New York, Apr. 3, 1962; reprinted as "What is 'Ugly'?" in *The Village Voice*, Apr. 16, 1962, and in *ICA Bulletin* (London), Aug.–Sept., 1964, pp. 14–15).

55. Sandler, Irving, "In the Art Galleries: Interview with Ad Reinhardt," *New York Post*, Aug. 12, 1962, p. 12.

56. "Art as Art," *Environment*, Autumn, 1962, pp. 53, 80–81 (reprinted in bibls. 59, 87, and elsewhere).

57. Wolter, Beverly, "On the Negative Side of Art," *Journal and Sentinel*, Winston-Salem, N.C., Apr. 26, 1964 (primarily interview about symposium on communications at Salem College).

58. "An Abstract Painter's Credo: Art in Art," *American Dialog*, July–Aug., 1964, pp. 17–19 (reprinted in bibls. 59, 87, and elsewhere).

59. "Art-as-Art," *Art International*, Dec., 1962, pp. 36–37 (reprinted in bibls. 56, 58).

60. [Letter to the editor on new figurative painting], *Art News*, Oct., 1962, p. 6.

61. "The 'New Figure'," *Arts*, Oct., 1962, p. 7 (letter to the editor).

62. [Letter to the editor], *Art News*, Jan., 1963, p. 6.

63. [Letter to the editor], *Dissent*, Spring, 1963, p. 200.

64. "Autocritique de Reinhardt," *Iris-Time* (Galerie Iris Clert, Paris), June 10, 1963, pp. 1, 3 (statement in facsimile; reprinted in bibl. 87).

65. [Reinhardt], *Art International*, June 25, 1963, pp. 71, 73–74, and cover (illustrations).

66. "The Next Revolution in Art: art-as-art dogma Part II," *Art News*, Feb., 1964, pp. 48–49; also published in *Art International*, Mar., 1964, pp. 57–58 (reprinted in bibl. 87).

67. "black," *Revue Integration* (Arnhem, Holland), no. 9, n.d. (c. 1965; black construction paper pages).

68. "Reinhardt Paints a Picture," *Art News*, Mar., 1965, pp. 39–41, 66 (auto-interview; reprinted in bibl. 87; letters to the editor by J. Born and Murray Hantman in Summer, 1965, p. 6).

69. "The Artists Say...Ad Reinhardt: 39 Art Planks," *Art Voices*, Spring, 1965, pp. 86–87 (reprinted in bibl. 87).

70. "Art in Art is Art as Art," *The Lugano Review*, no. 5–6, 1966, pp. 85–89 (reprinted in Kepes, Gyorgy, ed., *Sign, Image, Symbol*. Vision & Value series. New York: Braziller, 1966, pp. 180–83; and in bibl. 87).

71. *Poor Old Tired Horse* (Ardgay, Scotland), no. 18, n.d. (c. 1966; drawings and layout by Bridget Riley, writings and script by A. R.).

72. "Writings," in Battcock, Gregory, ed., *The New Art*. New York: E. P. Dutton, 1966, pp. 199–209 (reprints; see also second ed.).

73. "Art vs. History: *The Shape of Time* by George Kubler," *Art News*, Jan., 1966, pp. 19, 61–62 (book review; reprinted in bibl. 87).

74. "Ad Reinhardt: Three Statements," *Artforum*, Mar., 1966, pp. 34–35 (reprinted in bibl. 87).

75. [Reprinted statements], *Link* (Cheltenham), Sept.–Oct., 1966, pp. [6–8].

76. "Chronology by Ad Reinhardt," in *Ad Reinhardt: Paintings*. New York: The Jewish Museum, Nov. 23, 1966–Jan. 15, 1967, pp. 30–36 (reprinted as obituary in *Artforum*, Oct., 1967, pp. 46–47; and in bibl. 171).

77. Glaser, Bruce, "An Interview with Ad Reinhardt," *Art International*, Dec., 1966, pp. 18–21 (reprinted in bibl. 87).

78. *Ad Reinhardt*, produced by Ives-Sillman for the Wadsworth Atheneum, Hartford, Conn., 1966–67 (ten silkscreen prints).

79. Lil Picard [interview with Ad Reinhardt], *East Village Other*, 1967.

80. "Black," *artscanada*, Oct., 1967, pp. 4–19 (a symposium, followed by memorial supplement; excerpt reprinted in bibl. 87).

81. "Ad Reinhardt on His Art," *Studio International*, Dec., 1967, pp. 265–69 (edited passages from talk given at the ICA, London, May 28, 1964, on "art as

art dogma"; followed by Kallick, Phyllisann, "An Interview with Ad Reinhardt," pp. 269–73).

82. [Interview on religious imagery] in Gaudnek, Walter, *The Symbolic Meaning of the Cross in Contemporary American Painting*. Ph.D. dissertation, New York University School of Education, 1968.

83. Fuller, Mary, "An Ad Reinhardt Monologue," *Artforum*, Oct., 1970, pp. 36–41 (taped conversation took place Apr. 27, 1966; reprinted in McChesney, Mary Fuller, *A Period of Exploration: San Francisco 1945–1950*, Oakland Museum, Sept. 4–Nov. 4, 1973; and in bibl. 87).

84. "The Prize: an Exchange of Letters between Ajay and Reinhardt," *Art in America*, Nov.–Dec., 1971, pp. 106–109.

85. [Postcards to Joan Washburn], *Tracks*, Nov., 1974, pp. 9, 42, 49, 58, 62 (facsimile reproductions; card to Betty Parsons on cover).

86. Hess, Thomas B., ed., *The Art Comics and Satires of Ad Reinhardt*. Kunsthalle Düsseldorf/Marlborough, Rome, 1975 (facsimile reproductions of 23 *PM* and other cartoons; text by Hess).

87. Rose, Barbara, ed., *Art as Art: The Selected Writings of Ad Reinhardt*. New York: Viking Press, 1975 (published and unpublished writings; bibliography by Bernard Karpel).

87a. Masheck, Joseph, ed., "Five Unpublished Letters from Ad Reinhardt to Thomas Merton and Two in Return," *Artforum*, Dec., 1978, pp. 23–27.

See also bibls. 105, 107a, 113, 118, 126, 135, 138, 140, 143, 148, 163, 165, 166, 167, 168, 170, 172, 173, 175, 176, 273, 300, 305, 310, 326, 334, 337, 339, 343, 348, 360, 372, 381, 382, 402, 419.

II. ABOUT REINHARDT: ARTICLES AND EXTENSIVE REVIEWS (listed alphabetically by title or author)

88. "Abstract Painting," *PM*, Mar. 20, 1946, p. 12.

89. "Ad Absurdam," *Time*, Jan. 11, 1963, p. 68.

90. "Ad Reinhardt, Painter is Dead; Reduced Color to Bare Minimum," *The New York Times*, Sept. 1, 1967, p. 31.

91. "Ad Reinhardt, Photo Student, Illustrates New Children's Book," *Gosport*, Nov. 24, 1944.

92. "Ad Reinhardt ('Prince of Darkness') Converging on St. Louis Art Scene," *St. Louis Globe Democrat*, Mar. 25–26, 1967.

93. Argan, Giulio Carlo, "Reinhardt: la percezione non percepita," *Data*, Winter, 1973, pp. 28–33 (with English translation).

94. Arnason, H. Harvard, "Ad Reinhardt," in *Britannica Encyclopedia of American Art*. New York: Simon and Schuster, 1973, p. 463 (see also bibl. 171).

95. Ashton, Dore, "Art," *Arts and Architecture*, Dec., 1960, pp. 4–5.

96. Ashton, Dore, "Notes on Ad Reinhardt's Exhibition," *Arts and Architecture*, Jan., 1967, pp. 4–5, 31.

96a. B. R., "Amerikos Lietuvis—Zymus Dailininkas," *Sviesa*, no. 4, 1958, pp. 51, 64.

97. Barker, Walter, "The Dark Voids of Ad Reinhardt," *St. Louis Post-Dispatch*, Dec. 25, 1966, p. 5D.

98. Barr, Alfred H., Jr., and Soby, James Thrall, "Letter to the editor," *Art in America*, Oct., 1963, p. 143 (in reply to bibl. 289).

99. "The Black Monk," *Newsweek*, Mar. 15, 1965, p. 90.

100. Boswick, Helen, "Black Square Artist to Talk Here Friday," *Cleveland Plain Dealer*, Mar. 25, 1964.

101. Bourdon, David, "Master of the Minimal," *Life*, Feb. 3, 1967, pp. 45–52 (also published in *Amerika*, no. 137, 1968, pp. 52–55; letters to the editor of *Life* about Bourdon article, Feb. 24, 1967, p. 3).

102. Coates, Robert, "Rejections," *The New Yorker*, Dec. 10, 1966, pp. 172–76.

103. Colt, Priscilla, "Notes on Ad Reinhardt," *Art International*, Oct., 1964, pp. 32–34.

104. Cortese, Tito, "Le Mostre," *La Tribuna* (Rome), June 21, 1974.

105. Davis, Douglas M., "A Variety of Surrealism and Anti-Art," *The National Observer*, May 23, 1966 (includes statements).

106. De Kooning, Elaine, "Pure Paints a Picture," *Art News*, Summer, 1957, pp. 57, 86–87.

107. Denny, Robyn, "Ad Reinhardt, An Appreciation," *Studio International*, Dec., 1967, p. 264.

107a. Flagg, Nancy, "The Beats in the Jungle, or Life with Gibney, Lax and Reinhardt," *Art International/The Lugano Review*, Sept.–Oct., 1977, pp. 56–59; continued as "Reinhardt Revisiting," Feb., 1978, pp. 54–57 (includes excerpts from letters).

108. Fuess, Dave, "Reinhardt, 'Black Monk' to Present 'Art-as-Art'," *The Bucknellian*, Apr. 2, 1966, pp. 7, 8.

109. H[amilton], G[eorge] H[eard], "Painting—Ad Reinhardt," *Bulletin of the Association in Fine Arts at Yale University*, Feb., 1957.

110. Hess, Thomas B., "Ad (Adolph Dietrich Friedrich) Reinhardt," *Art News*, Oct., 1967, p. 23.

111. Hess, Thomas B., "The Art Comics of Ad Reinhardt," *Artforum*, Apr., 1974, pp. 47–51.

112. Hess, Thomas B., "Reinhardt: The Position and Perils of Purity," *Art News*, Dec., 1953, pp. 26–27, 59 (see also bibl. 86).

113. Hiller, Cathy, "Reinhardt Considers Historic Trends of Painting," *Kingsman* (Brooklyn College), Apr. 17, 1964 (includes statements).

114. Hopkins, Budd, "An Ad for Ad as Ad," *Artforum*, Summer, 1976, pp. 62–63 (review of bibl. 87).

115. Howard, Pamela, "Artist Tells His Audience Nothing," *Washington Daily News*, Jan. 20, 1966.
*Howe, Susan, see bibl. 162.

116. Hudson, Andrew, "Artist's Angle: Art-as-Art," *Washington Post*, Jan. 20, 1966.

117. Hunter, Sam, "Reinhardt Uses Power of Negative Thinking," *Sunday Bulletin* (Philadelphia), Jan. 8, 1967 (see also bibl. 170).

118. James, Martin, "Today's Artists: Reinhardt," *Portfolio and Art News Annual*, no. 3, 1960, pp. 48–63, 140–46 (includes statements).
*Judd, Donald, see bibl. 136.

119. Kosuth, Joseph, and Kozlov, Christine, "Ad Reinhardt: Evolution Into Darkness—The Art of an Informal Formalist; Negativity, Purity, and the Clearness of Ambiguity," unpublished typescript, assigned at the School of Visual Arts, New York, May, 1966 (with bibliography).

120. Kozloff, Max, "Andy Warhol and Ad Reinhardt; The Great Accepter and the Great Demurrer," *Studio International*, Mar., 1971, pp. 113–17 (reply by Jeanne Siegel, July, 1971, p. 4).

121. Kramer, Hilton, "Ad Reinhardt's Black Humor," *The New York Times*, Nov. 27, 1966, p. D17.

122. Kramer, Hilton, "Art," *The Nation*, June 22, 1963, pp. 533–34.

123. Kramer, Hilton, "Satirizing the Art World," *The New York Times*, Oct. 17, 1976.

124. [Letters to the editor of *PM* on Reinhardt's cartoons], "Reinhardt Fans", Mar. 24, 1946, p. 19; "Modern Art," May 5, 1946, p. 19; "Art and Ad," May 19, 1946, p. 19; "Concerning Art," Aug. 18, 1946, p. 17; "Ad and Art," Sept. 1, 1946, p. 17.

125. Lewis, John P., "Meet Our Collager," *PM*, Oct. 26, 1943.

126. Lewis, Owen, "Reinhardt Says 'I am Against...'," *Greensboro* (N.C.) *Daily News*, Apr. 26, 1964 (includes statements).

127. Lippard, Lucy R., "Ad Reinhardt: Black Painting," *Art and Australia*, Jan.–Apr., 1977, pp. 286–88

(adapted from the unpublished manuscript for this book).

128. Lippard, Lucy R., "Ad Reinhardt, 1913–1967," *Art International*, Oct. 20, 1967, p. 19.

129. Lippard, Lucy R., "Ad Reinhardt: One Art," and "Ad Reinhardt: One Work," *Art in America*, Sept.–Oct. and Nov.–Dec., 1974, pp. 65–75 and pp. 95–101 (adapted from the unpublished manuscript for this book).

130. Lippard, Lucy R., "New York Letter," *Art International*, May, 1965, pp. 52–53 (slightly revised and reprinted in Battcock, Gregory, *The New Art*. New York: E. P. Dutton, 1966, pp. 187–92).

131. Martin, Richard, "Red in Art is Red," *Arts Magazine*, Apr., 1974, pp. 40–41.

132. McClement, Lynne, "Speakers: Ad Reinhardt," *Archway* (Salem College, Winston-Salem, N.C.), Apr. 1, 1964, p. 9.

133. McConathy, Dale, "Keeping Time: Some Notes on Reinhardt, Smithson and Simonds," *artscanada*, June, 1975, pp. 52–57 (see also bibls. 173, 174).

134. McShine, Kynaston, "More Than Black," *Arts Magazine*, Dec., 1966–Jan., 1967, pp. 49–50.

135. "Meet *PM*'s Ad Reinhardt," *PM*, May 13, 1946 (includes statements).

136. "Memorial Supplement," *artscanada*, Oct., 1967, p. 19 (by Frank Stella, Barbara Rose, Donald Judd).

137. Michelson, Annette, "Ad Reinhardt or the Artist as Artist," *Harper's Bazaar*, Nov., 1966, pp. 176, 223.

138. Millet, Catherine, "Ad Reinhardt par Ad Reinhardt," *Art Press*, May–June, 1973, pp. 4–7 (essay plus French translations of Reinhardt writings).

139. Millet, Catherine, "Ad Reinhardt peint noir sur blanc," *Chroniques de l'art vivant*, June–July, 1972, pp. 6–8 (Italian version in *Flash Art*, May–July, 1972, pp. 35–37).

140. Mitchell, Matt, "Fine Art Has Its Own Meaning," *Eugene Register-Guard*, July 19, 1963, p. 7A (includes statements from lecture given in Oregon).

141. Mouhlas, Nicholas, ". . . I felt movement into a void . . ," (mimeographed statement on black painting in The Museum of Modern Art, New York, dated May 15, 1971).

142. Mueller, Gregoire, "After the Ultimate," *Arts Magazine*, Mar., 1970, pp. 28–31.

143. Nordland, Gerald, "Art: The Artist as Reinhardt," *Frontier*, Mar., 1962, pp. 23–24 (includes statements).

143a. [Obituary], *Kunstwerk*, Oct., 1967, p. 74.

144. O'Doherty, Brian, "Anti-Matter," and "Ad Reinhardt: Anti-Avant-Gardist," *Art and Artist*, Jan., 1967, pp. 42–45 (both reprinted in the author's *Object and Idea: An Art Critic's Journal*. New York: Simon and Schuster, 1967).

144a. Paskus, Benjamin G., "Ad Reinhardt: Art as Art. . . . ," *Art Journal*, Winter, 1976–77, pp. 172–76 (review of bibl. 87).

145. Pluchart, François, "La Rigueur de Reinhardt," *Combat*, June 11, 1973.

146. Porter, Fairfield, "Art," *The Nation*, Nov. 5, 1960.

147. Raynor, Vivien, "On Art: Modernism's Naysayer," *The New Leader*, Dec. 22, 1975, pp. 17–18 (review of bibl. 87).

148. "Reinhardt," *Arts and Architecture*, Jan., 1947, pp. 20–27 (includes statement and cartoons reprinted from *PM*).

149. Rose, Barbara, "Reinhardt," *Vogue*, Nov. 1, 1966, p. 183 (see also bibls. 87, 136, 171).

150. Rosenberg, Harold, "The Art World: Purifying Art," *The New Yorker*, Feb. 23, 1976, pp. 94–98.

151. Rosenstein, Harris, "Black Pastures," *Art News*, Nov., 1966, pp. 33–35.

152. Sandler, Irving, "New York Letter," *Art International*, Dec., 1960, pp. 24–25.

153. Sandler, Irving, "Reinhardt: The Purist Backlash," *Artforum*, Dec., 1966, pp. 40–47.

154. Schjeldahl, Peter, "Art as Art. . . . [and] The Art Comics and Satires of Ad Reinhardt," *The New York Times Book Review*, Feb. 15, 1976, p. 7 (review of bibls. 87, 86; see also bibl. 176).

155. Schloss, Edith, "Around the European Galleries: Rome," *The Herald Tribune* (international edition), May 25/26, 1974, p. 7.

156. Sowers, Robert, "Art and the Temptation of Ad Reinhardt," *ARC Directions*, June, 1966, pp. 3, 4, 6.

*Stella, Frank, see bibl. 136.

157. Sylvester, David, "Blackish," *The New Statesman*, June 12, 1964, p. 924.

158. Tillim, Sidney, "Month in Review," *Arts Magazine*, Dec., 1960, p. 47.

159. "Transition," *Newsweek*, Sept. 11, 1967 (obituary).

160. Wasserman, Burt, "Reinhardt: The Positive Power of Negational Thinking," *Art Education*, Dec., 1965.

161. "A Way to Kill Space," *Newsweek*, Aug. 12, 1946.

162. Whelan, Richard, and Howe, Susan, "Ad Reinhardt," *Art in America*, Mar.–Apr., 1976, pp. 33, 35, 37 (reviews of bibls. 87, 86).

163. Wolter, Beverly, "Hindemith Recital Shows Art Communication," *Winston-Salem* (N. C.) *Journal*, Apr. 17, 1964, p.11 (includes statements from symposium).

* See also bibl. 359.

III. ONE-MAN EXHIBITION CATALOGUES (listed chronologically)

164. "Art School Gallery," *The Brooklyn Museum Bulletin*, Apr., 1946, p. 3.

165. *Ad Reinhardt*. New York: Betty Parsons Gallery, Oct. 18–Nov. 6, 1948 (includes statement).

166. *Ad Reinhardt*. New York: Betty Parsons Gallery, Oct. 31–Nov. 19, 1949 (includes statement, "Incidental Note").

167. *Ad Reinhardt: Twenty-Five Years of Abstract Painting*. New York: Betty Parsons Gallery, Oct. 17–Nov. 5, 1960 (includes extensive reprints of writings).

168. *Reinhardt, Lo Savio, Verheyen*. Leverkusen: Städtisches Museum, Jan. 27–Mar. 19, 1961 (includes reprints of writings in German translation).

169. "Ad Reinhardt in London," *ICA Bulletin*, May, 1964, p. 6.

170. Lippard, Lucy R., *Ad Reinhardt: Paintings*. New York: The Jewish Museum, Nov. 23, 1966–Jan. 15, 1967 (preface by Sam Hunter; "chronology" by A. R.; extensive bibliography incorporated here).

171. *Ad Reinhardt: Black Paintings 1951–1967*. New York: Marlborough Gallery, Mar., 1970 (texts by H. Harvard Arnason and Barbara Rose; reprints bibl. 76).

172. *Ad Reinhardt*. Düsseldorf: Städtisches Kunsthalle, 1972; also shown at Zürich Kunsthaus, Feb. 11–Mar. 18, 1973 (includes statements).

173. *Ad Reinhardt*. Paris: Galeries nationales du Grand Palais, May 22–July 2, 1973 (reprints statements, chronology by A. R.; texts by Dale McConathy and Alfred Pacquement).

174. *Ad Reinhardt: A Selection from 1937 to 1952*. New York: Marlborough Gallery, Mar. 2–23, 1974 (text and chronology by Dale McConathy, translated when shown at Marlborough Galerie A. G., Zurich, Dec., 1974–Jan., 1975).

175. *Ad Reinhardt*. New York: Pace Gallery, Oct. 2–30, 1976 (facsimile of postcard to Arnold Glimcher and silkscreen reproduction of black painting).

176. *Ad Reinhardt: Art Comics and Satires*. New York: Truman Gallery, Oct. 2–30, 1976 (portfolio of reproductions and text by Peter Schjeldahl).

* See also bibl. 64.

IV. REVIEWS OF ONE-MAN EXHIBITIONS (listed chronologically; see also section II)

177. "Reinhardt," *Art News*, Feb. 15, 1944, p. 23.
178. Riley, Maude, "Reinhardt," *Art Digest*, Feb. 15, 1944, p. 20.
179. "Reinhardt," *Art News*, Nov., 1946, p. 45.
180. Lansford, Alonzo, "Variations on Reinhardt," *Art Digest*, Nov. 1, 1946, p. 21.
181. Solman, Joseph, "A Look at Abstract Art," *New Masses*, Dec. 3, 1946, pp. 25–26.
182. Carter, Adam B., "A Look at Frasconi, Hofmann, Reinhardt and Other Shows," *Daily Worker*, Nov. 28, 1947, p. 13.
183. Hunter, Sam, "Among Newly Opened Exhibitions," *The New York Times*, Nov. 30, 1947.
184. "Ad Reinhardt," *Art News*, Dec., 1947, p. 60.
185. Reed, Judith Kaye, "Abstracts by Reinhardt," *Art Digest*, Dec. 1, 1947, pp. 22–23.
186. "Reinhardt," *Art News*, Oct., 1948, p. 47.
187. P. F. C., "Painted Patterns," *Art Digest*, Nov. 1, 1948, p. 19.
188. Hess, Thomas B., "Reinhardt," *Art News*, Nov., 1949, p. 50.
189. Reed, Judith Kaye, "Without Subjects," *Art Digest*, Nov. 1, 1949, p. 26.
190. Frankenstein, Alfred, "Two Artists and Several Galleries," *San Francisco Chronicle*, Aug. 6, 1950.
191. Krasne, Belle, "Reinhardt," *Art Digest*, June 1, 1951, p. 19.
192. Goodnough, Robert, "Reinhardt," *Art News*, Summer, 1951, p. 47.
193. Fitzsimmons, James, "Reinhardt," *Art Digest*, Jan. 15, 1952, p. 20.
194. Porter, Fairfield, "Reinhardt," *Art News*, Feb., 1952, p. 41.
195. Sawin, Martica, "Reinhardt," *Art Digest*, Dec. 1, 1953, p. 21.
196. Preston, Stuart, "Color Keys Four Painters' Work," *The New York Times*, Feb. 5, 1955.
197. Crehan, Hubert, "Reinhardt," *Arts Magazine*, Feb. 15, 1955, pp. 25–26.
198. Campbell, Lawrence, "Reinhardt," *Art News*, Mar., 1955, p. 52.
199. Hess, Thomas B., "Ad Reinhardt: Portraits of Ahab," *Art News*, Nov., 1956, pp. 37, 67.
200. Pollet, Elizabeth, "Reinhardt," *Arts Magazine*, Dec., 1956, p. 54.
201. Campbell, Lawrence, "Reinhardt," *Art News*, Feb., 1959, p. 10.

202. Tillim, Sidney, "Reinhardt," *Arts Magazine*, Feb., 1959, p. 54.
203. Ashton, Dore, "Art: Busy Paris Season," *The New York Times*, June 28, 1960, p. 29.
204. Chevalier, Denys, "Reinhardt," *Aujourd'hui*, Sept., 1960, p. 45.
205. Campbell, Lawrence, "Reinhardt," *Art News*, Oct., 1960, p. 12.
206. Canaday, John, "Art Running the Gamut," *The New York Times*, Oct. 21, 1960, p. 36.
206a. Genauer, Emily, "Solos by Moderns," *New York Herald Tribune*, Oct. 23, 1960, S. 4, p. 7.
207. Schiff, Bennett, "In the Art Galleries," *New York Post*, Oct. 30, 1960.
208. Frigerio, Simone, "Leverkusen," *Aujourd'hui*, Feb., 1961, p. 53.
209. S[tiles], G[eorge], "Reinhardt," *Pictures on Exhibit*, Feb., 1961, pp. 16, 18.
210. Langsner, Jules, "Los Angeles Letter," *Art International*, Apr., 1962, p. 65.
211. Ashbery, John, "Range in Paris Galleries; Surrealist to All Black," *New York Herald Tribune* (Paris edition), June 19, 1963, p. 5.
212. Factor, Don, "Ad Reinhardt/Dwan Gallery," *Artforum*, Jan., 1964, p. 43.
213. Langsner, Jules, "Art News from Los Angeles," *Art News*, Jan., 1964, p. 50.
214. Thompson, David, "Art: Americans in London," *Queen Magazine*, June 3, 1964, p. 17.
215. Rosenthal, T. G., "All of the People Some of the Time," *The Listener*, June 11, 1964, p. 962.
216. Bowen, Denis, "Ad Reinhardt," *The Arts Review*, June 13, 1964 (blank square as review).
217. Preston, Stuart, "Things Seen Plain and Darkly," *The New York Times*, Mar. 7, 1965.
218. Gruen, John, "Tovish: Led by the Nose; Reinhardt: Black is the Color," *New York Herald Tribune Magazine*, Mar. 14, 1965.
219. Willard, Charlotte, [Ad Reinhardt], *New York Post*, Mar. 14, 1965, p. 14 magazine.
220. Raynor, Vivien, "Ad Reinhardt," *Arts Magazine*, Apr., 1965, p. 58.
221. Hudson, Andrew, "Viewpoint on Art," *Washington Post*, Jan. 23, 1966.
222. Genauer, Emily, "Reinhardt Exhibit Traces His Career from 1937 with 126 Works," *World Journal Tribune*, Nov. 22, 1966, p. 30.
223. Willard, Charlotte, "The 'Purity' Test," *New York Post*, Dec. 10, 1966, p. 14 magazine.

224. Perreault, John, "Variations," *The Village Voice*, Dec. 22, 1966, pp. 12–13.
225. Emanuel, Jerry, "New York," *artscanada*, Jan., 1967, supp. p. 7.
226. Ashton, Dore, "The Symbol Lurking in the Wings," *Studio International*, Feb., 1967, pp. 98–100.
227. Young, M. S., "Ad Reinhardt," *Apollo*, Mar., 1967, p. 229.
228. Benedikt, Michael, "New York," *Art International*, Apr. 20, 1967, p. 64.
229. Campbell, Lawrence, "Ad Reinhardt," *Art News*, Mar., 1970, p. 65.
230. Genauer, Emily, "Art and the Artist," *New York Post*, Mar. 28, 1970.
231. Pincus-Witten, Robert, [Ad Reinhardt], *Artforum*, May, 1970, pp. 75–76.
232. Plagens, Peter, [Ad Reinhardt], *Artforum*, Nov., 1970, p. 89.
233. Richter, Wolfgang, [Ad Reinhardt], *Aachener Volkszeitung*, Sept. 16, 1972.
234. Friedrichs, Yvonne, "Bilder an der Grenze des Darstellbaren," *Rheinische Post*, Sept. 19, 1972.
235. Vitt, Walter, "Ad Reinhardt: Bilder Über Nichts," *Aachener Nachrichten*, Sept. 19, 1972.
236. Krüser, Werner, "'Kunst-Kunst' ganz in Schwarz," *Mannheimer Morgen*, Sept. 26, 1972.
237. Catoir, B., "Kunsthalle: Düsseldorf; Austellung," *Kunstwerk*, Nov., 1972, pp. 74–75.
238. Kerber, Bernard, "Szene Rhein-Ruhr," *Art International*, Jan., 1973, p. 56.
239. Touraine, L., "A. D. Reinhardt an Kunstmuseum de Zurich," *La Galerie*, Apr., 1973.
240. Gibson, Michael, "Ad Reinhardt's 'Absolute Statement'," *International Herald Tribune*, May 8, 1973.
241. Lévêque, J. -J., "À Voir: Ad Reinhardt," *La Galerie*, June, 1973.
242. Hahn, Otto, "Les Noirs de Reinhardt," *L'Express*, June 25–July 1, 1973.
243. Conil-Lacoste, Michel, "L'Intransigéance d'Ad Reinhardt," *Le Monde*, June 29, 1973.
244. Stephano, Effie, "Paris," *Art and Artist*, Aug., 1973, p. 46.
245. Duval, Jean-Luc, "Ad Reinhardt: Force de l'absolu," *Art International*, Summer, 1973, pp. 69–70.
246. Bacchi, Anna and Giorgio, "Further Than This We Cannot Go," *Christian Science Monitor*, Sept. 21, 1973.
247. Genauer, Emily, "Art and the Artist," *New York Post*, Mar. 9, 1974.

248. Kramer, Hilton, "Art: Ad Reinhardt's Earlier Period," *The New York Times*, Mar. 9, 1974.

249. Hess, Thomas B., "Some Words About Paintings Without Words," *New York Magazine*, Mar. 25, 1974, pp. 70–71.

250. B.,D., "Ad Reinhardt," *Pictures on Exhibit*, Apr., 1974.

251. Derfner, Phyllis, "New York Letter," *Art International*, May, 1974, p. 67.

252. Henry, Gerrit, "Ad Reinhardt: A Selection from 1937 to 1952," *ARTnews*, May, 1974, p. 68.

253. Rubin, Vittorio, "Mostre," *Corriere della Sera*, May 26, 1974.

254. Trucchi, Lorenzo, "L'Arte Ad Reinhardt alla Marlborough," *Le Rubriche di Momento-Sera*, May 29–30, 1974.

255. L'Arte freddo di Ad Reinhardt," *L'Unita*, May 31, 1974.

256. Kuspit, Donald, "Ad Reinhardt at Marlborough," *Art in America*, May–June, 1974, pp. 111–12.

257. Terenzi, Claudia, "Arte di Reinhardt," *Paese Sera*, June 7, 1974, p. 3.

258. Salvi, Elvira Cassa, "Notizario delle arti l'azzeramento di Ad Reinhardt," *Giornale di Brescia*, June 20, 1974.

259. Frances, Eileen, "Report from Milan," *Pictures on Exhibit*, Oct., 1974, p. 43.

260. Duval, Jean-Luc, "Reinhardt et Botero," *Art Spectrum*, Jan., 1975, p. 77.

261. Mangold, Claude, "Zurich," *Arteguia*, Feb., 1975, p. 30.

262. Andre, Michael, "Ad Reinhardt," *ARTnews*, Dec., 1976, pp. 114–15.

262a. Lorber, Richard, "Ad Reinhardt," *Arts Magazine*, Dec., 1976.

262b. Cavaliere, Barbara, "Ad Reinhardt," *Arts Magazine*, Dec., 1977, p. 34.

262c. Schwartz, Ellen, "Ad Reinhardt and Red Grooms," *ARTnews*, Jan., 1978, pp. 141–42.

V. SELECTED GENERAL BOOKS, ARTICLES, AND REVIEWS INCLUDING REINHARDT (listed alphabetically by author or title)

263. Alloway, Lawrence, "Artists as Writers, Part Two; The Realm of Language," *Artforum*, Apr., 1974, pp. 30–35.

264. Alloway, Lawrence, "London Letter: Six From New York," *Art International*, Mar. 1, 1961, pp. 51–52.

265. Alloway, Lawrence, "Sol LeWitt: Modules, Walls, Books," *Artforum*, Apr., 1975, pp. 38–44.

266. Alloway, Lawrence, *Systemic Painting*. New York: Solomon R. Guggenheim Museum, Sept.–Nov., 1966, pp. 5, 8–10 (A. R. not in exhibition; essay reprinted in Alloway's *Topics in American Art Since 1945*. New York: W. W. Norton, 1975, which also includes other Reinhardt references).

 * Alloway, Lawrence, see also bibl. 390.

267. *American Abstract Artists, 1936–1966*. New York: George Wittenborn (distributor), 1966.

268. American Abstract Artists, ed., *The World of Abstract Art*. New York: George Wittenborn, 1957, pp. 60, 62, 116, 138, 139, 161.

269. Arnason, H. Harvard, *History of Modern Art*. New York: Harry N. Abrams, n.d., pp. 488, 508–10, 605, 621, 623.

270. Arnason, H. Harvard, "The New Geometry," *Art in America*, no. 3, 1960, pp. 55–61.

 * Arnason, H. Harvard, see also bibls. 342, 381, 383, 388, 391, 394.

271. "Art: Question Marks in Color," *Time*, Jan. 26, 1959, p. 92.

272. *L'Arte Moderna*, no. 37. Milan: Fabbri, 1961, pp. 61–63, 65–72, 87–90.

273. "The Artist Speaks: Part Six," *Art in America*, Aug.–Sept., 1965, p. 122 (includes statements).

274. Ashton, Dore ["Americans 1963"], *Arts and Architecture*, July, 1963, pp. 4–5.

275. Ashton, Dore, *The Unknown Shore*. Boston: Little, Brown & Co., 1962, pp. 123–24.

276. Baigell, Matthew, "American Painting: On Space and Time in Early 1960's Art," *Art Journal*, Summer, 1969, p. 371.

277. Barber, Nancy, [an interview with] "Betty Parsons," *Arts in Ireland*, June, 1975, p. 19.

278. Baro, Gene, "A Gathering of Americans," *Arts Magazine*, Sept., 1963, pp. 28–33.

279. Battcock, Gregory, *Minimal Art: A Critical Anthology*. New York: E. P. Dutton, 1968 (frontispiece and references throughout book).

 * Baur, John I. H., see bibl. 399.

280. Bennett, Ian, *A History of American Painting*. London and New York: Paul Hamlyn, 1973, pp. 197, 212.

281. Blesh, Rudi, *Modern Art USA*. New York: Knopf, 1956.

282. Brennan, Jay, ed., *American Painting, 1900–1970*. New York: Time-Life Books, 1970, p. 191.

283. Brown, Gordon, "An Editorial Comment on Art: Warm and Cool," *Art Voices*, Apr.–May, 1964, pp. 21–23.

284. Burton, Scott, "Time on Their Hands," *Art News*, Summer, 1969, p. 40.

285. Calas, Nicolas and Elena, "Problems of Invisibility (Reinhardt, Brach, Martin)," in *Icons and Images of the Sixties*. New York: E. P. Dutton, 1971, pp. 212–17.

286. Cameron, Eric, "Drawing Lines in the Desert (a Study of North American Art)," *Studio International*, Oct., 1970, p. 180.

287. Chandler, J. N., "Colors of Monochrome; An Introduction to Seduction and Reduction," *artscanada*, Oct., 1971, pp. 24, 26.

 * Chandler, John N., see also bibl. 321.

288. Cohen, George M., *A History of American Art*. New York: Dell, 1971, pp. 245–46.

289. Colin, Ralph F., "Fakes and Frauds," *Art in America*, Apr., 1963, p. 89 (see also bibl. 98).

 * Coplans, John, see bibl. 412.

289a. Coxhead, David, "A Conversation with Betty Parsons," *Art Monthly*, no. 22, 1978, pp. 5–8.

 * Crimp, Douglas, see bibl. 321.

290. Crosby, John, "A Few Notes on Art," *New York Herald Tribune*, June 21, 1963, p. 17.

291. Cummings, Paul, *A Dictionary of Contemporary American Artists*, 2nd ed. New York: St. Martins Press, 1971, p. 272.

292. Davidson, Marshall B., et al., *The American Heritage History of the Artists' America*. New York: American Heritage, 1973, pp. 388–89.

293. Davis, Alexander, ed., *LOMA (Literature of Modern Art)*. London: Lund Humphries, 1969–70.

294. De Kooning, Elaine, "A Cahier Leaf: Prejudices, Preferences and Preoccupations," *It Is*, Spring, 1958, p. 19.

 * Elderfield, John, see bibl. 417.

295. Elsen, Albert, *Purposes of Art*. New York: Holt, Rinehart and Winston, 1967, p. 434.

296. Esman, Rosa, ed., *New York International*. New York: Tanglewood Press, 1966 (portfolio of prints and objects including silkscreen by A. R.; introduction by Henry Geldzahler).

297. Fitzsimmons, James, "Art for Export: Will It Survive the Voyage?" *Art Digest*, Jan. 1, 1952.

298. Fitzsimmons, James, "Whitney Annual: Many Talents, Few Commitments," *Art Digest*, Apr. 1, 1952, p. 27.

299. Geller, S. A., "Faculty Artists Among 17 at Brussels," *Kingsman* (Brooklyn College), Mar. 14, 1958, p. 9.

300. Genauer, Emily, "Art and Artists: Fogg Museum

Forum," *New York Herald Tribune*, Apr. 29, 1951 (includes statements).

301. Genauer, Emily, "The Good-Will Show at Home," *New York Herald Tribune New York Magazine*, Mar. 28, 1965, p. 39.

302. Getlein, Frank, "Art: Dutch Treat," *The New Republic*, Mar. 2, 1959, p. 21.

* Goossen, Eugene, see bibl. 413.

303. Greenberg, Clement, "New York Painting Only Yesterday," *Art News*, Summer, 1957, pp. 85–86.

* Gunter-Dienst, Rolf, see bibl. 334.

* Henning, Edward B., see bibl. 408.

303a. Johnson, Ellen H., "American Art of the 20th Century," *Apollo*, Feb., 1976, p. 128.

318. LeWitt, Sol (in interview with Achille Bonito Oliva), *Album 9–68. 2–71*. Rome: Galleria L'Attico, 1971.

319. Lippard, Lucy R., "Alcuni manifesti politici e alcune questioni da essi sollevate intorno all'arte e alla politica," *Data*, Nov.–Dec., 1975, pp. 64–69 (with English translation).

320. Lippard, Lucy R., "The Silent Art," *Art in America*, Jan., 1965, pp. 58–63.

321. Lippard, Lucy R., and Chandler, John N., "The Dematerialization of Art," *Art International*, Feb., 1968 (reprinted in Lippard, *Changing*. New York: E. P. Dutton, 1971).

322. Lippard, Lucy R., "The Third Stream: Constructed Paintings and Painted Structures," *Art Voices*, Spring, 1965, pp. 44–49.

* Lippard, Lucy R., see also bibls. 410, 411.

323. Longo, Vincent, "Studio Talk: Color: Possibilities and Materials," *Arts Magazine*, Nov., 1955, pp. 60–61.

324. Louchheim, Aline B., "Betty Parsons: Her Gallery, Her Influence," *Vogue*, Oct. 1, 1951.

324a. Masheck, Joseph, "Cruciformality," *Artforum*, Summer, 1977, pp. 56–63.

325. McNeil, George, "American Abstractionists Venerable at Twenty," *Art News*, May, 1956, pp. 34–35, 64–66.

326. McQuade, Walter, "Architecture," *The Nation*, May 19, 1962, pp. 452–53 (includes statements).

327. Melville, Robert, "The Avant-garde at the Tate," *New Statesman*, May 1, 1964, p. 695.

328. Melville, Robert, "Movement in Decay," *New Statesman*, Sept. 24, 1965, p. 457.

329. Michener, James A., "Should Artists Boycott New York?" *Saturday Review*, Aug. 26, 1961, pp. 12, 48.

330. Michelson, Annette, "10 x 10: 'Concrete Reasonableness'," *Artforum*, Jan., 1967, pp. 30–31.

330a. Millet, Catherine, "Le problème du 'sujet' dans l'abstraction, l'éthique," *XX^e siècle*, Dec., 1977, pp. 122–27.

331. Molleda, Mercedes, "El Museum Whitney de Arte Americano," *Atlantico*, no. 11, 1959, pp. 47–62.

332. Monro, Isabel Stevenson, and Monro, Kate M., *Index to Reproductions of American Paintings*. New York: H. W. Wilson, 1948, p. 528; also first supplement, 1964, pp. 355–56.

* Morley, Grace McCann, see bibl. 386.

333. Nankoku, Hidai [American Reactions to Sho-Art—Oriental Calligraphy], *Mainichi*, Jan. 29, 1964 (in Japanese).

334. Jürgen-Fischer, Klaus, ed., "Neue Abstraktion/New Abstraction," special issue of *Kunstwerk*, Apr.–June, 1965, pp. 5, 30, 123 (includes statements; also text by Rolf Gunter-Dienst).

334a. Nordland, Gerald, "Los Angeles Letter," *Art International*, Mar.–Apr., 1976, p. 60.

335. O'Connor, Francis V., ed., *The New Deal Project: An Anthology of Memoirs*. Washington, D. C.: Smithsonian Institution Press, 1972, p. 337.

* O'Connor, Francis V., see also bibl. 409.

336. O'Doherty, Brian, *American Masters: The Voice and the Myth*. New York: Random House, 1973, p. 288.

337. O'Kane, Lawrence, "City Considering Low-Rent Studios," *The New York Times*, Dec. 10, 1963, p. 56 (includes statements).

338. Oster, Gerald, "Optical Art," *Applied Optics*, Nov., 1965, p. 1362.

339. "Panelists Dispute Rules for Federal Aid to Arts," *Harvard Crimson*, Apr. 28, 1962, p. 1 (includes statements).

340. Pousette-Dart, Nathaniel, *American Painting Today*. New York: Hastings House, 1956, p. 102.

341. Prampolini, Ida Rodriguez, *El Arte Contemporáneo*. Mexico: Pormaca, 1964, pp. 141, 177–78 (see also Rodriguez, Ida).

341a. Ratcliff, Carter, "New York Letter," *Art International*, Dec., 1977, pp. 65–67.

342. Read, Herbert, and Arnason, H. Harvard, "Dialogue on Modern US Painting," *Art News*, May, 1960, pp. 32–36.

343. "The Revolt of the Pelicans," *Time*, June 5, 1950 (includes statements).

* Ritchie, Andrew Carnduff, see bibl. 380.

344. Rodman, Selden, *The Eye of Man: Form and Content in Western Painting*. New York: Devin-Adair, 1955, pp. 135–36.

345. Rodriguez, Ida, "La Pintura Monocromatica," *Mexico en la Cultura*, Sept. 3, 1961, p. 5 (see also Prampolini, Ida).

346. Rosand, David, "At the Limits of Art," *The Second Coming Magazine*, July, 1961, pp. 52–58.

347. Rose, Barbara, "ABC Art," *Art in America*, Oct.–Nov., 1965, pp. 58, 62, 65.

348. Rose, Barbara, *American Art Since 1900*, rev. ed. New York/Washington: Praeger, 1968; also *Readings in American Art Since 1900: A Documentary Survey*, pp. 160–64 (includes statements).

349. Rose, Barbara, *American Painting: The 20th Century*. Geneva: Skira, 1970.

350. Rose, Barbara, "Americans 63," *Art International*, Sept. 25, 1963, pp. 77–79.

351. Rose, Barbara, "The Primacy of Color," *Art International*, May, 1964, pp. 22–26.

352. Rose, Barbara, "The Value of Didactic Art," *Artforum*, Apr., 1967, pp. 32–36.

353. Rosenberg, Harold, "Black and Pistachio," in *The Anxious Object*. New York: Horizon Press, 1964, pp. 52–54.

354. Rosenberg, Harold, "Tenth Street: A Geography of Modern Art," *Art News Annual*, 1959, p. 120.

* Rosenberg, Harold, see also bibls. 401, 416.

355. Sandler, Irving, "American Painting: A Will to Renewal," *Life*, Oct. 17, 1966.

356. Sandler, Irving, "In the Art Galleries," *New York Post*, Nov. 6, 1963, p. 14, and Jan. 12, 1964, p. 14.

357. Sandler, Irving, "In the Art Galleries: Americans 1963," *New York Post*, June 9, 1963, p. 12.

358. Sandler, Irving, "The New Cool-Art," *Art in America*, Feb., 1965, p. 97.

359. Sandler, Irving, *The Triumph of American Painting: A History of Abstract Expressionism*. New York: Praeger, 1970, chap. 8 (on A. R.).

* Sandler, Irving, see also bibl. 411.

* Schulman, Leon, see bibl. 414.

* Seitz, William C., see bibl. 404.

360. Seuphor, Michel, "La Peinture aux États-Unis," *Art d'aujourd'hui*, June, 1951 (includes statements).

361. Smithson, Robert, "A Museum of Language in the Vicinity of Art," *Art International*, Mar., 1968, pp. 21–27.

362. Smithson, Robert, "Quasi-Infinities and the Waning of Space," *Arts Magazine*, Nov., 1966, pp. 28–31.

363. Summers, Marion, "Abstract Art: Highway or Dead End?" *The Worker*, June 12, 1946.

364. Summers, Marion, "Art Today: Lessons in Utter Confusion," *The Worker*, May 19, 1946, p. 14.

365. Summers, Marion, "Art Today: Two Abstractionists and a Painter of Decay," *The Worker*, Nov. 1, 1946.

366. Sutton, Denys, "The Challenge of American Art," *Horizon*, Oct., 1949, pp. 268–84.

367. Thabit, Walter [on "Who is Responsible for Ugliness?" conference], *The Village Voice*, Apr. 19, 1962.

368. Tillim, Sidney, "What Happened to Geometry?" *Arts Magazine*, June, 1959, p. 43.

369. Vinklers, Bitite, "Variations in Geometric Abstraction," *Art International*, May 20, 1970, pp. 83–84.

370. Volpi Orlandini, Marisa, *Arte dopo il 1945: USA*. Milan: Cappelli, 1969.

371. Wagstaff, Sam, "Paintings to Think About," *Art News*, Jan., 1964, pp. 38, 62.

372. "What is Art Today?" *Time*, Jan. 27, 1967, pp. 24–25 (includes statement).

373. Wilmerding, John, ed., *The Genius of American Painting*. New York: Morrow, 1973, chap. 6 (by Dore Ashton).

374. Wolff, R. J., "On the Relevance of Abstract Art: A Memoir," *Leonardo*, Winter, 1972, pp. 19–26.

375. Wollheim, Richard, "Minimal Art," *Arts Magazine*, Jan., 1965, pp. 26–32.

376. Yates, Peter, "Art: The New Art," *Arts and Architecture*, Sept., 1966, pp. 6, 35–36.

VI. SELECTED GENERAL EXHIBITION CATALOGUES (listed chronologically)

377. *Abstract and Surrealist Art in the United States*. San Francisco Museum of Art, July, 1944 (preface by Sidney Janis; see also bibl. 310).

378. *The Intrasubjectives*. New York: Kootz Gallery, Sept. 14–Oct. 3, 1949 (organized by Harold Rosenberg and Sam Kootz).

379. *Young Painters in U.S. and France*. New York: Sidney Janis Gallery, Oct. 23–Nov. 11, 1950.

380. *Abstract Painting and Sculpture in America*. New York: The Museum of Modern Art, 1951 (text by Andrew Carnduff Ritchie).

381. *40 American Painters*. Minneapolis: University of Minnesota Gallery, June 4–Aug. 30, 1951 (text by H. H. Arnason; includes statements).

382. *Regards sur la peinture Américaine*. Paris: Galerie de France, Feb. 26–Mar. 15, 1952 (text by Leon De-gan; organized by Sidney Janis "with the advice of New York art critics" and shown first at the Sidney Janis Gallery, New York, Dec., 1951–Jan., 1952; includes statements).

383. *The Classic Tradition in Contemporary Art*. Minneapolis: Walker Art Center, Apr. 24–June 28, 1953 (text by H. H. Arnason).

384. *The 30's, Painting in New York*. New York: Poindexter Gallery, 1957 (edited by Patricia Pasloff).

385. *American Paintings: 1945–1957*. Minneapolis Institute of the Arts, 1957.

386. *American Art: Four Exhibitions*. Brussels World's Fair, Apr. 17–Oct. 18, 1958 (text by Grace McCann Morley).

387. *New York and Paris: Painting in the Fifties*. Houston: Museum of Fine Arts, Jan. 16–Feb. 8, 1959 (organized by Dore Ashton and Bernard Dorival).

388. *60 American Painters 1960: Abstract Expressionist Painting of the Fifties*. Minneapolis: Walker Art Center, Apr. 3–May 8, 1960 (text by H. H. Arnason; extensive bibliography).

389. *The Collection of Mr. and Mrs. Ben Heller*. New York: The Museum of Modern Art Circulating Exhibition, 1961 (texts by Alfred H. Barr, Jr., and William Seitz).

390. *6 American Abstract Painters*. London: Arthur Tooth & Sons, Jan. 24–Feb. 18, 1961 (text by Lawrence Alloway).

391. *American Abstract Expressionists and Imagists*. New York: Solomon R. Guggenheim Museum, Oct.–Dec., 1961 (text by H. H. Arnason; bibliography by Suzi Bloch).

392. *Art Since 1950*. Seattle World's Fair, Apr. 21–Oct. 21, 1962 (organized by Sam Hunter).

393. *Geometric Abstraction in America*. New York: Whitney Museum of American Art, Mar. 20–May 13, 1962 (text by John Gordon).

394. *Vanguard American Painting*. London: The American Embassy, Feb. 28–Mar. 30, 1962 (text by H. H. Arnason).

395. *Directions in Contemporary Painting and Sculpture: 66th American Exhibition*. Art Institute of Chicago, Winter, 1962–63.

396. *De A à Z 1963*. Paris: Centre culturel Américain, May 10–June 29, 1963.

397. *Americans 1963*. New York: The Museum of Modern Art, 1963 (edited by Dorothy C. Miller).

398. *Painting and Sculpture of a Decade: 54–64*. London: The Tate Gallery (with the Calouste Gulbenkian Foundation), Apr. 22–June 28, 1964.

399. *Between the Fairs: 25 Years of American Art: 1939–1964*. New York: Whitney Museum of American Art, June 24–Sept. 23, 1964 (text by John I. H. Baur).

400. *Artists Select*. New York: Finch College Museum of Art, Oct. 15–Dec. 15, 1964.

401. *Critics' Choice: Art Since World War II*. Providence (R.I.) Art Club, Mar. 31–Apr. 24, 1965 (texts by T. B. Hess, H. Kramer, H. Rosenberg).

402. *New York School: The First Generation: Paintings of the 1940s and the 1950s*. Los Angeles County Museum of Art, July 16–Aug. 1, 1965 (edited by Maurice Tuchman; extensive bibliography by Lucy R. Lippard; includes statements).

403. *Den Inre och den Yttre Rymden (The Inner and the Outer Space): An Exhibition Devoted to Universal Art*. Stockholm: Moderna Museet, 1965 (edited by K. G. Hultén; includes statements in Swedish).

404. *The Responsive Eye*. New York: The Museum of Modern Art, 1965 (text by William C. Seitz; see Part II, "Invisible Painting").

405. *Twentieth Century Paintings, Drawings and Sculpture Presented to the Institute of Contemporary Arts for sale on behalf of the Carlton House Terrace Project*. London: Sotheby & Co., June 23, 1966.

406. *Amerikaanse Schilderijen Collages*. Rotterdam: Museum Boymans-van Beuningen, Sept. 20–Oct. 30, 1966.

407. *10*. New York: Dwan Gallery, Oct. 4–29, 1966.

408. *Fifty Years of Modern Art, 1916–1966*. Cleveland Museum of Art/Press of Western Reserve University, 1966 (text by Edward B. Henning).

409. *Federal Art Patronage 1933 to 1943*. University of Maryland, Apr. 6–May 13, 1966 (text by Francis V. O'Connor).

410. *Focus on Light*. Trenton: New Jersey State Museum, May 20–Sept. 10, 1967 (text by Lucy R. Lippard).

411. *Two Decades of American Painting*. Circulating exhibition from The Museum of Modern Art, New York (texts by L. R. Lippard, I. Sandler, G. R. Swenson; also titled *American Painting 1945–1965*; shown in Australia, India, and Japan).

412. *Serial Imagery*. Pasadena Museum, Sept. 17–Oct. 27, 1968 (text by John Coplans; also shown in Seattle and Santa Barbara; trade edition of catalogue published by New York Graphic Society, Greenwich, Conn., 1968).

413. *The Art of the Real; USA 1948–1968*. New York: The Museum of Modern Art/New York Graphic Society,

1968 (text by Eugene Goossen; bibliography by B. Karpel).

414. *The Direct Image*. Worcester Art Museum, Oct. 16–Nov. 30, 1969 (text by Leon Schulman).

415. *New York Painting and Sculpture: 1940–1970*. New York: The Metropolitan Museum of Art, 1970 (text by Henry Geldzahler; trade edition published by E. P. Dutton, 1970).

416. *American Action Painting*. Rome: Marlborough Galeria, Apr., 1972 (text by Harold Rosenberg).

417. *Geometric Abstraction, 1926–1942*. Dallas Museum of Fine Arts, Oct. 7–Nov. 19, 1972 (texts by Michel Seuphor, John Elderfield).

418. *Contemporary Art, 1942–1972: Collection of the Albright-Knox Art Gallery*. Buffalo: Albright-Knox Art Gallery, Buffalo/New York: Praeger, 1973.

419. *Arte come Arte*. Milan: Centro Communitario de Brera, Apr.–May, 1973 (text by Douglas Crimp; includes statements).

420. *Perceptions of the Spirit in Twentieth-Century American Art*. Indianapolis Museum of Art, Sept. 20–Nov. 27, 1977 (texts by Jane and John Dillenberger; also shown at the University Art Museum, Berkeley, Calif., the Marion Kugler McNay Art Institute, San Antonio, Texas, and the Columbus Gallery of Fine Arts).

421. *Abstract Expressionism: The Formative Years*. Ithaca: The Herbert F. Johnson Museum of Art, Cornell University, Mar. 30–May 14, 1978 (texts by Robert Carleton Hobbs and Gail Levin; also shown at The Seibu Museum of Art, Tokyo, and the Whitney Museum of American Art, New York).

* *See also bibls.* 19, 27a.

INDEX

Footnote numbers are in parentheses. Black and white plate numbers are in italic type. Colorplate numbers are preceded by an asterisk.

PHOTOCREDITS

The author and the publisher wish to thank museums and private collectors for permitting the reproduction of works of art in their collections and for supplying the necessary photographs. Photographs from the following sources are also gratefully acknowledged: Baker, Oliver, fig. 100; Berezov, Maurice, fig. 71; Bowden, H., fig. 9; Burckhardt, Rudy, fig. 22; Clements, Geoffrey, pls. 2, 3, figs. 14, 15, 42, 46, 54, 62, 74, 75, 80, 91, 102, 104; Dienes, Regina, fig. 92; Lambert, Gretchen, figs. 94, 101; Lax, Robert, fig. 97; Lazarus, Marvin, fig. 107; Mates, Robert E., pl. 16, fig. 82; Nelson, O.E., pl. 7, figs. 5, 72; Newman, Irving J., pl. 20; Pollitzer, Eric, pls. 11, 17, 31, 32, 34, 35, 37, figs. 89, 105; Roos, George, pls. 4, 23, 40; Rosenblum, Walter, figs. 19, 23, 26, 27, 28, 29, 30, 41, 51, 52, 65, 66, 67, 68, 70, 76, 77, 81, 88, 90; Serisawa, I., fig. 93; Shifreen Studios, fig. 37; Siskind, Aaron, fig. 32; Sloman, Steven, fig. 78; Sunami, Soichi, fig. 12; Thomas, Frank J., pl. 21; Time, Inc., fig. 96.